I0235610

IMAGES
*of America*

# NORTH CAROLINA
# QUAKERS
## SPRING FRIENDS MEETING

ON THE COVER: A PERRY FAMILY REUNION. Spring Friends Meeting is the home to several families, some of whom have lived in the area since the mid-1700s. Some of the more prominent families are the Hadleys, Hollidays, Newlins, McBanes, Perrys, Zacharys, Lindleys, and Braxtons. (Dan Perry.)

IMAGES
*of America*

# NORTH CAROLINA
# QUAKERS
## SPRING FRIENDS MEETING

J. Timothy Allen on behalf
of Spring Friends Meeting

ARCADIA
PUBLISHING

Copyright © 2011 by J. Timothy Allen on behalf of Spring Friends Meeting
ISBN 978-1-5316-5460-3

Published by Arcadia Publishing
Charleston, South Carolina

Library of Congress Control Number: 2010940119

For all general information, please contact Arcadia Publishing:
Telephone 843-853-2070
Fax 843-853-0044
E-mail sales@arcadiapublishing.com
For customer service and orders:
Toll-Free 1-888-313-2665

Visit us on the Internet at www.arcadiapublishing.com

*This book is dedicated to the members, both past and present, of Spring Friends Meeting whose diligence, perseverance, and faith have refreshed many people and kept them in the Light of the Quaker heritage.*

# CONTENTS

# ACKNOWLEDGMENTS

Thanks go to the following people and organizations: Lindsay Carter (Hi, Tim!), my patiently persistent acquisitions editor; Gwen Erickson, librarian and college archivist, Friends Historical Collection, Guilford College, for her perseverance; Joe Bill and Jane Lindley (Thanks for the coffee.); Dan and Cindy Perry (Thanks, period.); A. Christopher Meekins, correspondence archivist, North Carolina Division of Archives; Jason Tomberlin, North Carolina research and instructional services librarian, Wilson Special Collections Library, University of North Carolina at Chapel Hill; Bryan Dalton and Lisa Cox of Alamance Battleground State Historic Site, Burlington, North Carolina; pastor Travis Brock, Sandy Creek Baptist Church; Hal Younts; Myrtle Phillips; Debbie Brown; Cathy and Dwayne Marley; Elizabeth "Pat" Shaw Bailey; William Murray Vincent, Laurie Smith (a former student), and Kevin Johnson of Alamance County Historical Museum Inc.; Charles and Laurie Newlin (Rachel Braxton's scrapbook saved this book!); pastor Mark Tope and John Allen of Cane Creek Friends Meeting; Paul and Shelby McBane; James Wilson and the Snow Camp Outdoor Theatre; Ron Osborne, whose meticulous eye saved me from several historical embarrassments; and Gerald Hampton. Unless otherwise noted, the names and dates of the photographers and photographs are unknown. Memories and histories become clouded with time, so the story presented here lives in the recollections of many.

# GLOSSARY

Quakers use terms that are not familiar to many outside of their circles. The following terms are important for this book:

**Preparative Meeting:** This is a meeting that is in "preparation" to become a monthly (independent) meeting. The preparative meeting is under the care of a monthly meeting. For Spring, some of the Cane Creek members wanted to form their own meeting, which was more than likely to save travel time. (It was about eight miles to Cane Creek Meeting for many Quakers in the Spring area). They requested from their meeting for preparative status. In Spring's case, Cane Creek Monthly Meeting sponsored Spring Preparative Meeting until it proved it could stand on its own. Then, Spring became Spring Monthly Meeting.

**Monthly Meeting:** This is a meeting that has independent status. A monthly meeting, like Spring Monthly Meeting, includes a worship and business meeting once a month.

**Quarterly Meeting:** Several monthly meetings collectively meet on a quarterly basis for worship with attention to business. Today, Spring is in the Western Quarterly Meeting of North Carolina Yearly Meeting. When Spring Monthly Meeting formed, North Carolina Quakers lived mostly in the eastern section of the colony. Thus, the rising Quaker population in the western section of North Carolina, beginning with Cane Creek Meeting, formed the Western Quarterly Meeting.

**Yearly Meeting:** A quarterly meeting is the quarterly meeting of numerous monthly meetings for worship and business, and a yearly meeting is the yearly meeting of numerous quarterly meetings to discuss business. Spring Meeting belongs to the North Carolina Yearly Meeting.

**First Day; Second Month:** Traditional Quakers did not use modern-day names such as Thursday or March because these names come from pagan deities (Thor's day and Mars), so they referred to the days of the week as 1st Day (January 1), 17th Day (January 17), and so forth. Likewise, First Month was January; Fifth Month was May. This system kept all days equal. On some of the early Spring Cemetery grave markers, the dates are inscribed as 1d 2m 23 (year). The year can be difficult to pinpoint, but context and records help to clarify an obscure date.

**Laid Down:** A meeting that cannot support itself is laid down, which translates to closed.

**Disowned:** A meeting member who violates certain Quaker principles is disowned. The member can still attend the meeting, but he or she is not allowed to have any say in the business meetings. Some of the "disownable" offenses that were observed by the Spring and Cane Creek Meetings and verified by their meeting minutes were marrying a non-Quaker, participating in a militia, owning slaves, or bad behavior, such as drinking. Committees were formed to visit disowned members, and if satisfied with a disowned member's contrition, a committee could recommend him or her to be reinstated. The member would most likely have to pay a "fine" and apologize but would then be readmitted into the meeting.

**Meetinghouse:** Friends typically do not use the word *church* but instead prefer *meetinghouse* to describe where they worship.

**Open Worship:** In the United States, traditional Quakers did not emphasize preaching; instead, members sat quietly and patiently waiting for the Light (somewhat equal to the Spirit) to inspire them to offer a word or thought. Quakers believe that as the Light leads the meeting members will all speak about the same idea or topic. Spring Meeting has open worship on the first Sunday (the first First Day) of each month.

# INTRODUCTION

In the mid-1700s, due to increasing tensions with Indians and rising political strife, Quakers from Virginia and especially Pennsylvania left their homes for the cheap land and pioneering adventures of a new life in northern Carolina. As they settled, they formed new Quaker communities in the Piedmont, including the following: New Garden, Cane Creek, Spring, Eno, Deep River, and Rocky Creek. In addition, other meetings quickly emerged. Many of these hearty pioneers settled in what is known as the Piedmont of North Carolina along Cane Creek in a broad area that came to be called Snow Camp.

Spring Meeting began with the arrival of Henry Holliday, Thomas Lindley, and Hugh Laughlin who scouted the land around Cane Creek in 1750 and then brought their families back in 1751 to settle down. These and other families, such as the Braxtons, Woodys, Hollingsworths, Newlins, and Carters, took the Great Trading Path from Pennsylvania and Virginia to their new homes. Initially, they were affiliated with Cane Creek Meeting, established in 1751, but when the eight-mile trek to nearby Cane Creek Meeting began to take its toll on more distant Quaker worshippers, the need arose for a new meeting closer to home. A place was found on the main road from Hillsborough, the county seat of Orange County and a major trading post in the backcountry of the Piedmont of North Carolina, to Wilmington. Even though people had gathered near several springs for worship before 1761, it was not until 1773 that Spring Preparative Meeting was officially established by its parent meeting. In 1793, Spring Monthly Meeting emerged from the womb of its mother, Cane Creek Meeting.

In the meeting's early days, an insurrectionist group, called the Regulators and led by former Quaker Herman Husband, fought against Governor Tryon in 1771. A few years later, Lord Cornwallis marched his British army through the Snow Camp area on his way to Guilford Courthouse, roughly 30 miles northwest. Quakers, traditionally pacifists, were often trapped between their beliefs and the increasing political persuasions of their neighbors. After the war, fervent revivals arose in the late 1700s and late 1800s, and Spring and other churches and meetings opened their doors to each other in ecumenical unity. After the Revolutionary War, slavery became an issue, and as Quakers became abolitionists, many fled the slave South for what was then called the Northwest, including Ohio, Indiana, and other frontier areas. Spring lost many members in this large migration in the early 1800s.

As the Civil War emerged, the religious, political, and regional loyalties of Quakers in the South were tested: would they side with the North and abolition or with the South and its "peculiar institution"? Just as during the American Revolution, Quakers were persecuted for their pacifist and abolitionist beliefs. Many Southern Civil War deserters swarmed to the Piedmont for sanctuary, no doubt aided by the Quaker conviction that stood firm against slavery as well as the war. The Underground Railroad, the pathway to freedom for many slaves, ran right by Spring Friends Meeting as it moved from there to Cane Creek Meeting, on to New Garden Meeting in Greensboro, and eventually then to freedom beyond the "Jordan," also known as the Ohio River.

After the war, Northern Quakers participated in the Reconstruction of the South. Schools for young black children were established, a need that was questioned by many Southerners. Along with this, Northern Quakers helped Southern meetings recuperate from the depression caused by the tragedies and disasters of the war. There was a resurgence of revivals as the emerging

national Pentecostal movement rose in the South. Would Quaker meetings remain faithful to the traditional form of expectant waiting and open worship, or would they switch to the new and more emotional style of worship? Spring initially chose the former, but the warmth of the revival fires was difficult to resist. Between 1867 and 1868, the second meetinghouse, replacing the original log structure, was built to accommodate the rising membership of Spring Monthly Meeting. It featured the typical two entrance doors, one for women and the other for men, who worshiped in silence in a room divided by a partition. However, when the current meetinghouse was constructed in 1907, Spring Friends Meeting adopted the pastoral style of worship that lasted until the 21st century.

As World Wars I and II brought their devastation across the globe, Spring members once again had to choose between loyalties with the Allied war efforts or their traditional pacifist beliefs. Along with this, a cultural war arose. With the rise of entertainments—anything from bubble gum to movies to baseball—the staid ways of conservative Quaker beliefs were challenged. Also, as the evangelical religion spread in the South, Spring and other monthly meetings began to hire pastors to lead them. This new form of pastoral leadership again affected the mode of worship and the theologies of the faithful.

Throughout all of these years, Spring Friends Meeting dealt with myriad issues that confront any community of worship: How to pay the bills during hard times? Who lights the stoves on First Day mornings? Is there enough money to paint the building? Would the addition of electric lights be too fancy for Quakers? What ministerial approaches will increase attendance? Which hymnals should be purchased? As always, Spring waited until the Light led to a unanimous or acceptable decision and then moved forward, if at times very slowly.

The membership of Spring Monthly Meeting has always included notable people. John Newlin owned a local mill and bought slaves in order to give them freedom. Probably the most famous member was Tom Zachary, who played professional baseball and was on the roster of the 1928 World Series champion New York Yankees. Algie Newlin, author of the *Friends "at the Spring,"* a history of Spring Friends Meeting, served as a professor at nearby Guilford College for many years. Local educators were also leaders in the meeting as well as in their community. Most notable was Ernest P. Dixon, who taught at and was principal of Eli Whitney School. Spring produced two missionaries, Ellen and Martha Woody, who worked in Cuba in the early 1900s. Many members were well educated. The list goes on and on.

Despite a severe drop in attendance in the 1990s, Spring Monthly Meeting survives today. Open worship is still practiced on the first Sunday. On the second and fourth Sundays, students from nearby Guilford College in Greensboro bring a spoken message. Spring participants provide spoken messages on the third Sundays. Hymns are sung from an old Broadman (Baptist) hymnal. New members and interested attendees fill the benches with the old members. And, as has been since its inception, the doors are never locked so that whoever drives by can enjoy the quiet of the spring and the peace of silent worship in the meetinghouse.

# One

# IT HAPPENED
# AROUND SPRING

Spring Friends Meeting rests in a region full of history. Religious scholars and historians often refer to the Piedmont area today as the Quaker Belt. Friends from Pennsylvania, Virginia, and other states began settling there around 1749. Cane Creek Meeting was the first Quaker meeting in the Piedmont, and from it arose five other meetings, one of which was Spring. Spring Monthly Meeting gave birth to Chatham, Eno (now laid down), and South Fork Meetings.

Revival fires occasionally swept through the community, beginning in the mid-1750s and returning in the early and late 1800s. Revivals were held in various churches and Quaker meetinghouses, as ministers shared pulpits to spread the Word.

Spring played a small role in the American Revolution. The members refused to join the Regulators Movement begun by then Cane Creek member Herman Husband (later disowned) as well as other Quakers. Governor Tryon's soldiers confiscated their goods and food after the Battle of Alamance in 1771. Spring members took care of the wounded, and the meetinghouse served as a hospital for troops wounded and killed in the 1781 Battle of Lindley's Mill. Several soldiers were buried in the cemetery, and a tombstone recalls the sacrifices of these men.

Spring members have a reputation for being a well-educated group. This was born out in their service to Spring School, which was nearby. Many members of Spring have connections to Guilford College, in Greensboro. In 1921, E.P. Dixon started Eli Whitney School, which was located just one mile east of Spring Meeting. In 1931, he also began what is known as Uncle Eli's Quilters' Party, which still meets annually today. Along with this, Spring Meeting was an original contributor to the Snow Camp Outdoor Theatre, which is eight miles to the west.

Today, vestiges of the early days of Spring Meeting still flow. This is their story told in pictures.

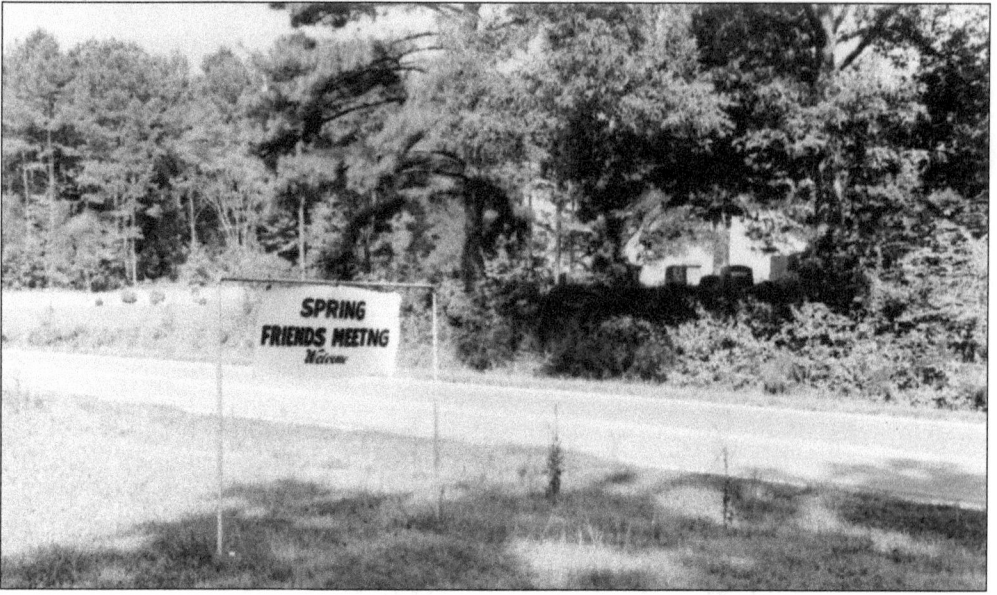

**OLD SPRING SIGN.** In this 1973 photograph, the old Spring Friends Meeting sign stands firm, if a bit crooked. It was replaced in the early 1990s. Spring member Ron Osborne found the sign in the woods near Spring Meeting. Quakers have traditionally been simple, frugal folks, so ostentatious displays of any type were frowned upon. The simple pipe frame and plaque are indicative of Spring Meeting's continued adherence to these old Quaker values. In the background is the cemetery. (Spring Friends Collection.)

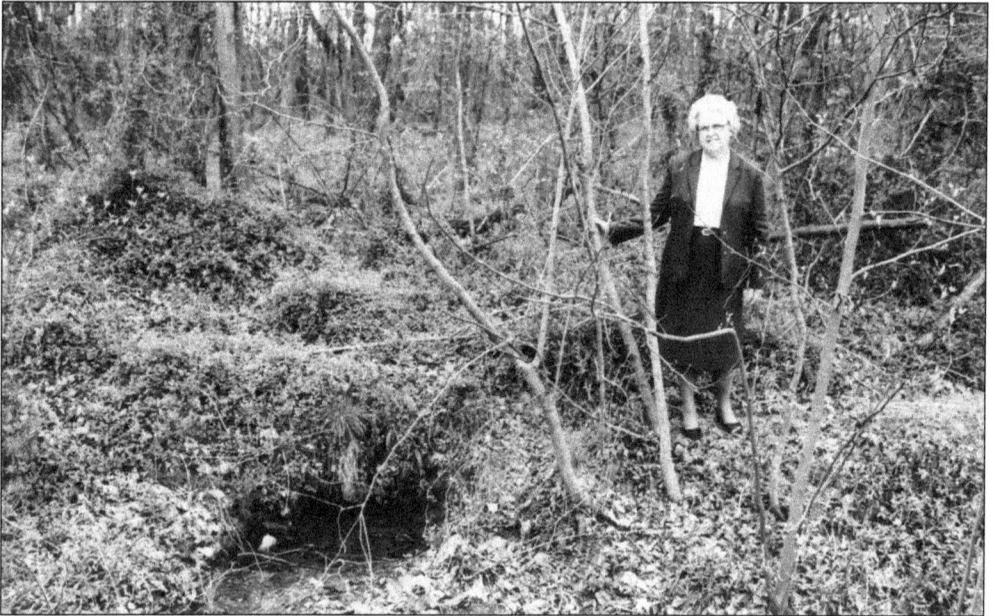

**MARY RUTH PERRY.** Several springs surround Spring Meeting, and there is a running debate over which is the "correct" one. Mary Ruth Perry stands by one of these springs. Perry was a longtime clerk of the meeting. She served on the planning committee for the 200th anniversary celebration of Spring Meeting, was an elder and a Bible school officer, and was on the Spring Stewardship Committee (Dan Perry.)

12

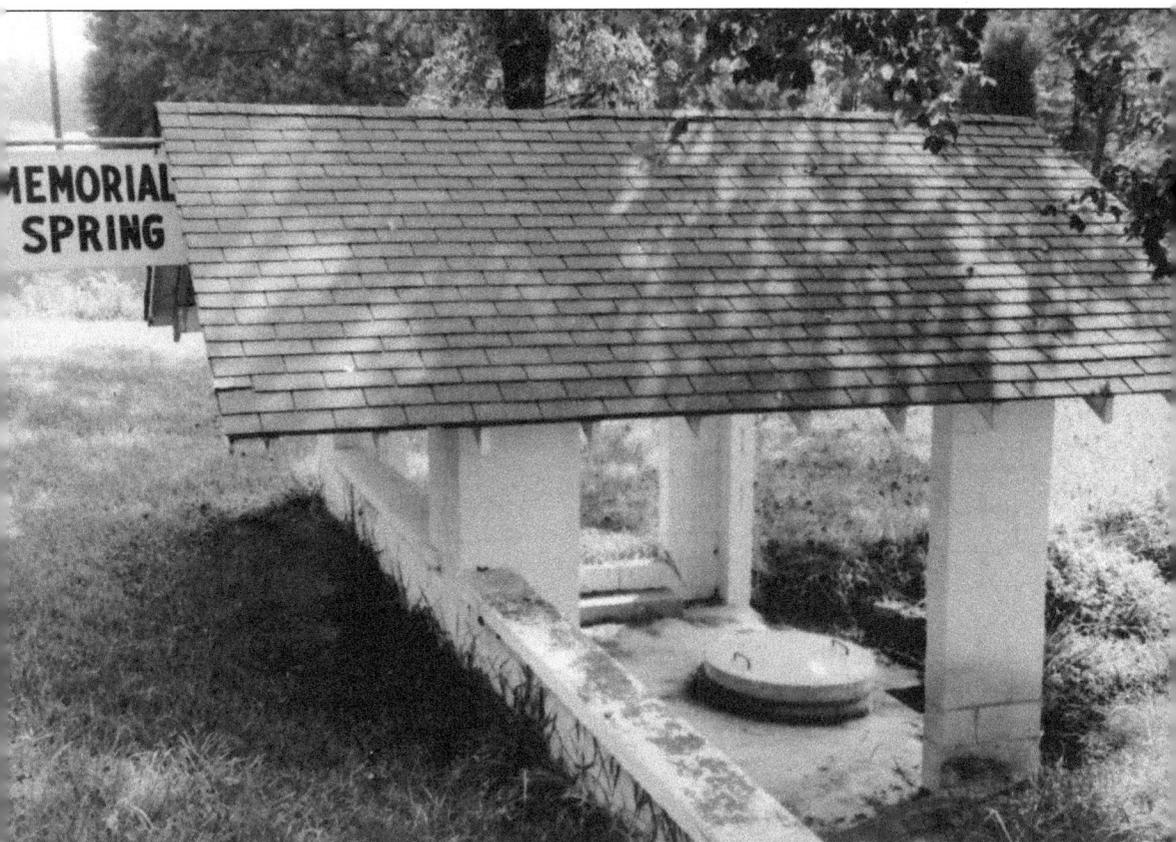

SPRING WELL HOUSE, 1973. Passersby often stopped by this spring, which still runs, and dipped a refreshing cup of water. In times of drought, people from the community used the spring for water. Once, two young boys from Spring stole watermelons from a local store and hid them there. Some called the water in this well "graveyard soup" since drainage from the graveyard across the road supposedly flowed into the well. Because of this, people began using the other, previously mentioned spring. The funds to build this well house were donated by Edgar H. McBane in memory of Alfred N. and Ada B. McBane in 1952. The memorial cover cost $767.40. Edgar McBane, a star athlete at Guilford College, later owned an oil and coal business in Greensboro. A bronze plaque inside the cover reads as follows: "Erected in 1952 in memory of Alfred N. and Ada B. McBane lifelong residents in this community and members of Spring Monthly Meeting of the Religious Society of Friends, which was founded here in 1793 and derived its name from this spring 'Ho, every one that thirsth, [sic] come ye to the waters' Isaiah, 55:1." (Spring Friends Collection.)

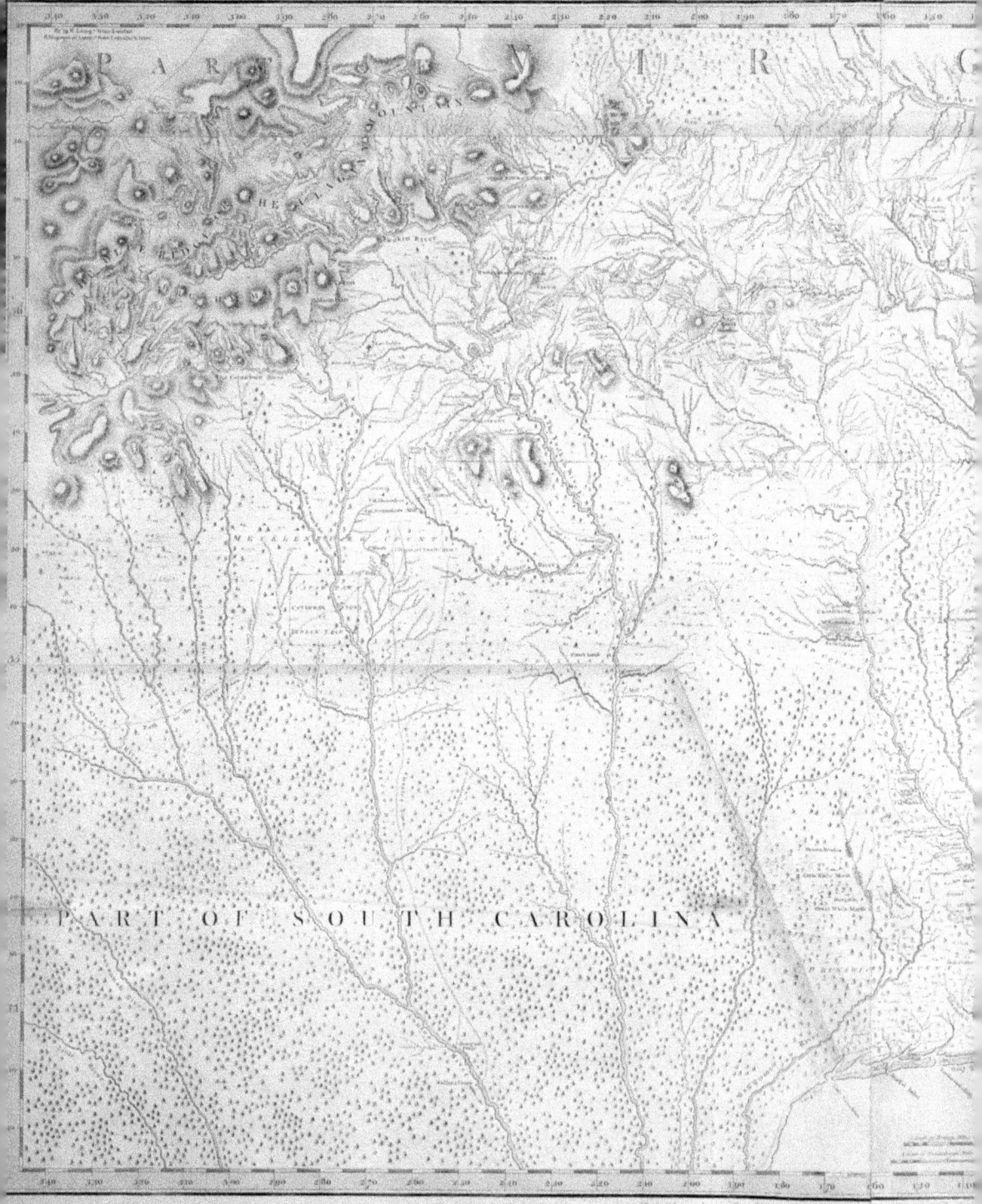

PART OF SOUTH CAROLINA

14

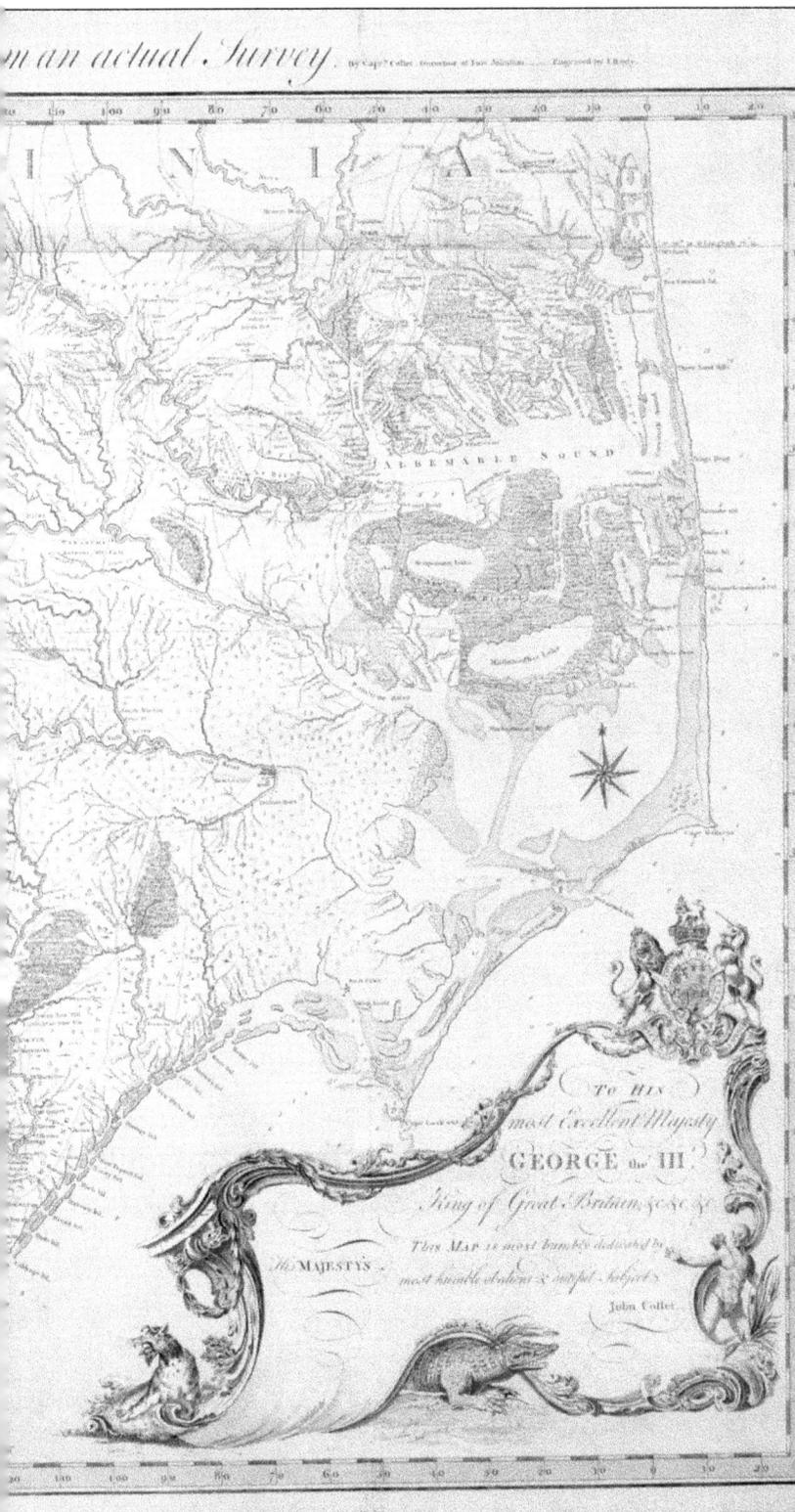

To His
*most Excellent Majesty*

GEORGE the III.

*King of Great Britain, &c &c &c*

*This Map is most humbly dedicated by*

*His* MAJESTYS

*most humble obedient & dutiful subject's*

John Collet

**CAPTAIN COLLET'S MAP, 1770.** In 1764, North Carolina passed a comprehensive roads bill to enable commerce. Public roads, ferries, and bridges were constructed, as well as signs and mileposts. Ferry operators were licensed in order to ensure safer boats. The act produced a system of crude roads. In 1770, John Collet drew this map of North Carolina to show the major north-south routes to surrounding Virginia and South Carolina. At the lower-central portion of the map are the locations of Cane Creek Meeting ("Q. Meet houfe"), and south and east from there is Lindley's Mill on the Lower Cain [sic] Creek. Spring Meeting was just east of Lindley's Mill. (North Carolina State Archives.)

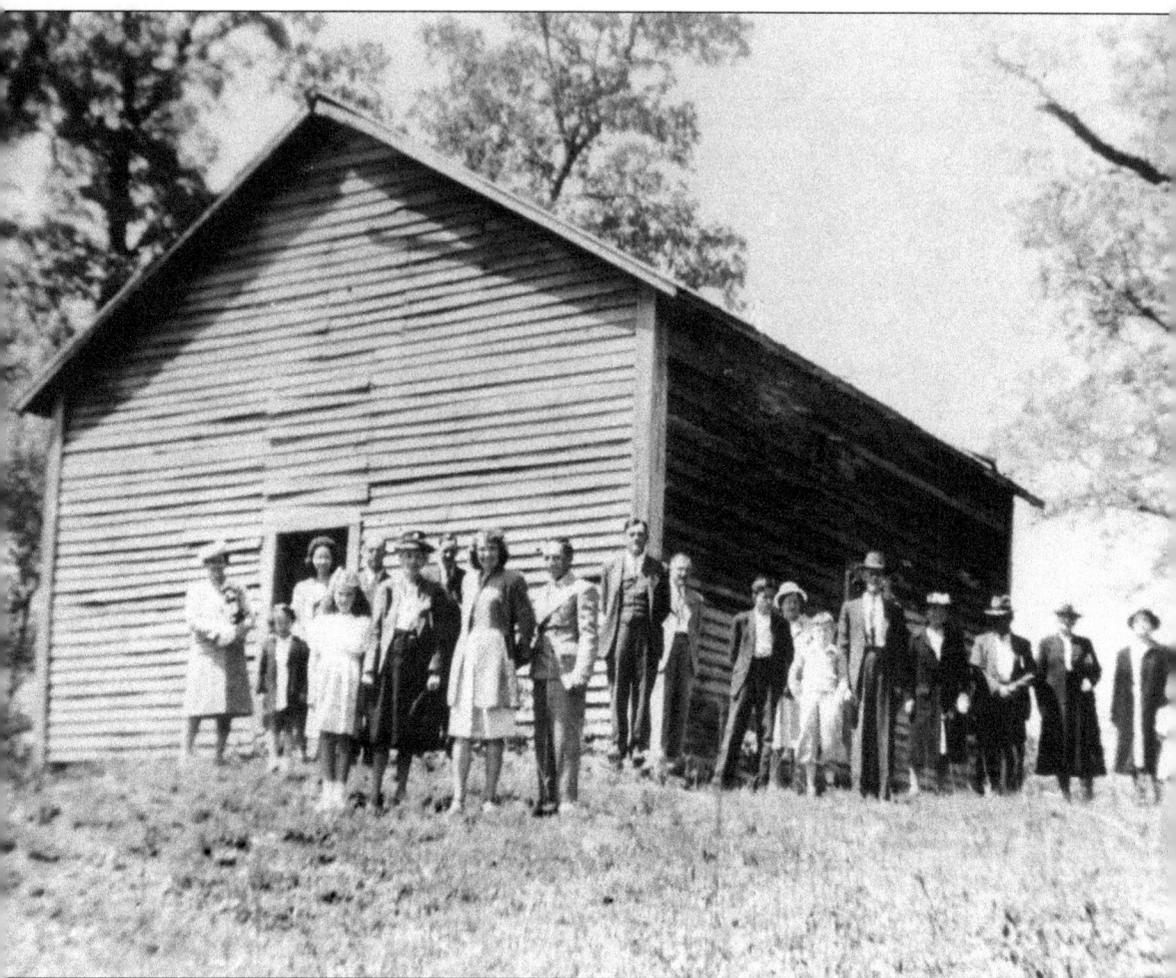

**SANDY CREEK PRIMITIVE BAPTIST CHURCH, C. 1947.** Shubal Stearns (January 28, 1706–November 20, 1771) moved from Massachusetts to Virginia and then North Carolina and, in 1755, started Sandy Creek Separate Baptist Church, near present-day Liberty. In two years, the membership reached 600 to 900 people. Stearns and other preachers spread revival fires to the coast of North Carolina. Stearns's ties to the Regulators Movement and his stubborn personality led to a sharp decline in membership of Sandy Creek. This building was constructed in 1804 and is the third structure in the church's history. Sandy Creek Primitive Baptists still meet there on the third Sunday of each month at 2:00 p.m. for worship. Those pictured include, from left to right, (first row) Bernice Nance, Annie Nance, Myrtle Nance, and Gurney Nance; (second row) Annie Booth Slaves (first on the left) and James Nance (seventh from the left). (Hal Younts.)

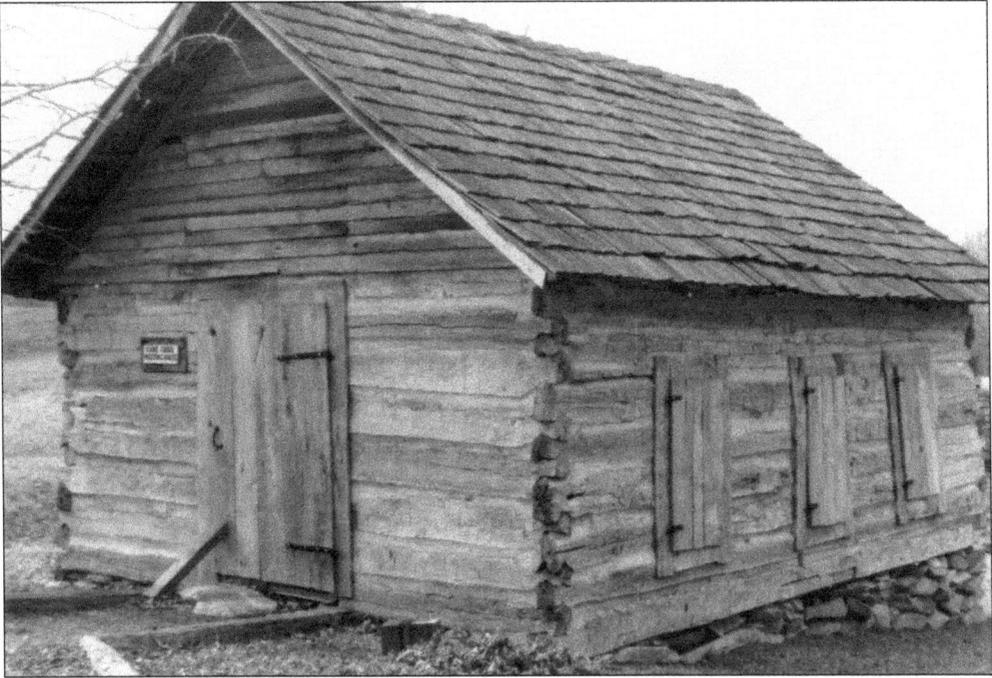

LOG MEETINGHOUSE BUILDING, C. 1975. Cane Creek, established in 1751, was the first Quaker meeting in the Piedmont. Many other meetings were "born" by Cane Creek, including Spring Friends Meeting, officially organized in 1773 and given full status as an independent meeting in 1793. According to tradition, this log structure may be from Cane Creek Meeting. The first Spring structure may have been similar. (Snow Camp Outdoor Theatre.)

CANE CREEK MEETINGHOUSE, 1940. This white clapboard structure was built in 1880 after a fire destroyed the previous building in 1879. As members gathered for a First Day meeting, fire erupted and engulfed the structure. Only a piano and a few chairs survived. A faulty heating system may have been the cause. Members watched the meetinghouse burn and then offered prayers as the building smoldered. (Dan Perry.)

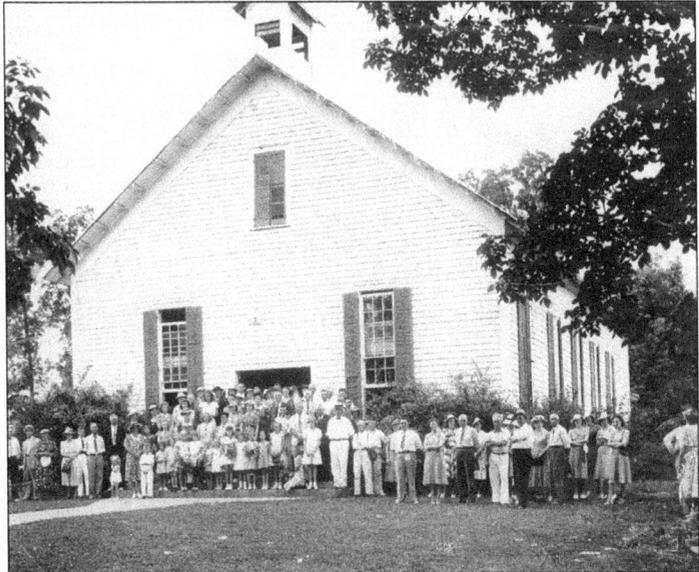

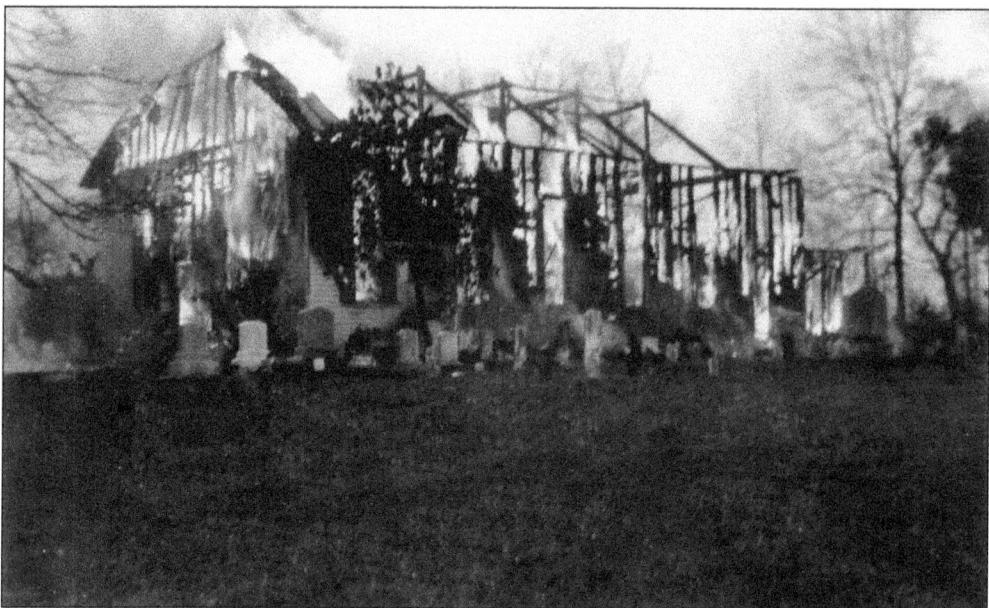

**BURNING CANE CREEK MEETINGHOUSE.** This is a picture of the building (1880–1942) burning on January 4, 1942. Spring, struggling with financing its own renovations, donated $24.75 to rebuild the meetinghouse, which cost an estimated $30,000–35,000. (Cane Creek Friends Meeting.)

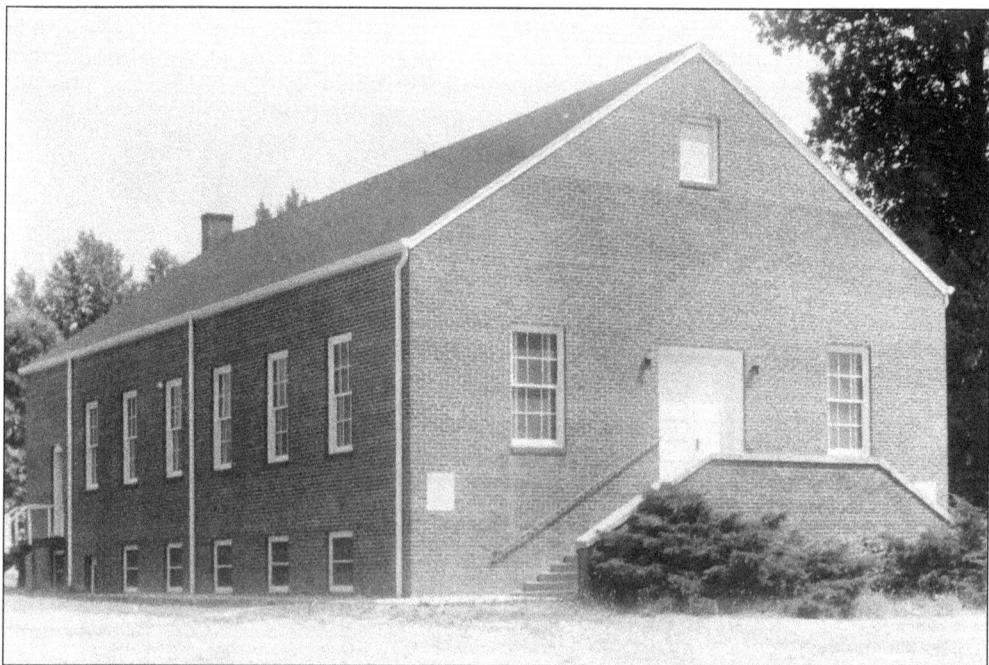

**PRESENT-DAY CANE CREEK MEETINGHOUSE.** Cane Creek Meeting quickly rebuilt its meetinghouse and dedicated it on Homecoming Day, October 6, 1942. "Homecoming" is an annual gathering of members, past and present, to celebrate the meeting's history. A former pastor is often invited to speak, and dinner on the grounds follows the meeting. This brick structure is still in use today. Pastor Elbert Newlin, who also served Spring, provided spiritual guidance for the project. (Cane Creek Friends Meeting.)

The Extract of a minute from the Quarterly
meeting being produced is as follows —

At a Quarterly meeting held at Cane Creek
the 12 of the 11 month 1790. The Committee
appointed last meeting to visit friends of
pecky river on account of having their meet
-ing for worship established report in writing as
follows — to our Quarterly meeting to be held
at Cane Creek the 12 of the 11 month 1792 —

We of the Committee appointed last meeting
to visit friends of pecky river on account of
their request of having their meeting for
worship established have complied therewith
and after a time of solid opportunity and
Conference with them agree to report, as our
opinion that it may be best to grant their
request —

     Jeremiah Reynolds
     Robert Hodson
     Isaac Beeson
     John Winslow
     John Beard
     Phineas Nixon

With which this meeting unites & establishes
the same on first & fourth days Except that
fourth day of the week of Cane Creek monthly
meeting ——

    Extracted from the minutes by
      Jacob Marshill clerk

At a monthly meeting held 20/2 mo 1793
the friends appointed to visit Spring meeting
preparative respecting their request, report they
have complied therewith and that they unite
with them therein it is therefore thought proper
to be forwarded to the Quarter for further
inspection

**SPRING MEETING RECOGNIZED.** In these minutes, Cane Creek officially recognizes the independent status of Spring Friends Meeting. (Friends Historical Collection, Guilford College, Greensboro, North Carolina.)

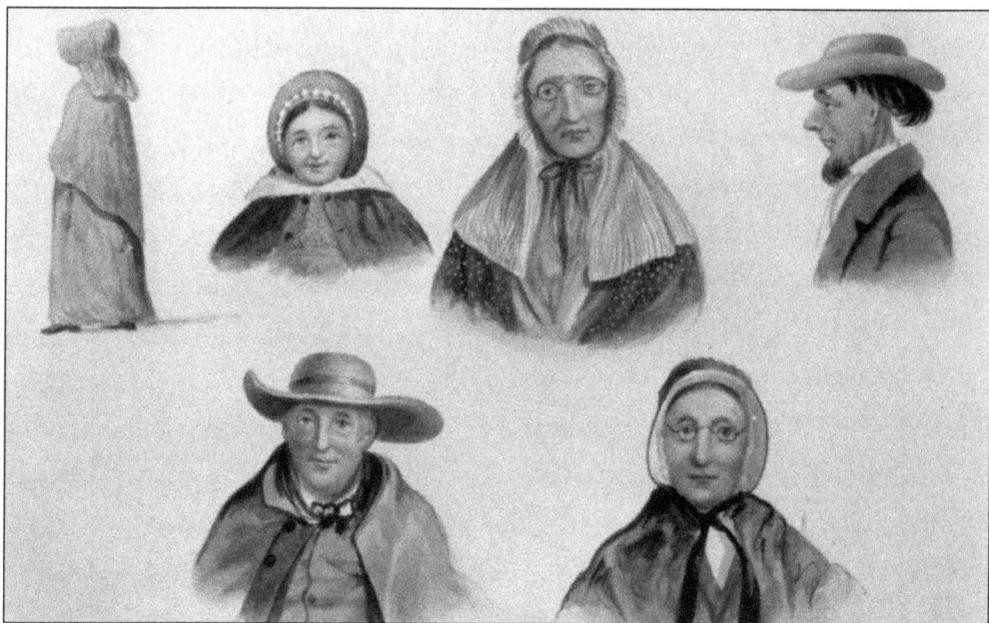

**Period Clothes.** Quakers were known for their simple dress. The manner of dress brought equality of classes by leaving off frills, like buttons and ruffles, which were symbols of the upper class. Soon, Quaker clothing developed a sacredness of its own. Typically, women wore bonnets, and men wore flat-brimmed hats. Women and men removed their hats when they stood to speak in the meetings. (Friends Historical Collection, Guilford College, Greensboro, North Carolina.)

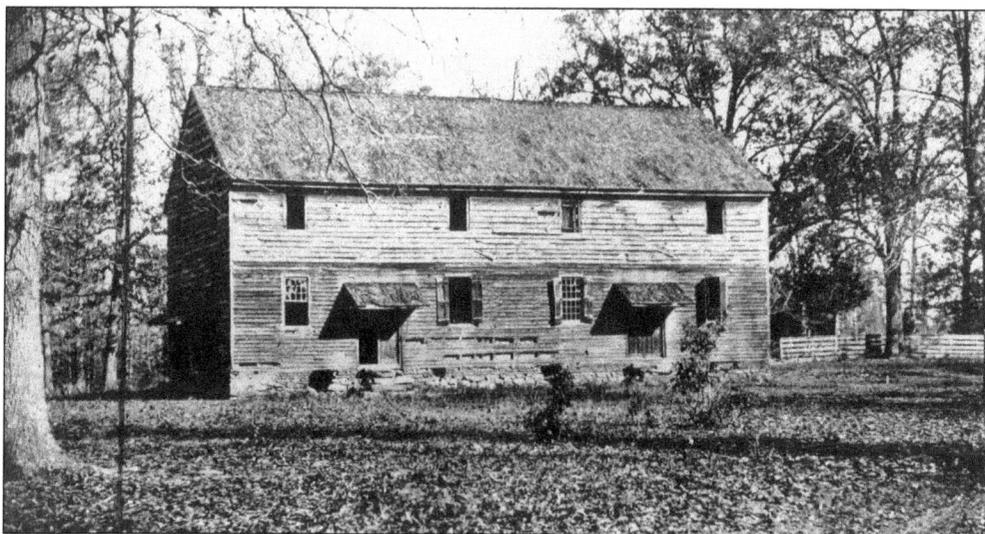

**New Garden.** Piedmont Quakers lived throughout the Piedmont region. Cane Creek Monthly Meeting was the closest meeting to attend for New Garden Quakers. Tired of the 30-mile trek on horseback and in buggies to attend monthly meeting, in October 1751, one group who lived in present-day Greensboro requested the privilege to hold its own meeting. By 1754, attendance met the requirements for an independent meeting. Pictured here is the 1791 meetinghouse. The upper windows may have been more for effect than function. The requirement for separate meeting rooms where men and women typically conducted business meetings precluded balconies. (Friends Historical Collection, Guilford College, Greensboro, North Carolina.)

20

**SPRING FRIENDS WOMEN'S MINUTES.** Early Quaker meetings kept two records of meeting minutes, women's and men's. The Spring men's minutes for the early history of Spring Meeting are lost. The women's minutes from 1793 are the first records of Spring Meeting. Separate men's and women's meetings continued at Spring until about 1887. Here, Spring Meeting requests to be recognized by the quarterly meeting. (Friends Historical Collection, Guilford College, Greensboro, North Carolina.)

**DEEP RIVER MEETING.** Deep River Friends Meeting was established in 1753 from Cane Creek Monthly Meeting. It is near what is now High Point. The Friends there gathered for worship in the home of Thomas Mills on every other Fifth Day. Pictured here is the 1758 meetinghouse. (Friends Historical Collection, Guilford College, Greensboro, North Carolina.)

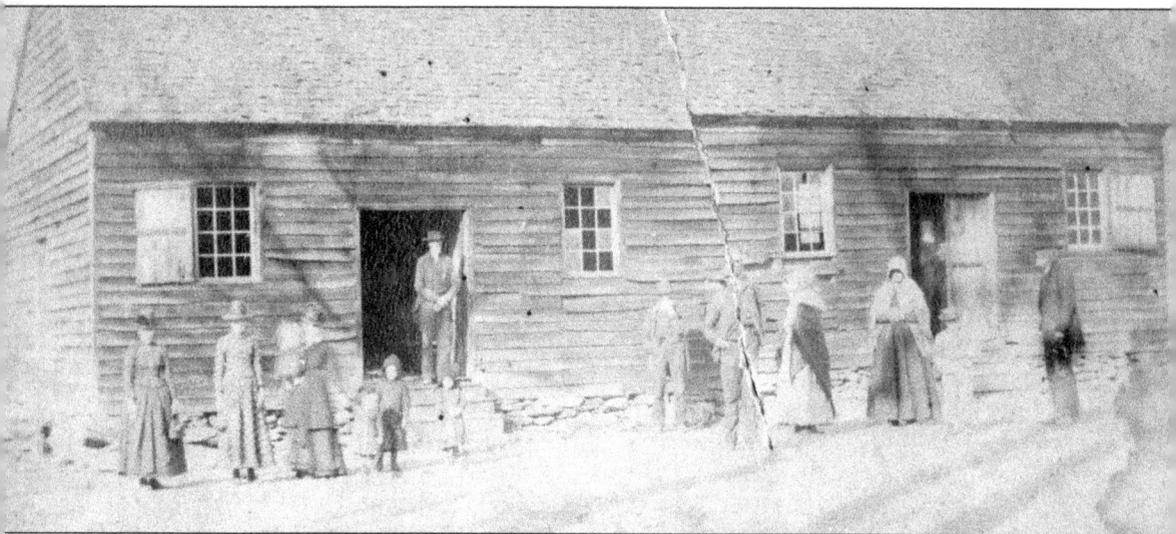

**HOLLY SPRING MEETING.** Holly Spring Friends Preparative Meeting began in 1790 and was granted monthly meeting status by Cane Creek Monthly Meeting in 1818. The most striking feature of this picture is the two entranceways. Quaker men and women met in separate rooms until the late 1800s. A man emerges from the one on the left, and a woman stands in the door on the right. (Friends Historical Collection, Guilford College, Greensboro, North Carolina.)

**SPRING MINUTES FROM 1828.** In these minutes, two of the meetings sponsored by Spring, Chatham, and Eno are mentioned. Chatham, which lies just below Spring, probably began in 1824 and continues today. Eno Meeting has had a difficult history. The meeting may have started with the help of Cane Creek Meeting. Divisions and member conflicts led to it being laid down in 1768. A migration of Friends from Pennsylvania may have revived the meeting, with Spring taking it over. In 1847, the meeting was laid down again. (Friends Historical Collection, Guilford College, Greensboro, North Carolina.)

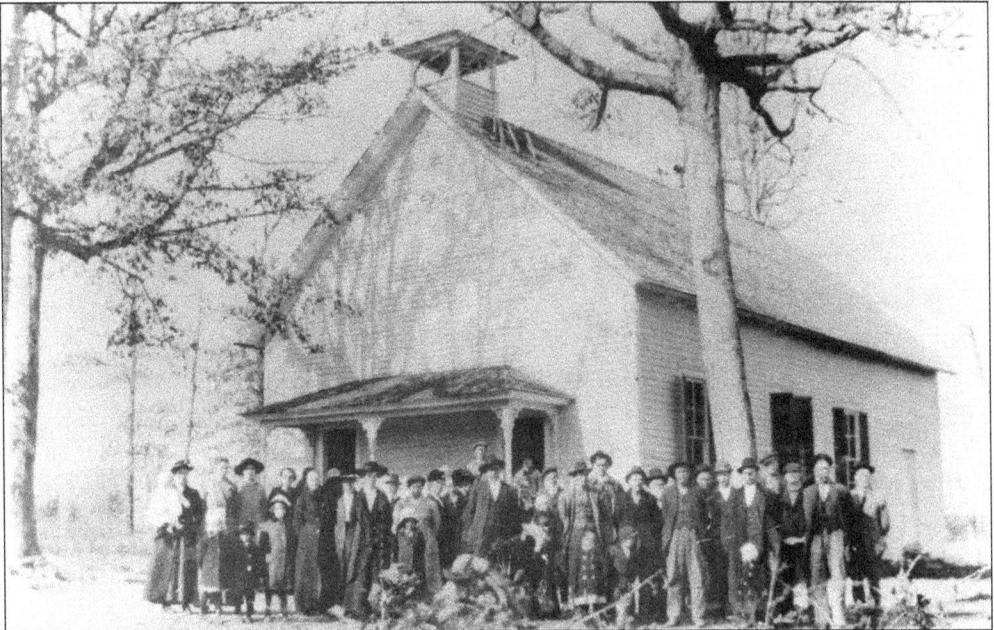

**CHATHAM MEETINGHOUSE.** Spring Meeting has always had close connections to Chatham Meeting, perhaps as early as 1824. The two shared ministers in the 1900s; Spring Meeting held preaching on the fourth Sunday each month. The original log meetinghouse was replaced in 1888 by a new building on a new parcel of land. (Dan Perry.)

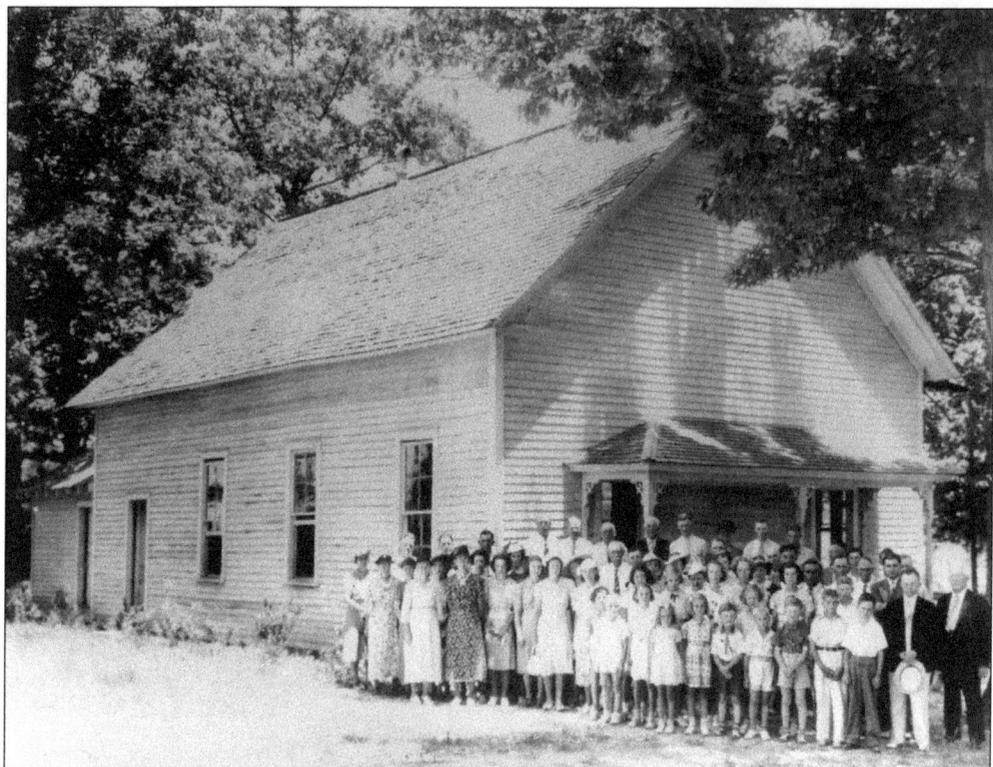

**CHATHAM MEETING.** Chatham Monthly Meeting achieved independent status from Spring Meeting in 1910. (Dan Perry.)

**INTERIOR SHOT OF NEW HOPE MEETING.** Pictured here is one of the two meeting rooms in the New Hope Meetinghouse. The bench locations reflected the significance of those who sat in them. It is not known which side was the women's or men's room. Spring Meetinghouse had divided rooms until the late 1800s, with women on the left and men on the right. (Snow Camp Outdoor Theatre.)

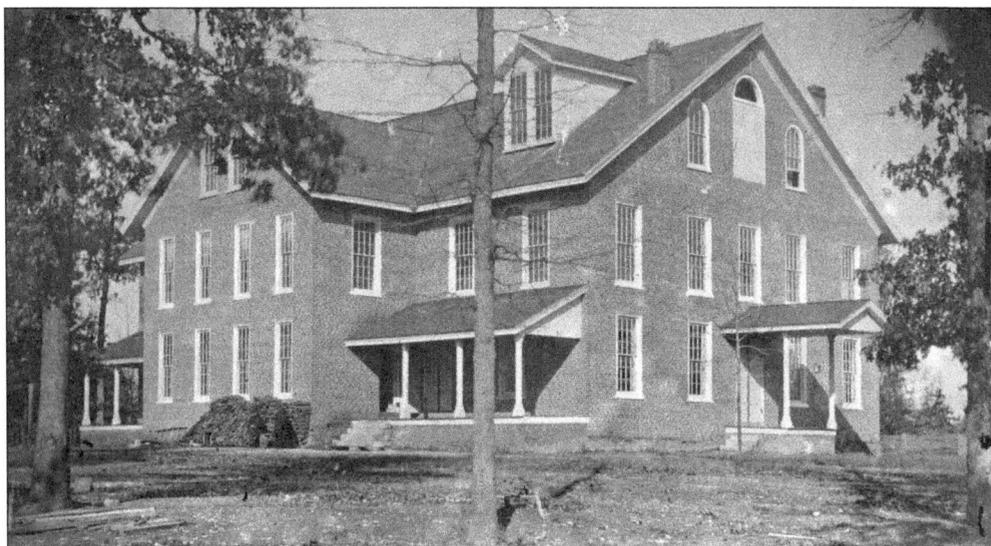

NORTH CAROLINA YEARLY MEETINGHOUSE. This brick building was the home of the North Carolina Yearly Meeting, which met here from 1872 to 1882. The structure was built on the campus of the New Garden Boarding School. It was later named King Hall when the boardinghouse became Guilford College. (Friends Historical Collection, Guilford College, Greensboro, North Carolina.)

ALLEN HOUSE. Built by John Allen on 600 acres of land around 1780 and located just a few miles west of Spring Meeting, this house was somewhat upscale for the time, but thrifty Quakers often achieved higher economic statuses than what many perceived. Most log homes of this period had dirt floors and only one room. Allen's family of 14 lived in this oak-and-ash, two-story, wattle-and-daub log cabin. The house included a cellar and back room, and originally, windows did not exist in the house because they were taxed. The family cooked, dined, lived, and slept in the lower floor, and the upper floor was only for sleeping. The enclosed chimney added more heat than an external one but was also more of a fire hazard. Records indicate that the family may have operated a store from the lower room as well. The building was occupied until 1929 by descendants of John Allen and was later moved to the Alamance Battleground site. (North Carolina Department of Cultural Resources, Alamance Battleground State Historic Site.)

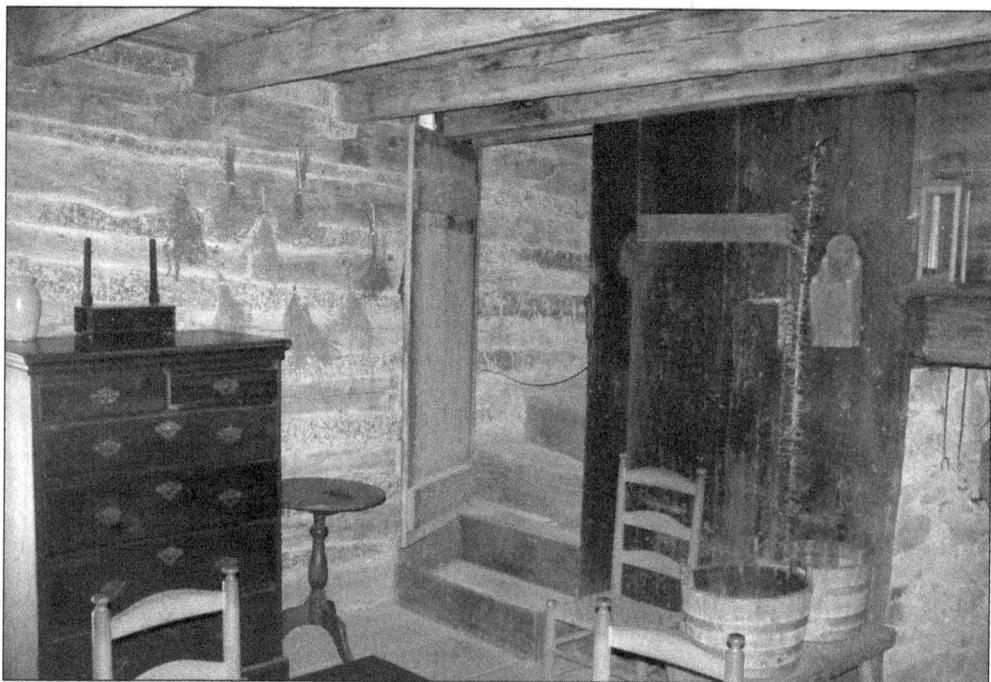

ALLEN HOUSE INTERIOR PICTURES. The Allen house has a Chippendale chest and ladder-back chairs, which were reproduced from an original chair donated by the Allen family. Various kitchen implements fill the room. The pottery is not authentic to the time period. (North Carolina Department of Cultural Resources, Alamance Battleground State Historic Site.)

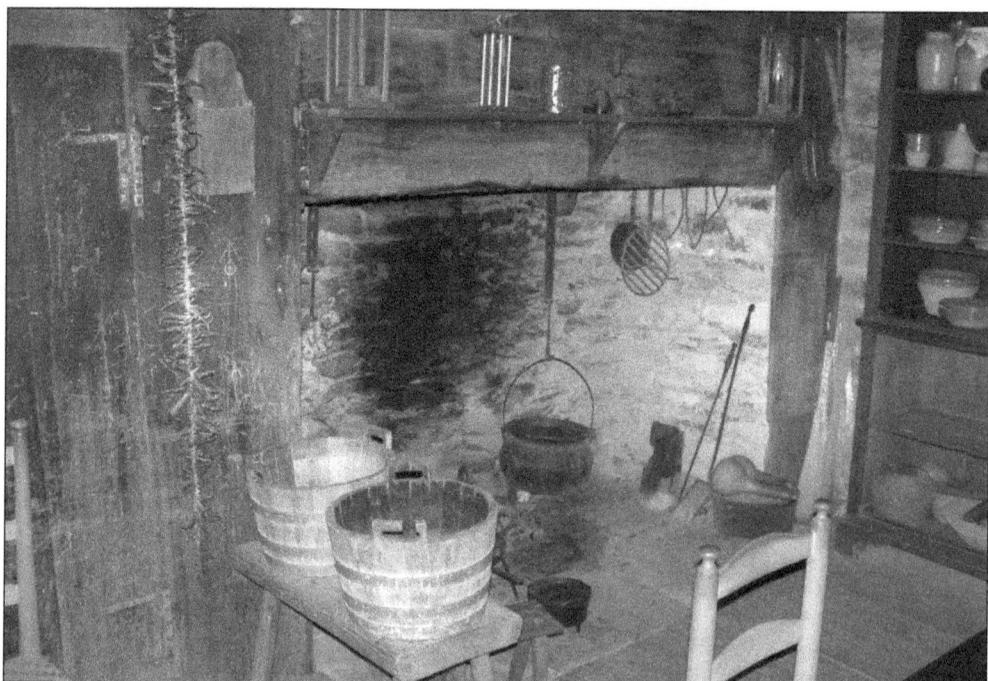

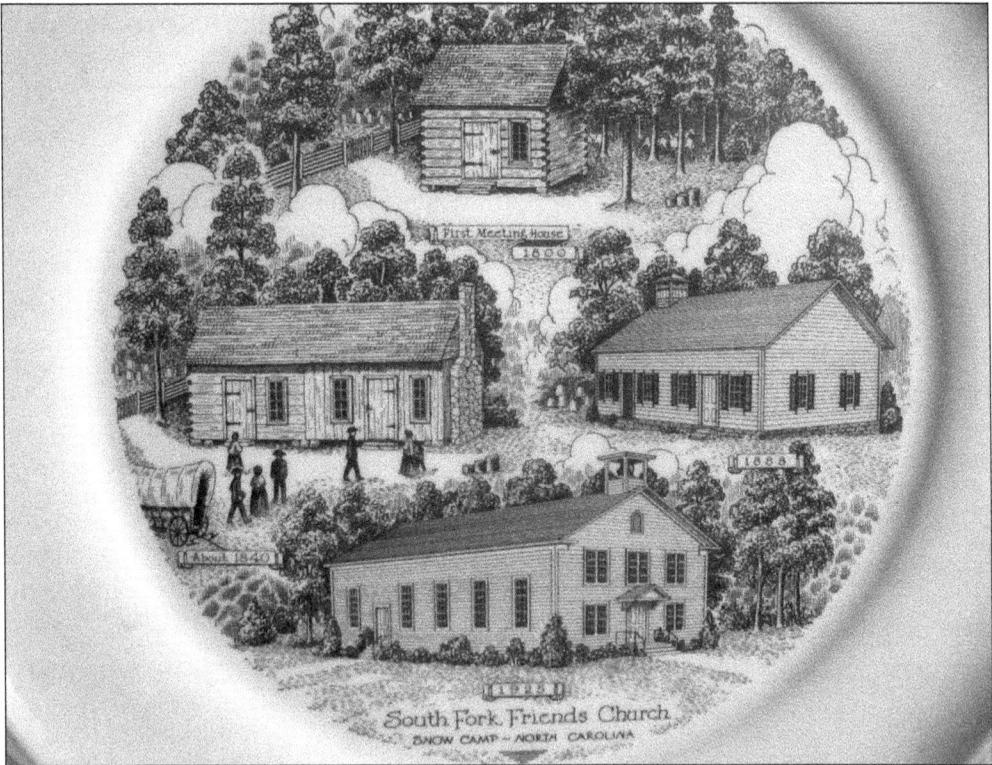

South Fork Friends Church
SNOW CAMP ~ NORTH CAROLINA

**SOUTH FORK MEETING.**
South Fork Monthly Meeting originated from Spring Meeting. The commemorative plate here shows the progression of meetinghouses of the South Fork Meeting through the years. (Photography by the author, plate courtesy of Jane Lindley.)

**EDMUND FANNING.** In the mid-1700s, corrupt officials like Edmund Fanning took advantage of local residents. Confronted by angry locals, the arrogant Fanning refused to change his policies. Growing resentment led to the "Regulators' Revolt," which lasted from the late 1760s up to March 1771. Quakers did not condone the violent actions of the movement but were sympathetic to the cause. (Alamance County Historical Museum Inc.)

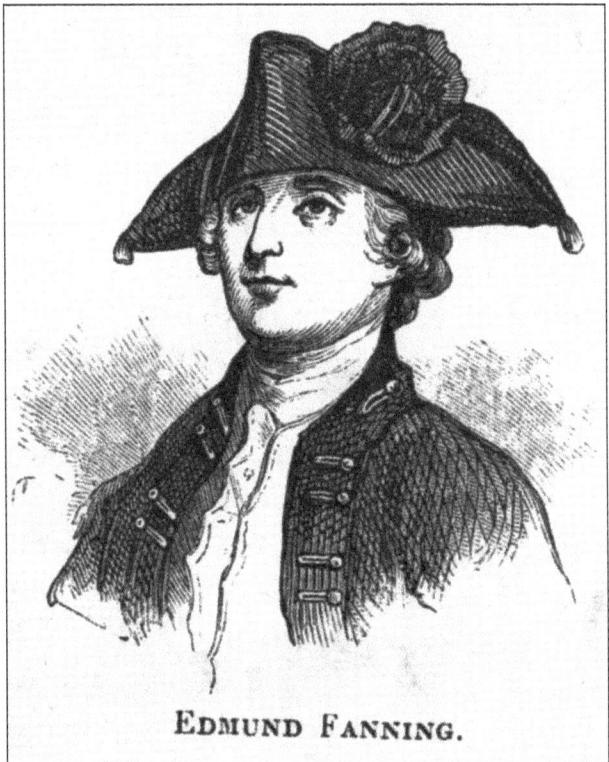

EDMUND FANNING.

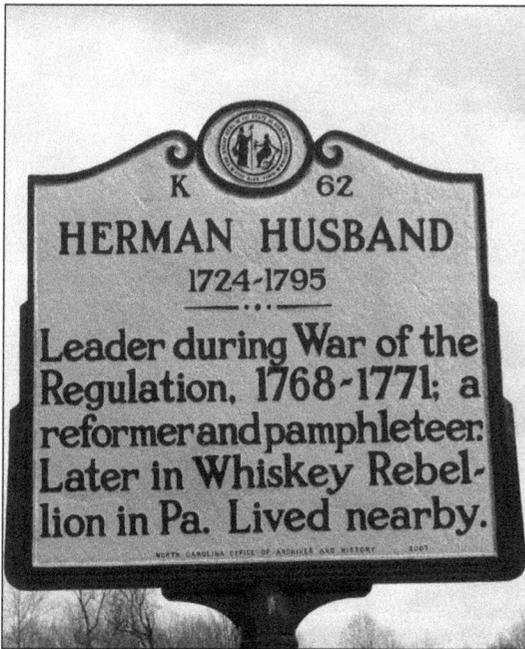

**HERMAN HUSBAND ROADSIDE MARKER.** Radical Quaker Herman Husband argued for the rights of colonists against the increasing taxation by the British. Combining Protestant freedom of conscience, the traditional Quaker resentment of England's Anglican Church, and emerging natural rights theories of his day, he was a major leader in the Regulators Movement. Piedmont farmers organized by Husband and others fought against North Carolina governor William Tryon's troops on May 16, 1771, in the Battle of Alamance. In the days after the battle, Governor Tryon's army devastated the countryside, forcing members of Spring Friends Meeting and other locals to feed the troops. Because of his involvement with the government and his growing radicalism, Cane Creek Meeting disowned Husband along with 46 other Regulators. (Author.)

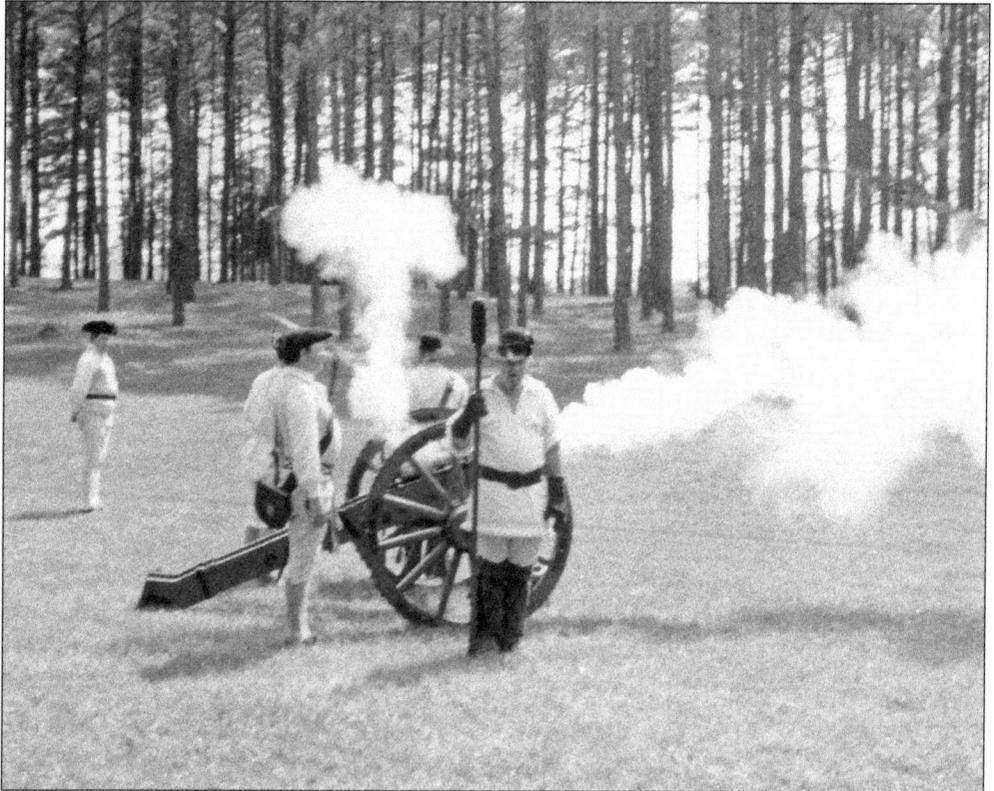

**MUSTER.** Every year, the Alamance Battleground site reenacts the Battle of Alamance. The reenactors are unidentified. (North Carolina Department of Cultural Resources, Alamance Battleground State Historic Site.)

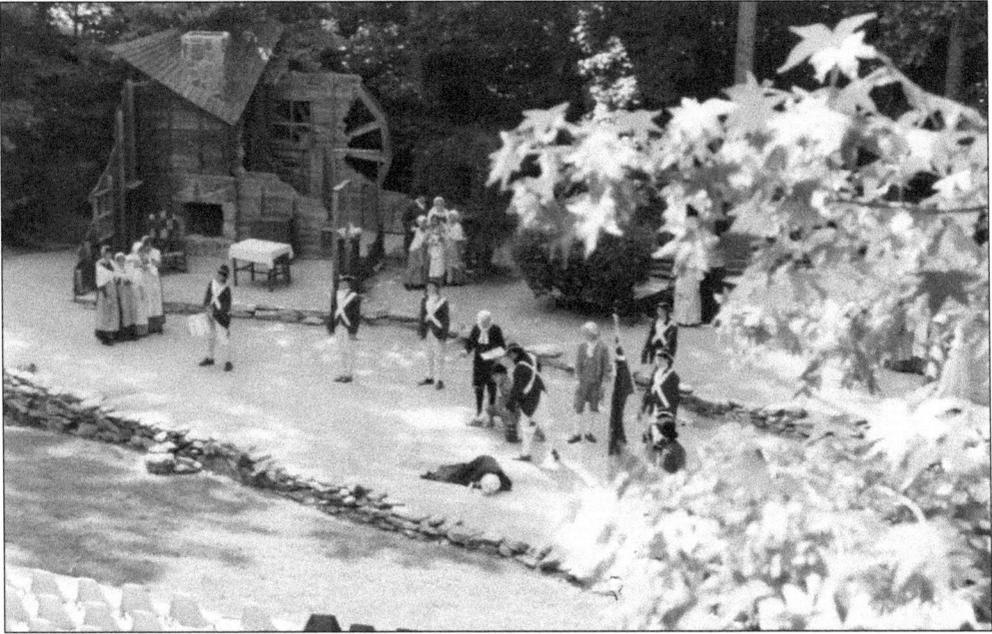

THE SWORD OF PEACE. Two centuries later, the battle is reenacted in the Snow Camp Outdoor Theatre's production of *The Sword of Peace*. The drama retells the history of Quaker pacifism during the American Revolutionary battles in Piedmont North Carolina. In this late-1970s photograph of a dress rehearsal, noted local Presbyterian minister Rev. David Caldwell tries to intercede to prevent the battle. The actors are unidentified. (Snow Camp Outdoor Theatre.)

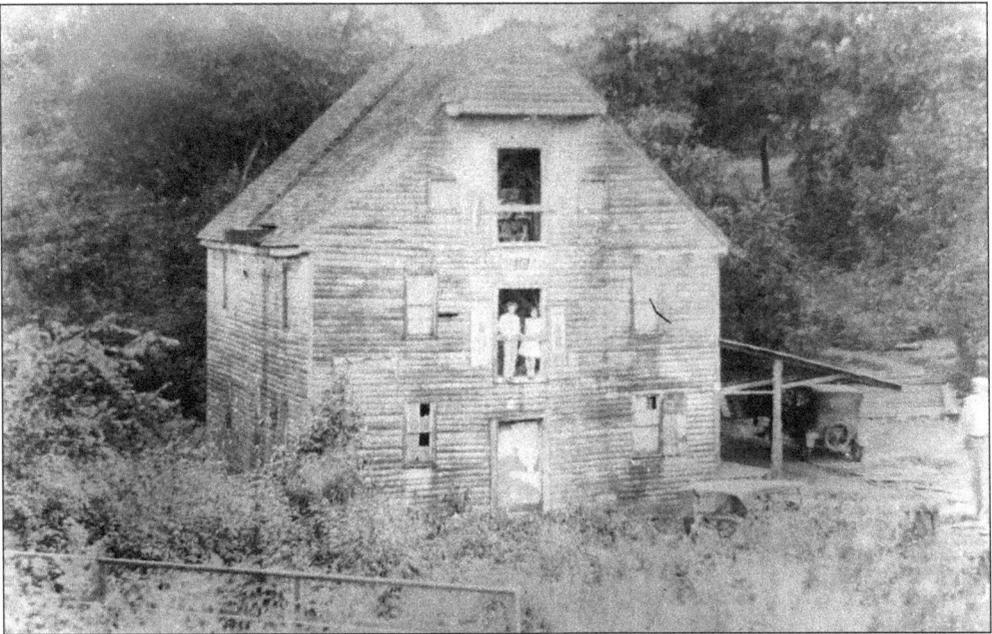

LINDLEY'S MILL. Thomas Lindley and Hugh Laughlin built this mill in the 1750s on Cane Creek. This picture was taken around 1920 by Ralph Johnson and then reproduced by C.M. Newlin of Snow Camp. The mill has been restored, and its large stone, water-powered wheels grind meal and flour for customers today. (Dan Perry.)

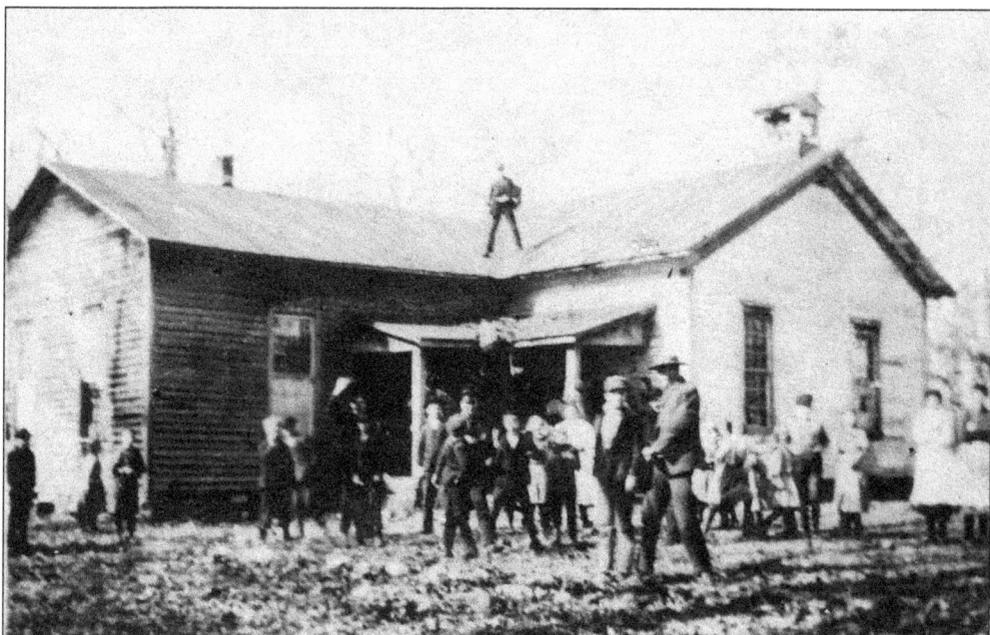

**SYLVAN SCHOOL.** After the Civil War, the Baltimore Association Friends assisted Cane Creek Meeting in establishing Sylvan of the Grove Academy in 1866. In 1908, the name was changed to Sylvan High School. (Cane Creek Friends Meeting.)

**HAMMER SCHOOL.** This postcard is of Hammer Memorial Academy. The Hammer family gave an endowment for the old Sylvan School, and a new Georgian-style brick building was constructed, and several local high schools, including Spring School, were consolidated into the new facility. The name Hammer Memorial Academy was not popular, so the school was renamed Sylvan School. Victor Murchison, a minister at Spring from 1938 to 1943, attended and later taught at Sylvan School. Today, Sylvan School is an elementary school. (Cane Creek Friends Meeting.)

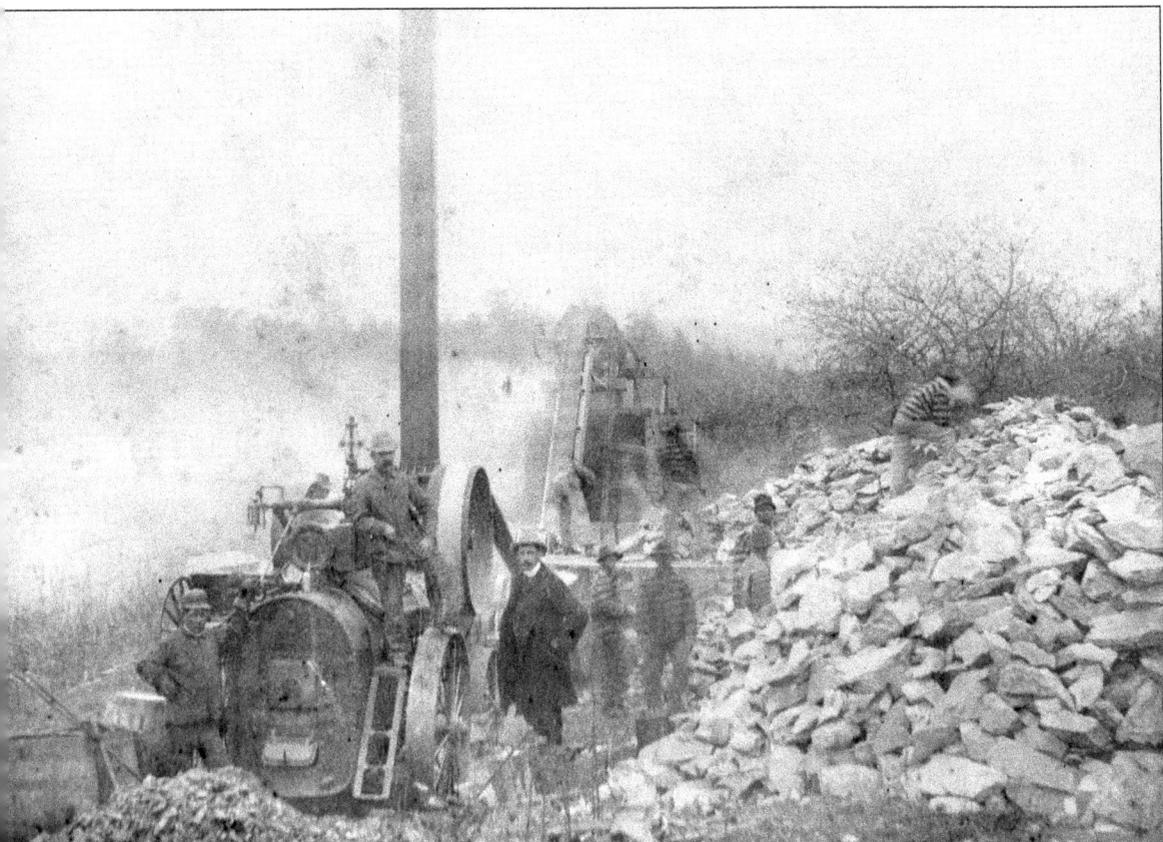

**WILLIAM SPOON.** William Luther Spoon (center, in dark suit) was a surveyor and mapmaker who knew Alamance County very well. Here, he is shown constructing a new road in the county. Wet dirt roads meant mud-covered wagons, and eventually cars, for Spring members going to meeting on Sundays. Members often slid off the road or were splotched with mud. In dry seasons, they were covered in dust. Around 1949, the roads around Spring were paved. Legend says the new road by Spring sliced off a few graves from the cemetery. (Alamance County Historical Museum Inc.)

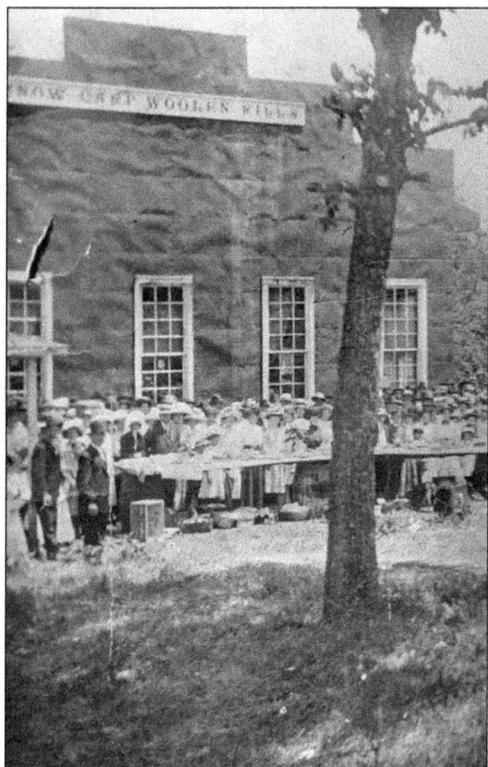

SNOW CAMP WOOLEN MILL. The Snow Camp Woolen Mill was constructed on Cane Creek in 1886 by Hugh and Thomas Dixon. Machines from a mill near Bethabara (near Winston-Salem) were used in the mill. The mill paid workers $1 a day, twice the pay earned in Burlington mills. Houses were built to accommodate workers during the week. The structure burned down in 1908 and was not rebuilt. Other mills and two foundries in the area provided ample opportunities for work in the Snow Camp area. (Alamance County Historical Museum Inc.)

SARAH KIMBALL PHOTOGRAPH. This photograph was donated by Sarah Kimball, a longtime resident of Snow Camp, to the Alamance County Historical Museum. This early 1900s picture probably reveals the deconstruction of a mill in the Snow Camp area. The names of people in the photograph are unknown. (Alamance County Historical Museum Inc.)

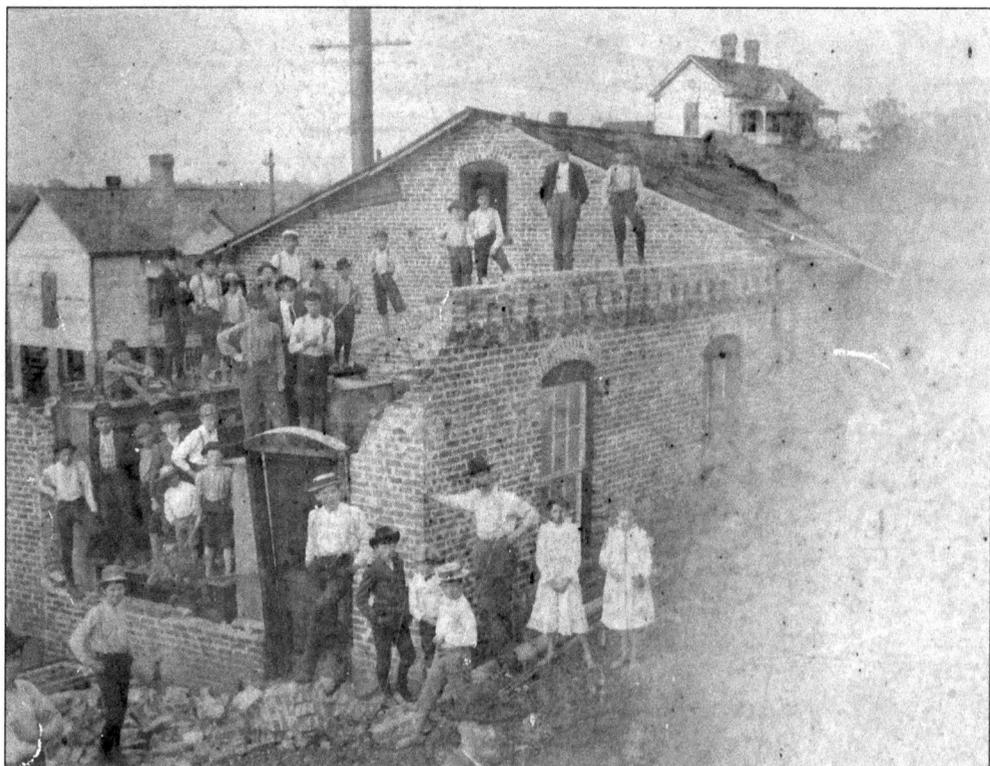

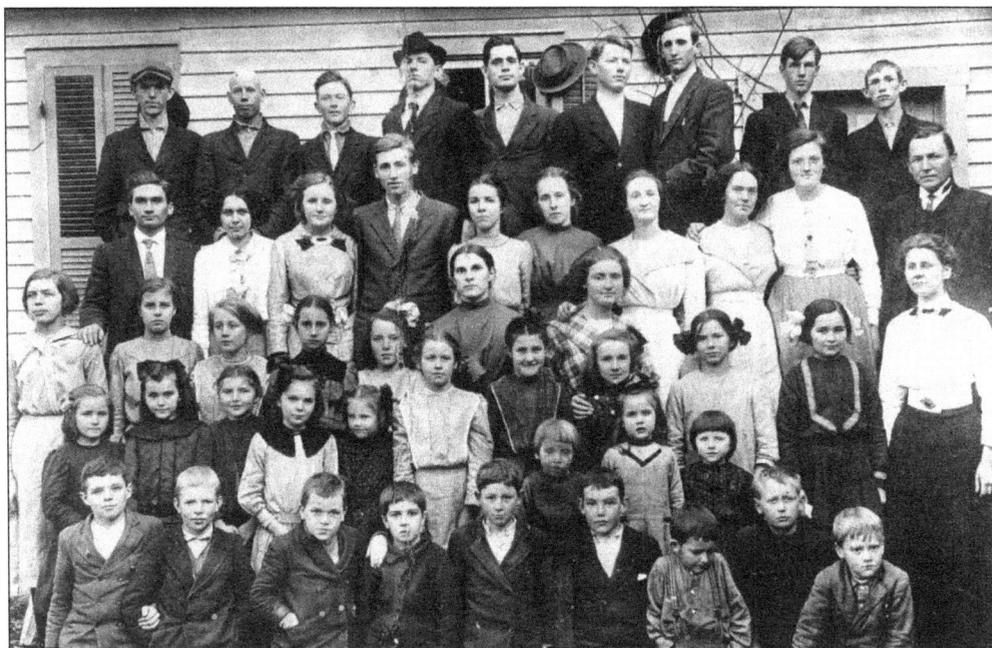

CLASS AT SPRING SCHOOL. This is a c. 1905 photograph of the Spring Schoolhouse that stood in front of Spring Friends Meeting. Over 600 new schools were financed from local taxes as part of a statewide movement in North Carolina between 1902 and 1903. The Spring School was in existence before this time. Two more rooms were added in just a few years. Spring School added high school courses in 1907. In 1903, the enrollment was 110 pupils, 34 of whom were from Spring. The names of students are unknown. (Dan Perry.)

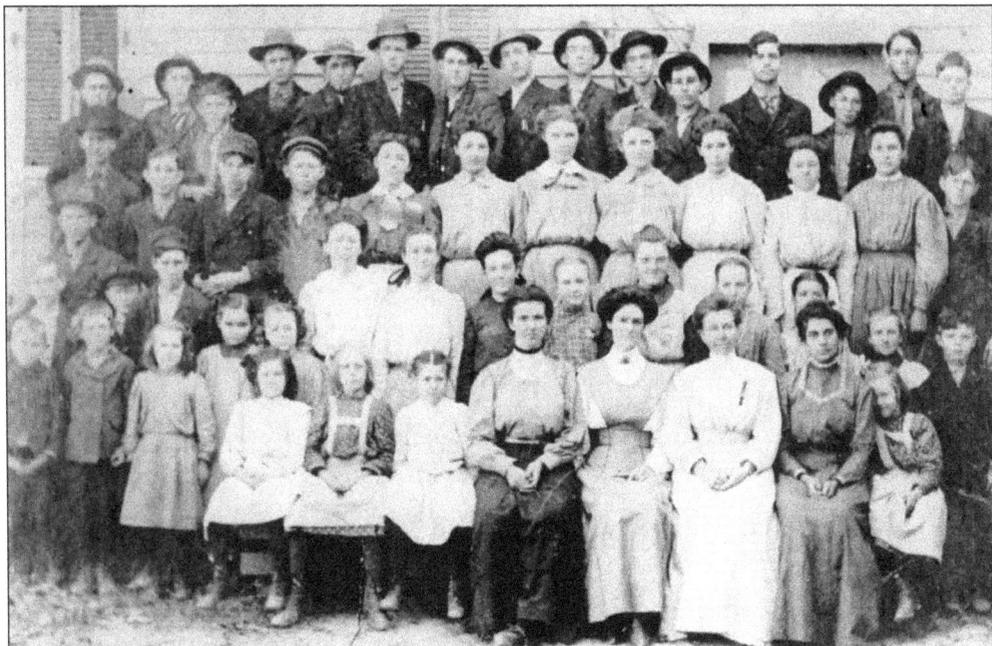

CLASS AT SPRING SCHOOL. The date of this photograph is around 1900. The names of those in the picture are unknown. (Jane Lindley.)

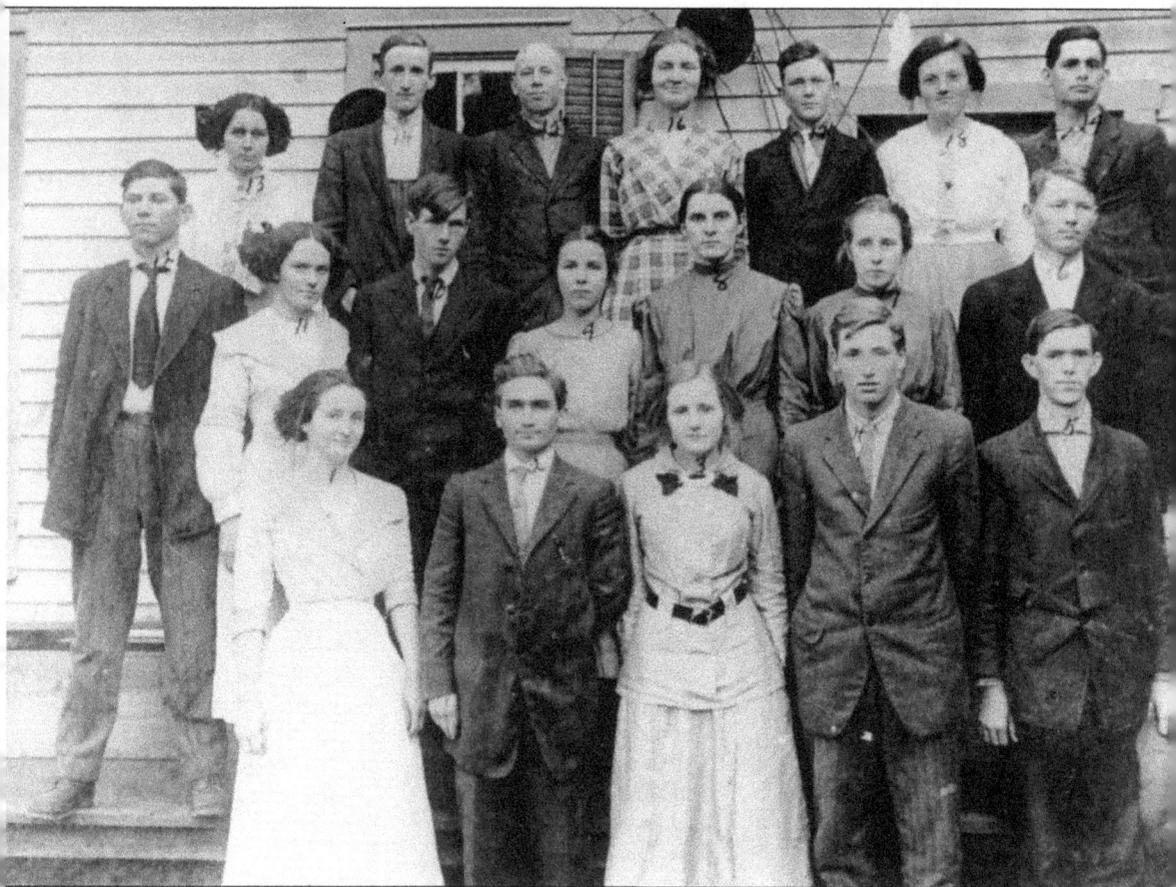

SPRING SCHOOL, 1912. Several of the people in this photograph are from Spring Meeting. Those pictured include, from left to right, (first row) Vera McBane or Mabel McBane, two unidentified, Parker Lewis, and unidentified; (second row) George Zachary (on the right end); (third row) Tom Zachary, unidentified, Ross McBane, and five unidentified. Spring members who taught there included the following: Elzena McBane Woody, Jesse Thompson, Samuel Woody, Martha Woody, Jesse Stockard, Mary Holmes, J. Waldo Woody, and principal J. Clark Wilson, who was also principal of the Spring Sunday school. (Jane Lindley.)

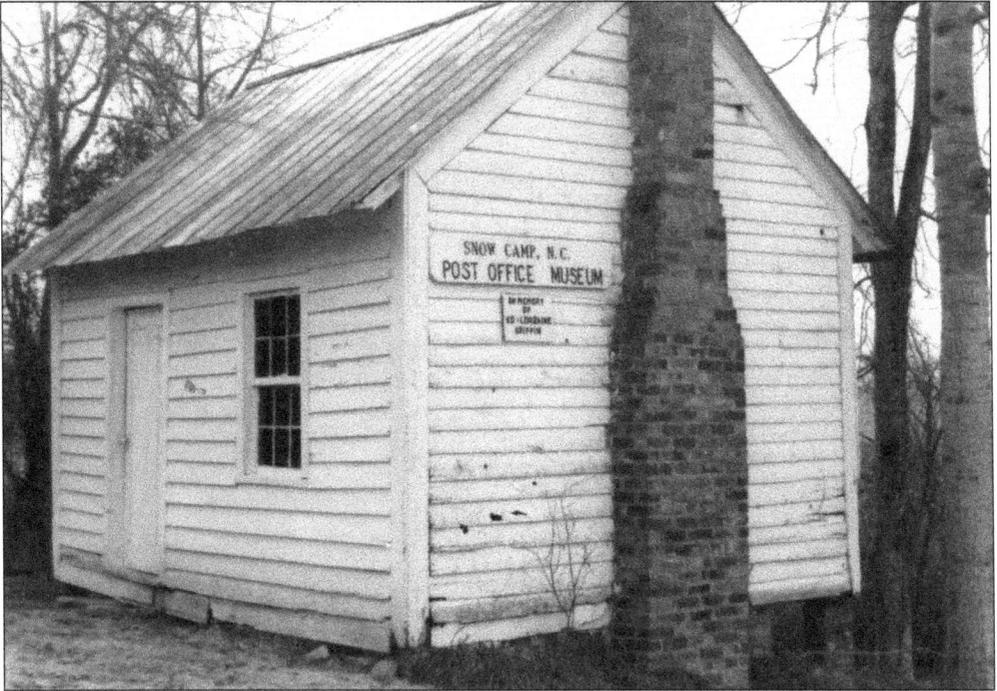

**SNOW CAMP POST OFFICE.** According to the 1893 Spoon map of Alamance County, the Snow Camp Post Office has been in the same location since at least that date. It was about a mile northeast of Cane Creek Meeting and off of a dirt road. According to the map, Spring may have been served initially by Sutphin Post Office, which was close to Lindley's Mill. (Snow Camp Outdoor Theatre.)

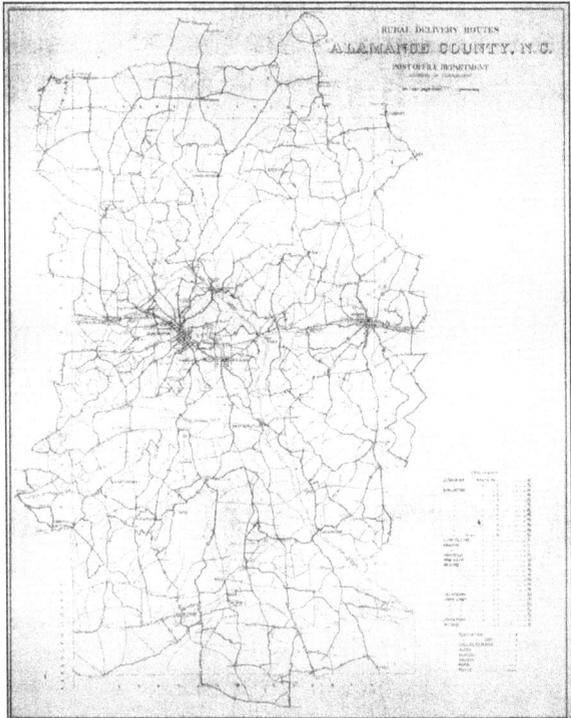

**POSTAL ROUTES IN SNOW CAMP.** In this map, the Sutphin Post Office is no longer in existence. Here, Spring Meeting is on the main postal route of the Snow Camp Post Office, which ran north and then east of the post office. Also, the Snow Camp Post Office is now shown on a main road in Snow Camp, which was indicative of the new road construction. There was still no direct route from Snow Camp to Spring. Today, the Greensboro–Chapel Hill Road runs directly east from the Snow Camp Post Office by Spring. (The North Carolina Collection, University of North Carolina at Chapel Hill.)

**SWITCHBOARD HOUSE.** The residence of Jim and Martha Newlin was also home to the local telephone switchboard for the Cane Creek Telephone Exchange. Martha Newlin was the first switchboard operator for the exchange. She died in 1921, and approximately 2,000 people attended her funeral. (Charles and Laurie Newlin.)

**FARM EQUIPMENT ADVERTISEMENT.** While some in the area of Spring went to the new mills in Burlington for work, Spring farmers stayed and continued raising wheat, barley, and corn. New equipment, such as that depicted in this advertisement, led to higher yields. (Alamance County Historical Museum Inc.)

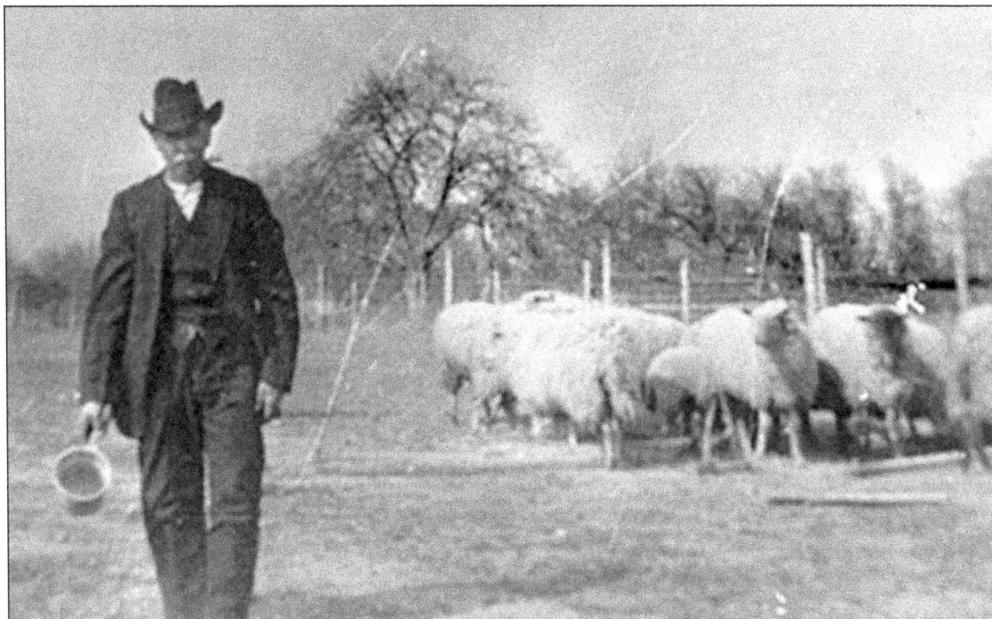

SHEEP. Not all farmers focused on grains. Here, Jim Newlin, who lived from 1884 to 1961, is shown with his sheep in a 1920s photograph. (Charles and Laurie Newlin.)

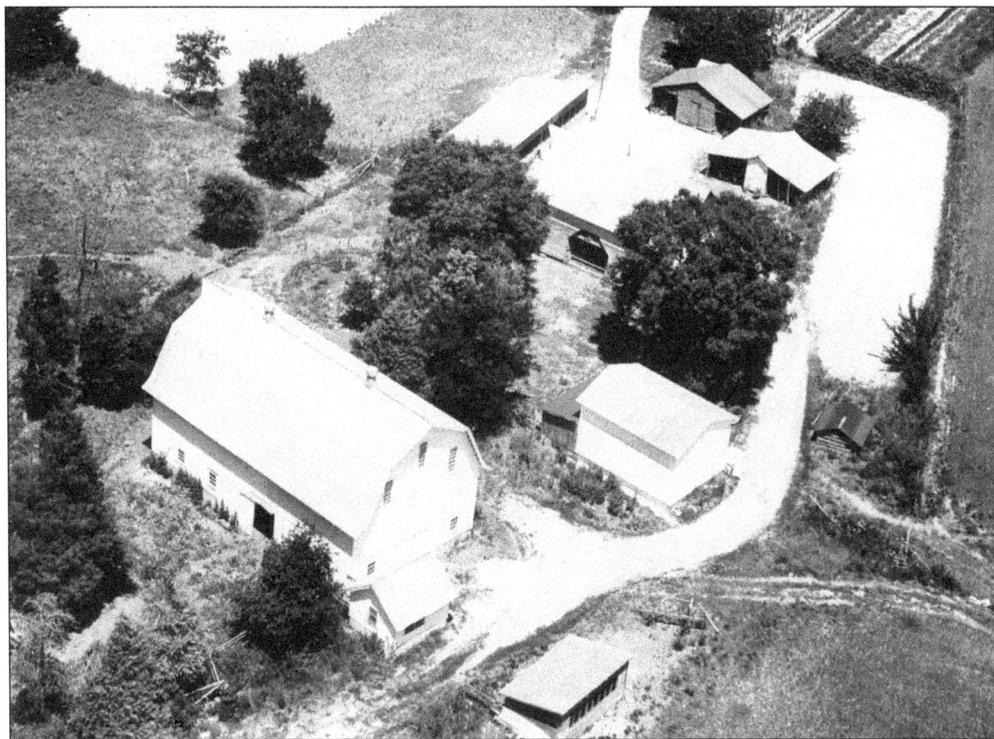

GLENN PERRY FARM. This 1955 aerial picture was taken for a local magazine (title unknown). In the early 1900s, grains were still the staple crop. By the 1940s, Spring farmers had shifted to milk production. Other Spring members tended small gardens and raised chickens and one or more cows. The Lindleys and the McBanes still farm today. (Dan Perry.)

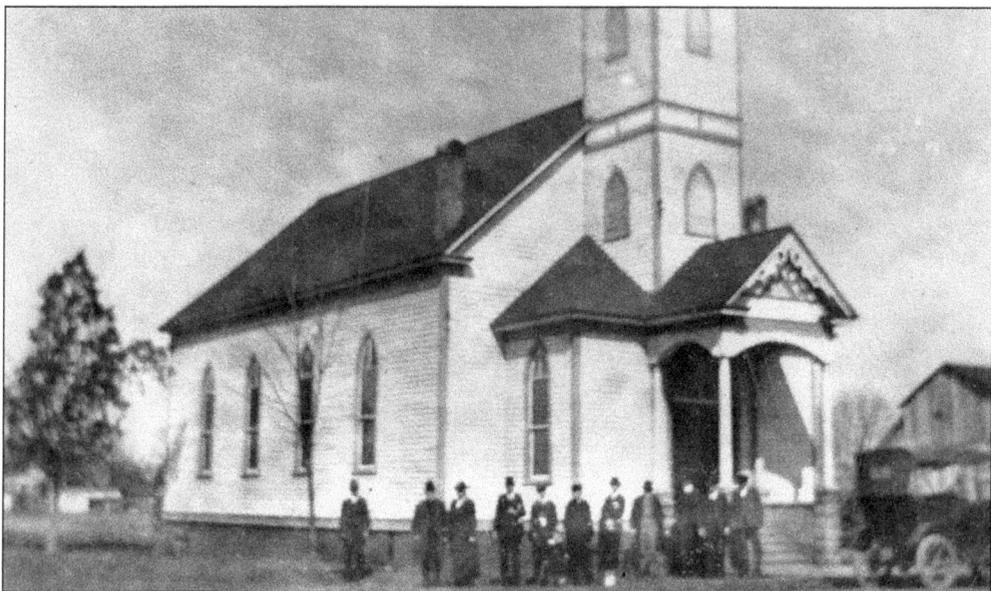

**GRAHAM FRIENDS MEETING.** Spring donated money for the budding meeting in the town of Graham, about 16 miles north of the Spring Meeting. Two pastors from Graham Meeting also served Spring: Fleming Martin in 1917 and John Permar, who took over in 1918 at a yearly salary of $69.05. Spring Meeting purchased him an automobile so he would not have to ride a horse and buggy to meetings. Permar resigned in 1922. (Friends Historical Collection, Guilford College, Greensboro, North Carolina.)

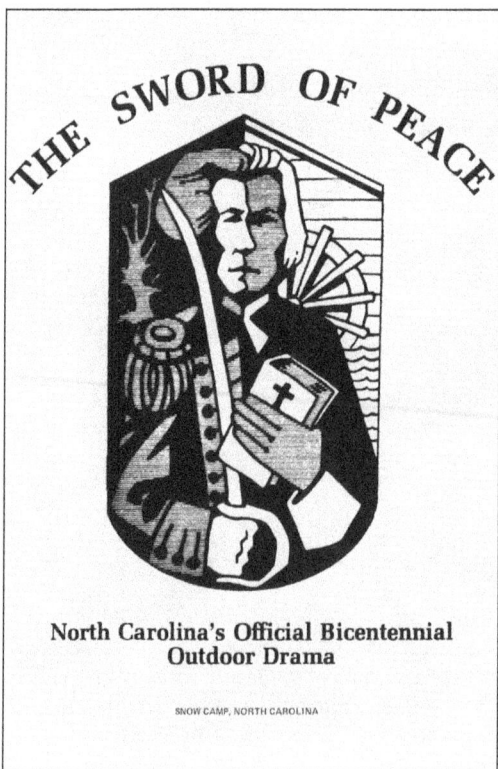

THE SWORD OF PEACE

North Carolina's Official Bicentennial Outdoor Drama

SNOW CAMP, NORTH CAROLINA

**THE SWORD OF PEACE LOGO.** Local Quaker James Wilson of Cane Creek Meeting proposed the construction of an outdoor theater to Spring Meeting at the February 1972 quarterly meeting. In 1974, the Snow Camp Outdoor Theatre opened eight miles west of Spring Meeting. Pictured here is the cover for the 1976 bicentennial year production, when the state of North Carolina and Gov. James E. Holshouser declared the theater "North Carolina's Official Bicentennial Outdoor Drama." (Snow Camp Outdoor Theatre.)

**JAMES WILSON.** On the right stands James Wilson, who has been instrumental in the creation and continuation of the Snow Camp Outdoor Theatre. Shown around 1978, he is a well-known figure in the Snow Camp area. The other man is unidentified. (Snow Camp Outdoor Theatre.)

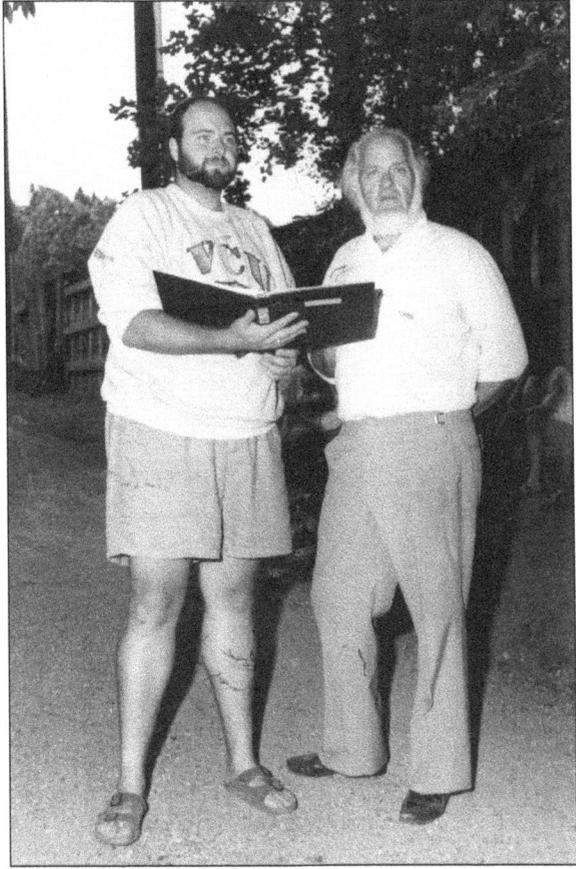

**THEATER, C. 1975.** Two productions are presented each summer; *The Sword of Peace* reenacts Quaker resistance to the American Revolution, and *Pathway to Freedom* retells the story of the Underground Railroad and the involvement of Quakers in this endeavor. The theater also offers several Broadway-style productions as well. Today, Spring serves a meal for the actors before the start of each production season. (Snow Camp Outdoor Theatre.)

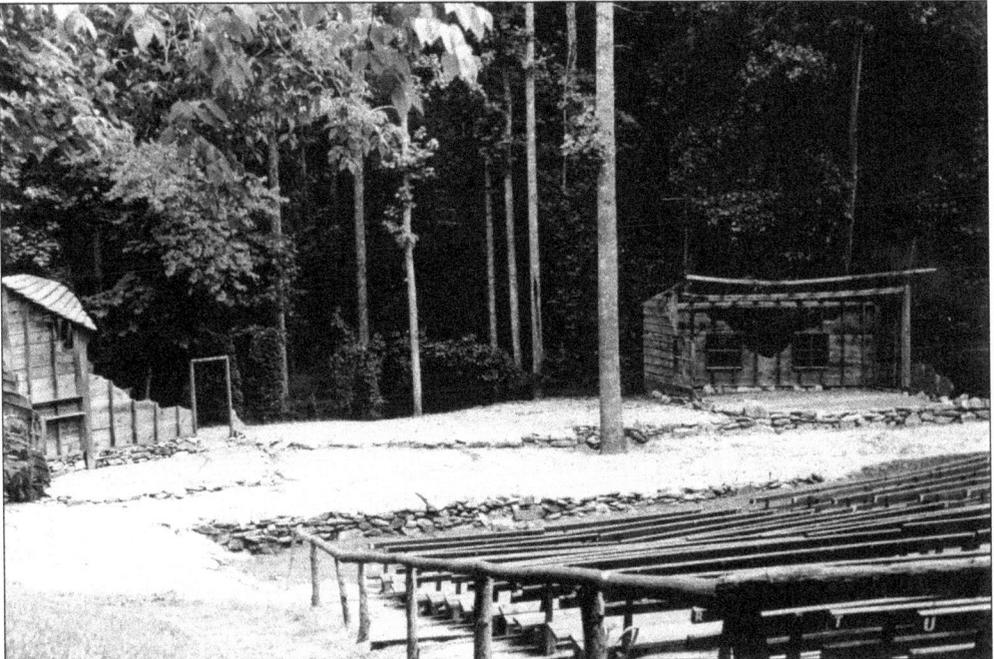

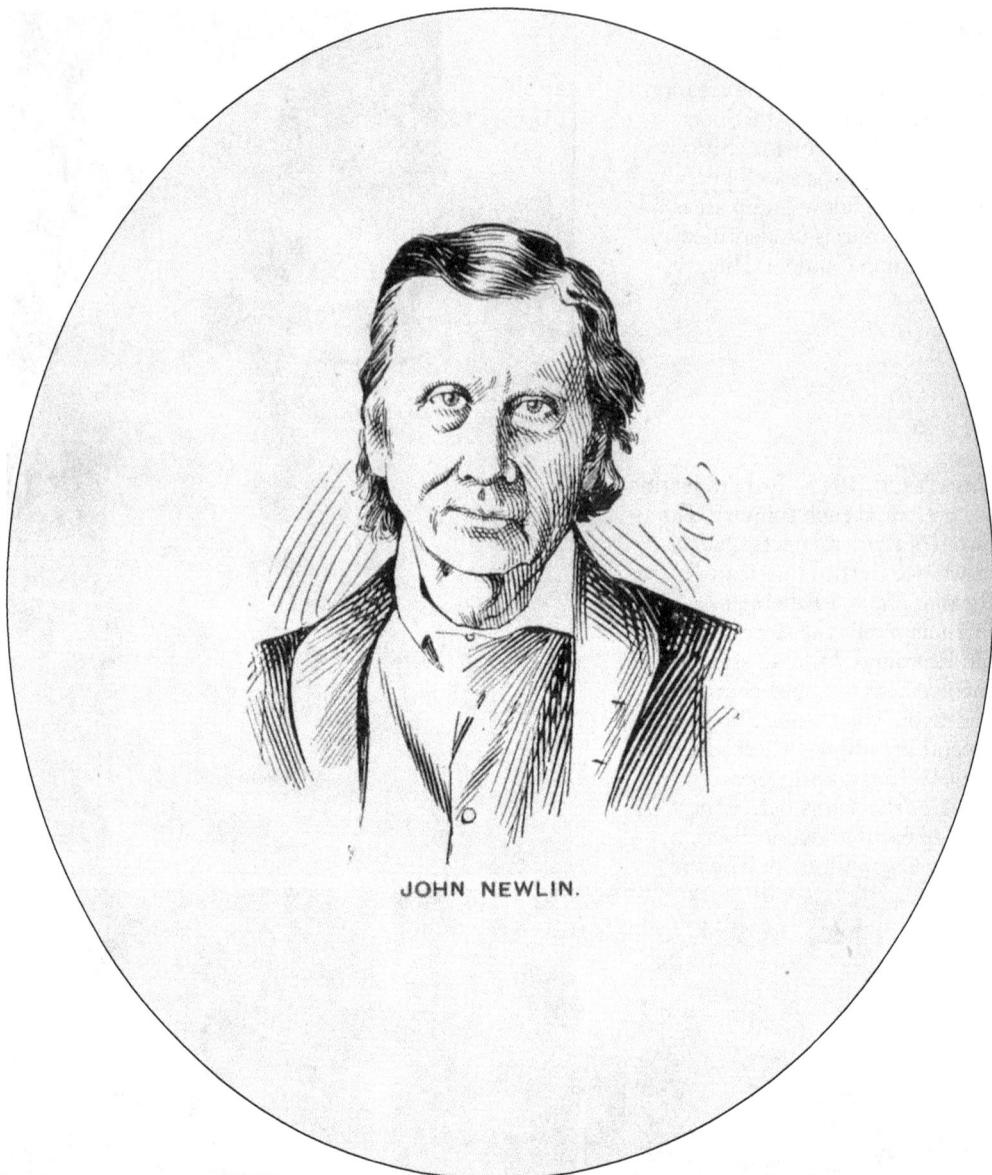

JOHN NEWLIN.

**JOHN NEWLIN.** John Newlin, a prominent Spring member, was pivotal in raising funds for the New Garden Boarding School and he may have been in charge of the committee to build the school. John and his wife, Rebecca, sent six children to New Garden Boardinghouse. (Alamance County Historical Museum Inc.)

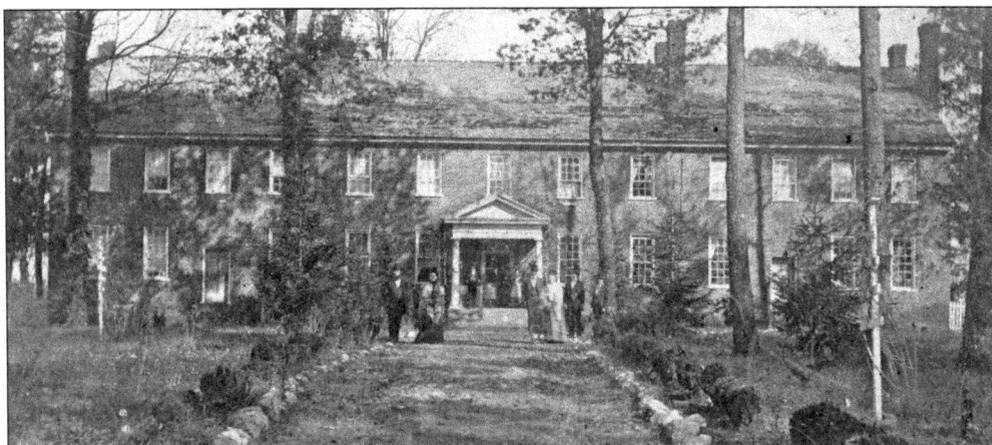

GUILFORD COLLEGE. Founders Hall, originally built in 1837, was part of New Garden Boarding School, which was chartered in 1834 and opened in 1837. New Garden School was the only coeducational institution in the area. Spring's affiliation with the school began between 1834 and 1837. The first class commenced in 1837–1838. Seven of Spring member Nathaniel Woody's nine children attended the school. New Garden Boarding School eventually became Guilford College, which is now the only Quaker college in the South. Its first commencement was in 1888–1889. Alpheus Folger Zachary and Edgar Holt McBane were the first and second, respectively, Spring members who graduated from Guilford College. This picture was taken in 1875. (Friends Historical Collection, Guilford College, Greensboro, North Carolina.)

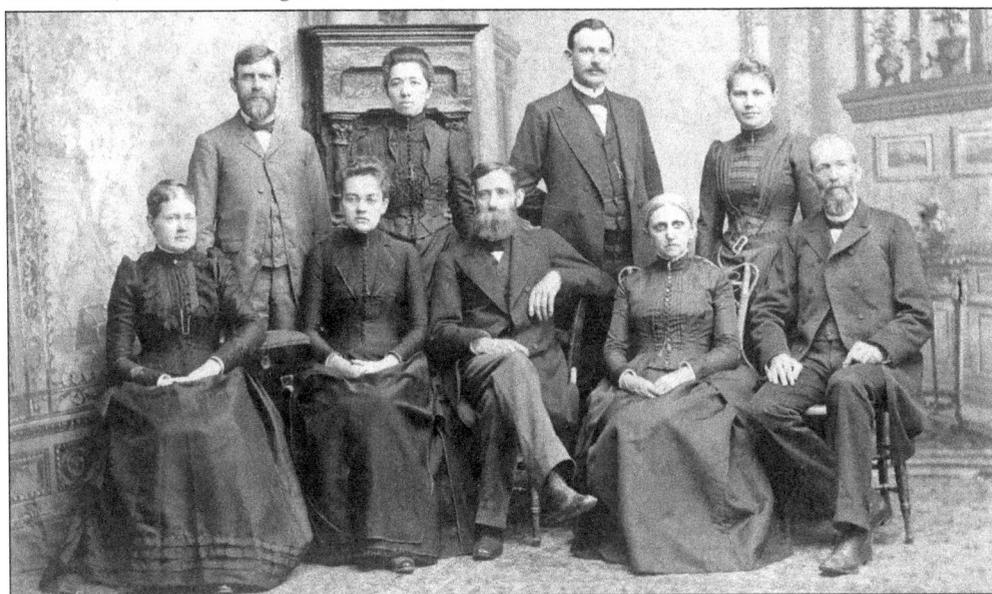

FIRST FACULTY OF GUILFORD COLLEGE. While the faculty at other schools remained the domain of men for many more decades, the first faculty at Guilford consisted of males and females. Those pictured are, from left to right, (first row) Mary E. Mendenhall, Gertrude Mendenhall, Dr. L.L. Hobbs, Priscilla B. Hackney, and John W. Woody; (second row) J. Franklin Davis, Mary M. Petty, Elwood C. Perisho, and Julia White. All were active members of the North Carolina Yearly Meeting. Today, students participating in the Quaker Scholars Leadership Program regularly offer spoken messages at Spring on the second and fourth Sundays. (Friends Historical Collection, Guilford College, Greensboro, North Carolina.)

Lindley-McBane Reunion
August 22, 1936

PROGRAM

I—Song . . . . . . . . . . . . . . . . . . . . . Choir
II—Devotional . . . . . . . . . . . . Jabus Braxton
III—Address of Welcome . . . . . . . Clyde McBane
IV—Response . . . . . . . . . . . David E. Buckner
V—Music . . . . . . . . . McBane Junior Band
VI—Characteristics of McBanes . . . . Edgar McBane
VII—Duet . . . . . . . . Ruth and Rachel McPherson
VIII—History of McBane Family . . . Harvey Newlin
IX—Solo . . . . . . . . . . . . . . Marvin Lindley
X—Remarks by the Visitors
       Address—J. Waldo Woody

PICNIC DINNER
(Music by McBane Band)

I—Song . . . . . . . . . . . . . . . . . . . Choir
II—Recitation . . . . . . . . . . . . Ollie McBane
III—"Way Bill" . . . . . . . . . Anderson McBane
IV—Dedication of Marker:
       (a) Presentation—Grady McBane
       (b) Acceptance —Everette McBane
       (c) Unveiling —Paul McBane
                       —George McBane
                       —Daniel McBane
                       —Daniel McBane
                       —William Henry McBane

V—Benediction

LINDLEY-MCBANE REUNION. On a Saturday in August 1936, a reunion of these two families was held. Spring Meeting hosted many gatherings like this one. The outing was organized by E.P. Dixon. This reunion featured the McBane Junior Band, among other activities. (Charles and Laurie Newlin.)

COCA-COLA SIGN, C. 1940. This sign on a building on Main Street in Burlington was indicative of growing threats to Sunday worship, which included Sunday drives, professional sporting events such as baseball and football, stores open on Sunday, radio, movies, chewing gum, and other amusements. In the 1920 minutes of advice from the North Carolina Yearly Meeting, Quaker parents were warned to keep their children away from the narcotic effects of Coca-Cola. (Alamance County Historical Museum Inc.)

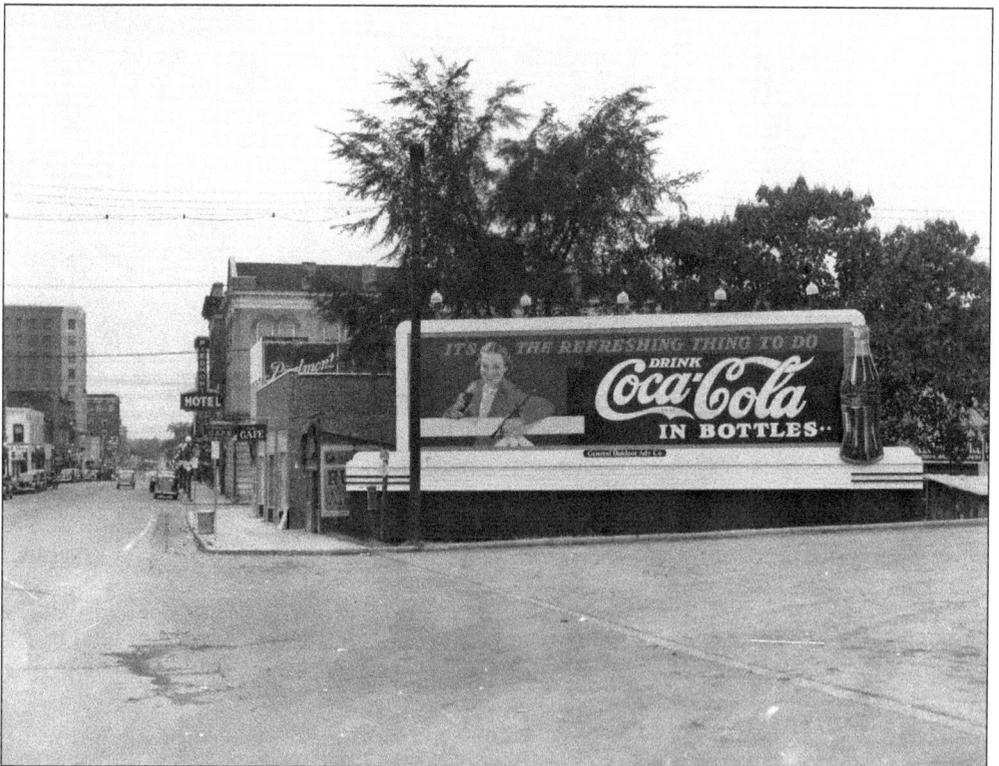

**MOVIE ADVERTISEMENT.** This risqué advertisement from a Burlington theater is just one example of the entertainments that tempted Spring members and other Snow Camp residents to deviate from staid religious values. (Charles and Laurie Newlin.)

The Most Amazing Picture of the Decade
Wild Children of Today on Rampage!

**The 7TH COMMANDMENT**

A WARNING TO THE YOUNGER GENERATION

## A Flaming Drama of Sin's Consequences!!

Road-Show Attractions Presents

A DWAIN ESPER SCREEN HIT— Direct from Hollywood It Comes Forth Like a Thunderbolt and Strikes into the Average Home Where Parents Fail to Warn Their Children—

**7TH COMMANDMENT**

How Many Break This Commandment Every Year? —Profit by Its Vital Lesson

A SMALL TOWN BOY ARRIVES IN THE CITY NOT KNOWING ITS PITFALLS AND IS TRAPPED WITH NO ONE AROUND TO GUIDE HIM— ARE WILD YOUTH ON A RAMPAGE TEARING DOWN EVERY COMMANDMENT ON ITS DOWNWARD PATH OF DESTRUCTION

Adults Only Admitted

## Carolina Theatre
### BURLINGTON, N. C.

**Wednesday & Thursday**
JULY 19-20

**MOVIE TICKET.** This ticket to a movie in Burlington, taken from Rachel Braxton's scrapbook, shows that she did not heed the advice of the North Carolina Yearly Meeting that warned North Carolina Quakers of this and other cultural phenomena of the time. Rachel, who had attended nearby Bethel Methodist Church, joined Spring Meeting when she married Dewey Andrew in 1935. (Charles and Laurie Newlin.)

JANET GAYNOR
IN
"CAROLINA"
Monday and Tuesday, February 12 - 13

PARAMOUNT THEATRE
BURLINGTON, N. C.

**TEMPERANCE JOURNAL.** This 1840 journal was possessed by an Alamance County resident and reflects the prohibition movements in the mid-1800s. Quakers and others closed distilleries and saloons in North Carolina in 1909 as a result of the efforts of prohibition campaigns. However, one Spring family's still was frequented by Quakers for "medicinal reasons." The 1910 North Carolina Yearly Meeting minutes recorded that freight trains brought liquor into the state illegally and near-beer saloons opened up offering alcohol to "foster the sad habit of drinking under the shameful disguise of healthfulness and harmlessness." In January 1926, a letter from Gaston Wright, who lived in Snow Camp and served on the Western Quarter Alcohol and Narcotics Committee, was received by Spring Meeting and read concerning "alcohol and narcotics." In 1928, Milo S. Hinckle, pastor of Asheboro Street Meeting, sent a letter to Spring asking for support of the alcohol and narcotics committee of the North Carolina Yearly Meeting. (Alamance County Historical Museum Inc.)

**HUNDREDTH ANNIVERSARY OF SPRING, CHATHAM, AND SOUTH FORK SUNDAY SCHOOLS.** On July 28, 1935, these three meetings celebrated their educational programs. They had Sunday school classes, two song services, and presentations by Algie Newlin, Harvey Newlin, and Dr. P.E. Lindley. Sunday school was a controversial subject for Quakers; many of them felt it would detract from both the Quaker practices of silently awaiting for spiritual enlightenment and using the Bible as only one of several means of enlightenment. Still, the very first Quaker Sunday schools were in North Carolina in the early 1800s. The fact that this celebration took place in 1935 indicates that these three meetings had some form of school long before Quakers officially approved of Sunday or Sabbath school. (Charles and Laurie Newlin.)

HUNDREDTH ANNIVERSARY
OF
SPRING, CHATHAM and SOUTH FORK
SUNDAY SCHOOLS
AT
SPRING FRIENDS CHURCH

SUNDAY, JULY 28th, 1935

10:00 A. M.—Sunday School.
11:00 A. M.—Song Service.
　　　　　　Special Song.
　　　　　　Sermon.
12:00　　　 Noon.
1:45 P. M.—Song Service.
　　　　　　Historical Sketch of Early Sunday School—
　　　　　　　　　　　　　　　　　　Harvey Newlin.
　　　　　　Special Song.
　　　　　　Modern Sunday School—Dr P. E. Lindley.
　　　　　　Address—Prof. A. I. Newlin.

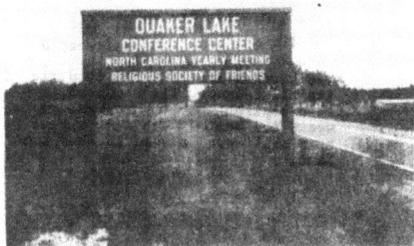

**ABOUT QUAKER LAKE . . .**

Have you been to Quaker Lake recently? If you have, you know that our Conference Center is more beautiful than ever. The wooded areas, the green fields, the lakes, and the new buildings offer an excellent setting for our camping program. The Quaker Lake facilities are available also for use by Meetings and Friends groups for retreats, picnics, worship services, banquets and other activities. You are invited to come to Quaker Lake.

**CAMP DATES**

Junior High Camps (Grades 7-8-9) Ages 12-14

　　June 11-June 17　　　June 18-June 24

Junior Camps (Grades 4-5-6) Ages 9-10-11

　　June 25-July 1　　July 9-July 15
　　July 2-July 8　　July 16-July 22

**THE CAMPING PROGRAM**

Quaker Lake Camp is people—the young people who come as campers and the adults who serve as their leaders are the center of the camping program. The Quaker Lake facilities can accommodate approximately 360 campers during the six weeks which are planned. Approximately 100 people will be needed to serve as leaders (counselors, nurses, teachers, cooks) of the boys and girls who come. You are invited to be a part of the Quaker Lake Christian Camping Community for a week this summer either as a camper or a member of the staff.

For additional information contact:

Camp Director: Charles Snow, Box 8328, Greensboro.

Superintendent: Orval Dillon, Climax, N. C.

*Quaker Lake Camp*

*1967*

QUAKER LAKE
CONFERENCE CENTER
NORTH CAROLINA YEARLY MEETING
RELIGIOUS SOCIETY OF FRIENDS

**QUAKER LAKE CAMPGROUND.** Orval Dillon, who also served Spring Meeting as pastor, worked at Quaker Lake, a recreational site for Quakers in nearby Climax, North Carolina. In April 1951, minister J. Floyd Moore encouraged Spring Friends to contribute to the camp. Monetary gifts were placed in special envelopes. The previous year, Spring had contributed $22.30. In 1976, Spring Meeting held a field day at Quaker Lake. Spring Friends also raised $800 for Quaker Lake with a bikeathon in 1976. Today, Spring members camp at the site once a year for a weekend of fellowship and outdoor spirit. (Spring Friends Collection.)

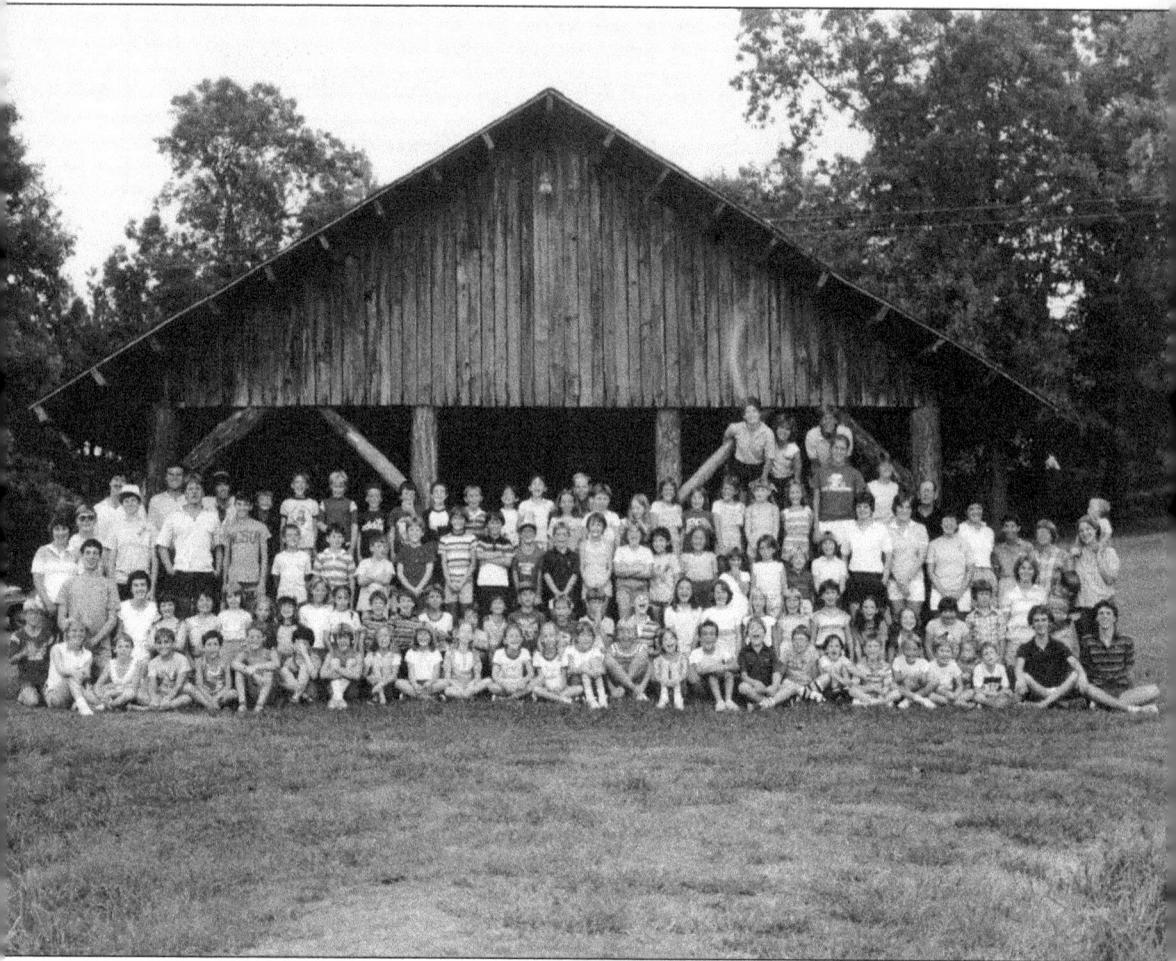

**RON OSBORNE.** In 1983, Ron Osborne is pictured in the fourth row, second from the left, with other counselors at Quaker Lake. He was a camp counselor and lifeguard from 1980 to 1982. He has been instrumental in the revival of Spring Meeting in the 21st century. (Ron Osborne.)

# Two

# The People of Spring Friends Meeting

Spring Friends Meeting was attended by many throughout the past centuries, but most of its members came from only a few families. Holladays (also Hollidays and Holidays), Lindleys, McBanes, Zacharys, Guthries, Newlins, Marlettes, Woodys, and others fill the membership list. Unfortunately, Spring members did not take many pictures of themselves. This reluctance may have come from the Quaker emphasis on simplicity and modesty. However, because of their active participation in their community and in Quaker ministry, a history of Spring members can be pieced together. Much can be learned about past members from plaques, letters, markers, lists, and meeting minutes.

at a Monthly Meeting held at Spring [...]
the 4th Day of the 10th Month 1793 agreable t[...]
Direction of the Quarterly Meeting the [...]
[...]atives being Called the [appeared]

this Meeting appoints Mary Woody Clark an[d]
hannah thomson assistant thereof further [...]

Joseph Chamness and Ruth mccrakin appea[red]
Here and Signified there intentions of Marra[ge]
with Each other it being the first time and th[is]
[m]eeting apoints Sarah Lindly and Hannah th[e]
to Enquire into the young womans life and conve[rsation]
And Clearness in Relation of Marrage w[ith]
others and Return their Account to our Next
Monthly Meeting

the preparative Meeting Enters a Complaint a[gainst]
Ruth fausot formerly Burnside for going out in
Marriage with a man not of our Society & this
Meeting appoints Rachel haly and Hannah thom[son]
to visit her and Likewise Draw up a testification
Against her and produse to our Next monthly
Meeting for aprubation

Jane jones hath for some time past been und[er]
the notice of friends and now Requests to be take[n]
Membership with us therefore this Meeting the[n]
[ap]t to Recieve her as Shuch

**WEDDING REQUEST.** Quaker discipline required its members to ask for permission to marry. According to Spring Friends Meeting minutes, Joseph Chamness and Ruth McCrakin presented to the meeting their request to be married on 4th day 10th month 1793 (October 4). Also, the meeting condemned Ruth ? for associating with someone outside of the Society of Friends. (Friends Historical Collection, Guilford College, Greensboro, North Carolina.)

**NCYM Tract on Slavery.** In the mid-1700s, Quakers in America owned slaves, but with the persistence of John Woolman, Quakers began manumitting slaves by the late 1700s. In 1848, the North Carolina Yearly Meeting sent out this tract addressing the controversial issue of slavery. Quakers understood the idea of increasing revelation; in essence, this meant that while older Quakers may have defended slavery, contemporary Quakers now disagreed with the practice. Still, charity for those who owned slaves was encouraged by the yearly meeting. Despite this, some Quakers retained their slaves, as evidenced in these minutes from Spring Meeting. (Friends Historical Collection, Guilford College, Greensboro, North Carolina.)

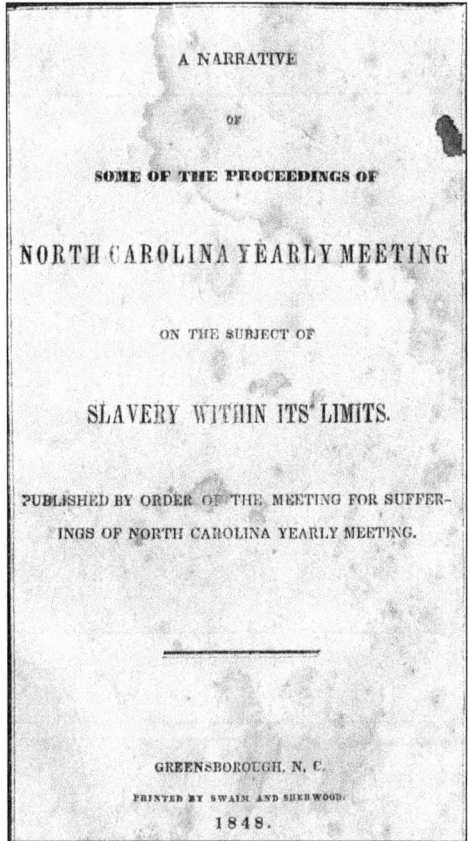

A NARRATIVE

OF

SOME OF THE PROCEEDINGS OF

NORTH CAROLINA YEARLY MEETING

ON THE SUBJECT OF

SLAVERY WITHIN ITS LIMITS.

PUBLISHED BY ORDER OF THE MEETING FOR SUFFER-
INGS OF NORTH CAROLINA YEARLY MEETING.

GREENSBOROUGH, N. C.
PRINTED BY SWAIM AND SHERWOOD.
1848.

**Minute of 1842, 29th of 10th Month.** The meeting complains of Oliver Newlin for owning slaves and also for marrying "contrary to discipline," in other words marrying a non-Quaker. (Friends Historical Collection, Guilford College, Greensboro, North Carolina.)

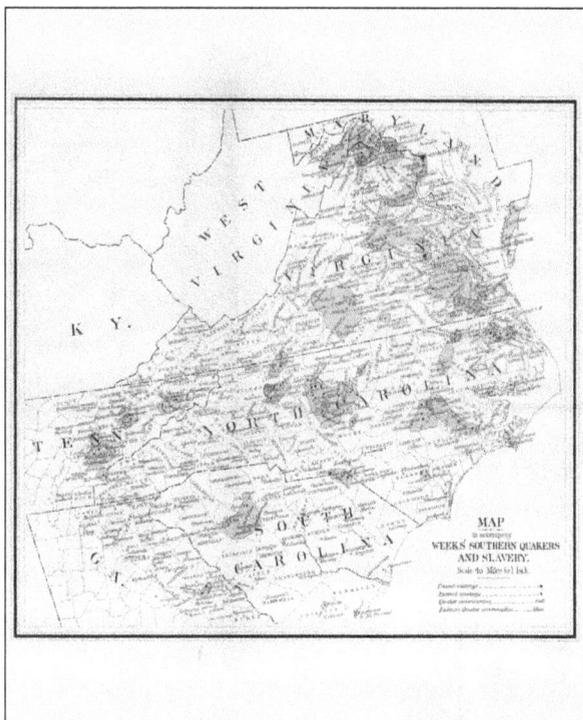

WEEKS SLAVERY MAP. Led by Quaker Levi Coffin, the Underground Railroad was started. Stephen Weeks's 1893 map marks off Quaker safe havens in North Carolina for slaves fleeing the South for the Northern areas of Ohio, which was where they crossed the "Jordan River," better known as the Ohio River, Indiana, and other states, as well as Canada. The area around Spring Meeting was also part of the Underground Railroad. Cane Creek Meeting and Freedom's Hill Wesleyan Church, both eight miles west from Spring Meeting, were safe houses for slaves. John Newlin of Spring, like other Quakers, illegally bought slaves in order to give them freedom. (The North Carolina Collection, University of North Carolina at Chapel Hill.)

PATHWAY TO FREEDOM. Each summer, the Snow Camp Outdoor Theatre performs the play *Pathway to Freedom*, which began in 1994. The production explores the Quakers' involvement in the Underground Railroad. The identities of the actors are unknown. (Snow Camp Outdoor Theatre.)

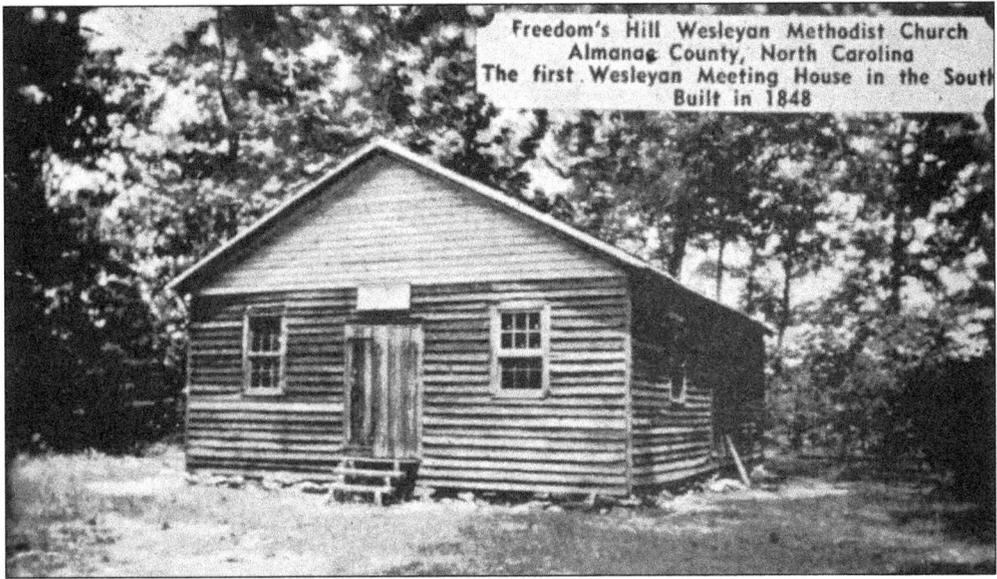

Freedom's Hill Wesleyan Methodist Church
Almanac County, North Carolina
The first Wesleyan Meeting House in the South
Built in 1848

FREEDOM'S HILL WESLEYAN CHURCH, 1970. Some Cane Creek Friends and a few antislavery Methodists established this Wesleyan Methodist church, which took an unpopular stance against slavery. Rev. Adam Crooks was brought from Ohio in 1847 to serve as the first minister. Pro-slavery people shot at the church and dragged Crooks from the pulpit. He eventually fled the state. The church remained reticent until the late 1850s, when it renewed its antislavery stance. The log building was eight miles west of Spring and just over one mile east from Cane Creek Meeting. It has been moved to Southern Wesleyan University in Central, South Carolina. (Myrtle Phillips.)

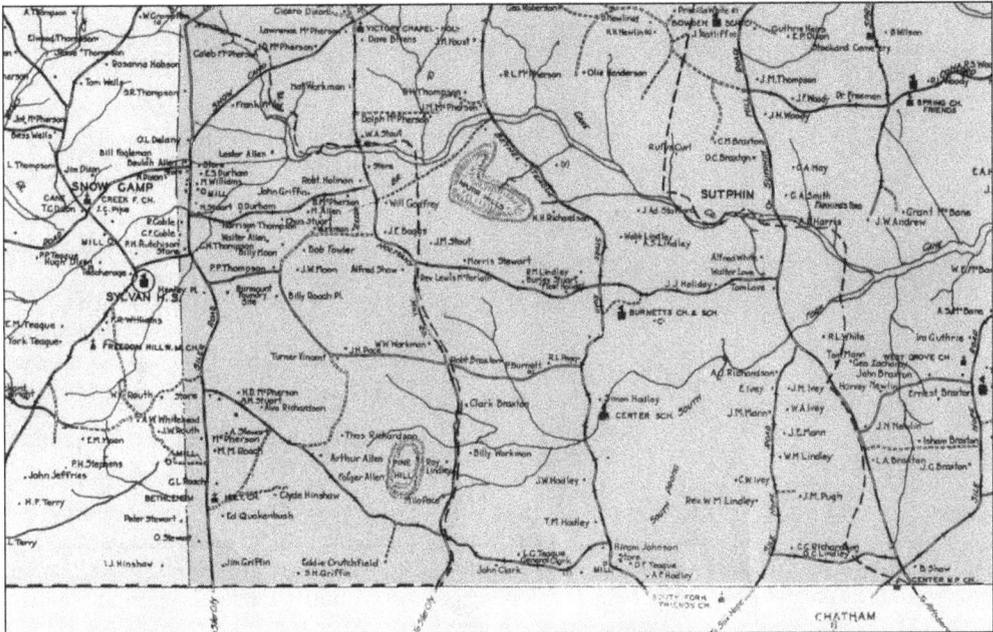

FREEDOM'S HILL CHURCH. In this reproduction of the 1928 William Spoon map of Alamance County, Freedom's Hill Church can be seen near Cane Creek Meeting. (Alamance County Historical Museum Inc.)

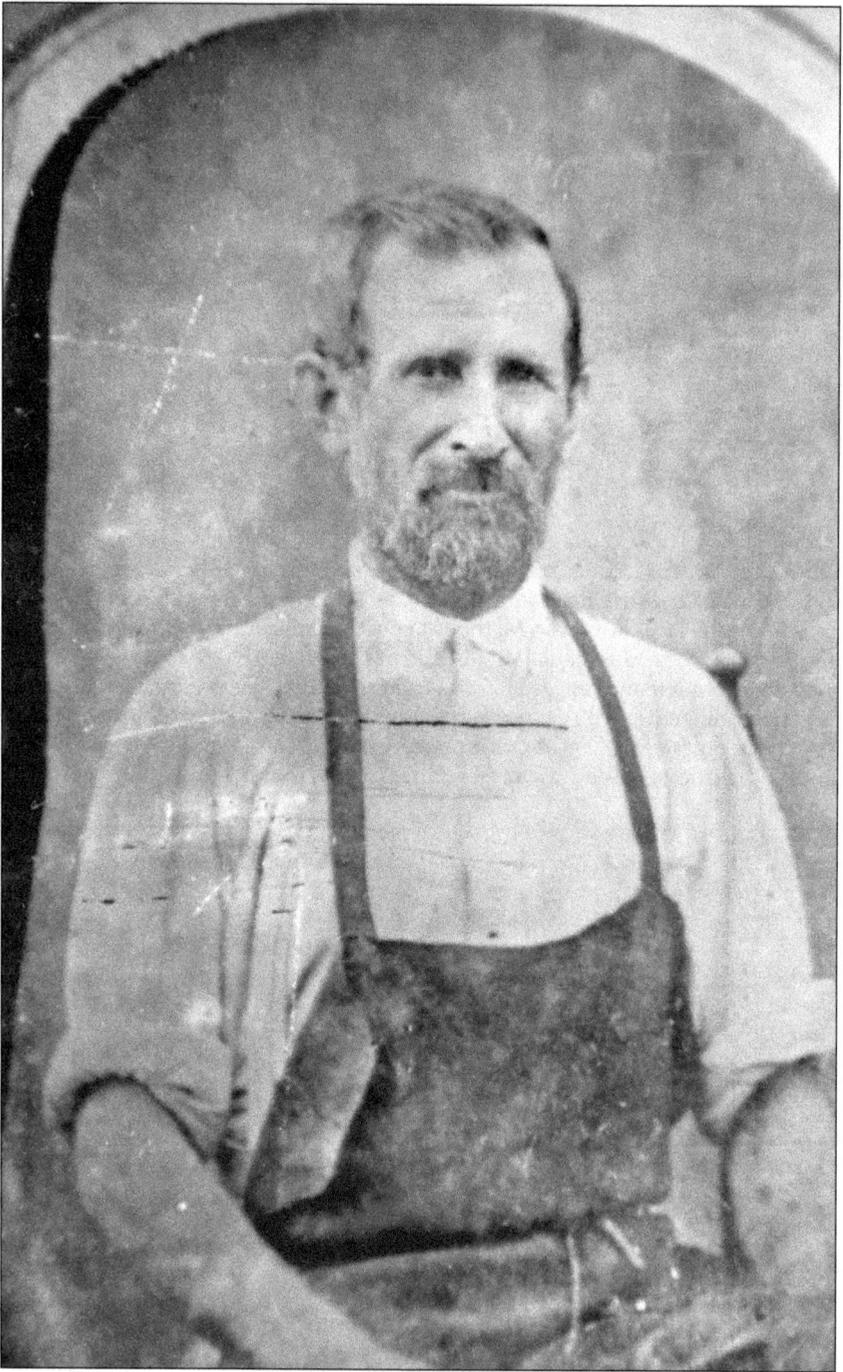

**JESSE D. BUCKNER.** Jesse Buckner was a colonel in the Confederate militia but soon became sympathetic to pacifist Friends. For this, he was stripped of his rank. He joined Spring Meeting in January 1863, paid his $500 exemption fee, but was then sent to various Confederate camps where he was tortured in the hopes of returning to service. Never giving up his Quaker beliefs, he survived the persecution and was a valuable member of Spring Meeting for years afterward. He served on the building committee in 1873. (Spring Friends Collection.)

**JAMES NEWLIN AND JONATHAN NEWLIN.** Quakers have always been against war, but this did not mean that all Quakers complied with this belief. In the times of the Civil War, the issue became complicated. Men were required to fight or to hire a conscript to take their places. Those who refused to fight were fined. If a man could not afford to pay the fine, he had to fight. Still, some Quakers joined the army. In these minutes from 1861, "Spring Preparative complains of James Newlin for attending at muster and performing military service, he produced an offering to this meeting condemning his breach of order which this meeting receives and continues him a member as his future conduct deserves." The same exact entry occurs for Jonathan Newlin. After these entries, the minutes recall the previous meeting minutes where the Quaker stance against war is outlined as follows: "Being thus careful to abstain from war and everything connected with war we cannot conscientiously pay any fines that may be imposed upon us, individually, for the nonperformance of military duty, but rather quietly submit to have the value of the same distrained by the proper officer." (Friends Historical Collection, Guilford College, Greensboro, North Carolina.)

**HANNAH ZACHARY MARLETTE.** This photograph was taken in 1882. Hannah was the sister of Alfred Zachary, who may have been the first minister at Spring Meeting. Hannah was clerk of the meeting. She was born in 1861 and died in 1921. (Charles and Laurie Newlin.)

**MEMBERSHIP LIST C. 1900, WITH 124 MEMBERS.** This list of Spring members is not indicative of the membership over the years. Membership fluctuated throughout the 1900s and dwindled to less than 10 at the beginning of the 21st century. (Spring Friends Collection.)

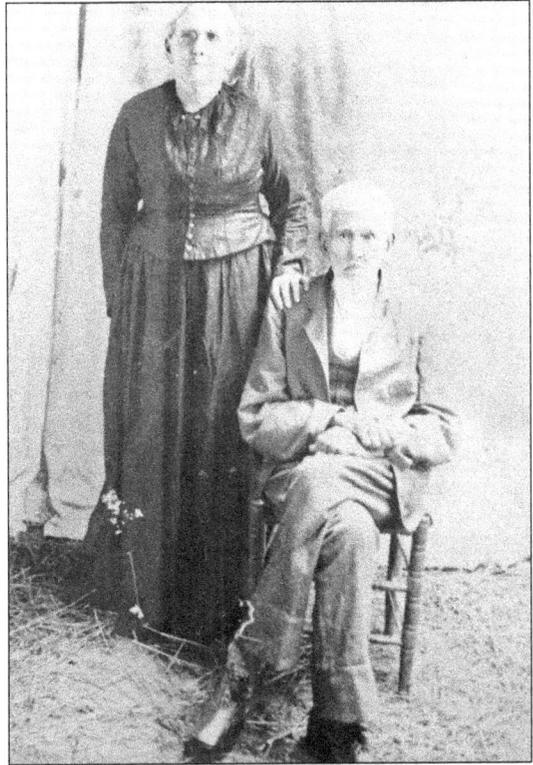

**ISAAC AND UNITY ANDREW.** The Andrew family arrived from Chester County, Pennsylvania, in the 18th century. Isaac was a member of Spring Meeting. (Lisa Cox.)

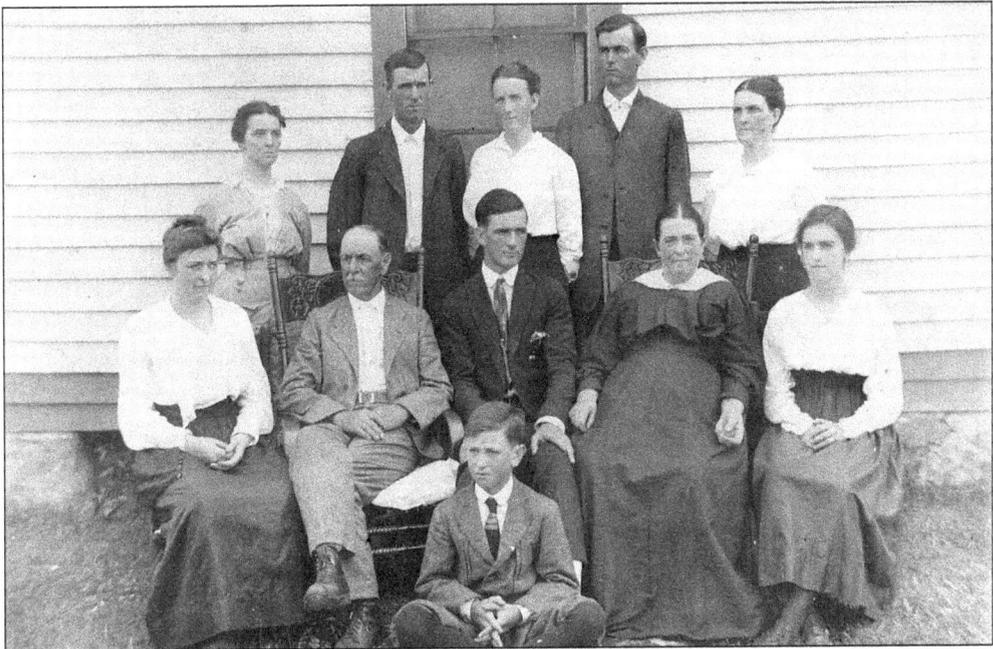

**JIM AND MARTHA NEWLIN FAMILY.** Pictured are, from left to right, (first row) Ira Guthrie Newlin; (second row) Elizabeth Newlin, James Nathaniel Newlin, Algie I. Newlin, Martha Elizabeth Guthrie Newlin, and Alta N. Guthrie; (third row) Elvira "Ila" N. Braxton, Mahlon Newlin, Mary N. Clark, Harvey Newlin, and Sarah N. Shaw. (Charles and Laurie Newlin.)

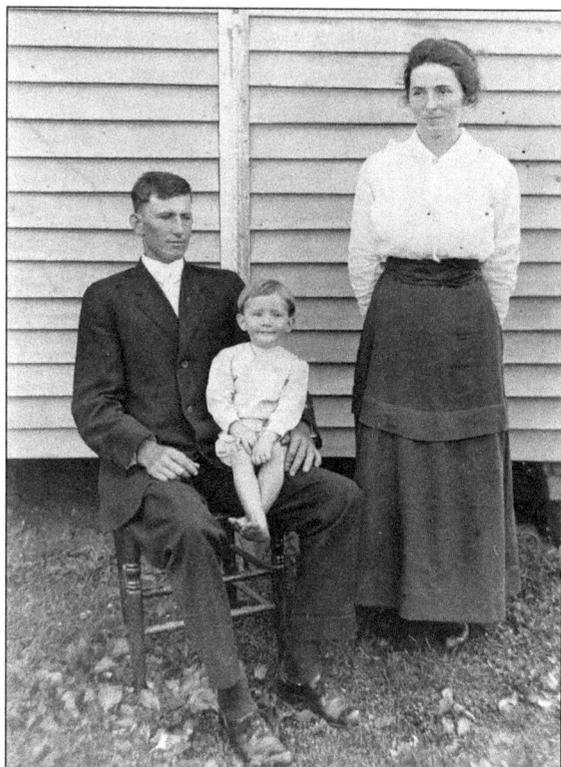

JOE PERRY AND MATTIE ANN ZACHARY, 1916. One day, pictures were being taken in the community, possibly by John Norwood. When the Perrys heard about this, they dressed up and drove over to the location to have their photograph made. Glenn Perry sits on his father's knee. His sister, Kathleen, was not born at this time. (Dan Perry.)

PERRY FAMILY REUNION. Spring members included in this photograph are Eva Ferguson Perry, Mattie Ann Zachary Perry, Mahlon Zachary, Glenn Perry, Clay Perry, and Joe Perry. (Dan Perry.)

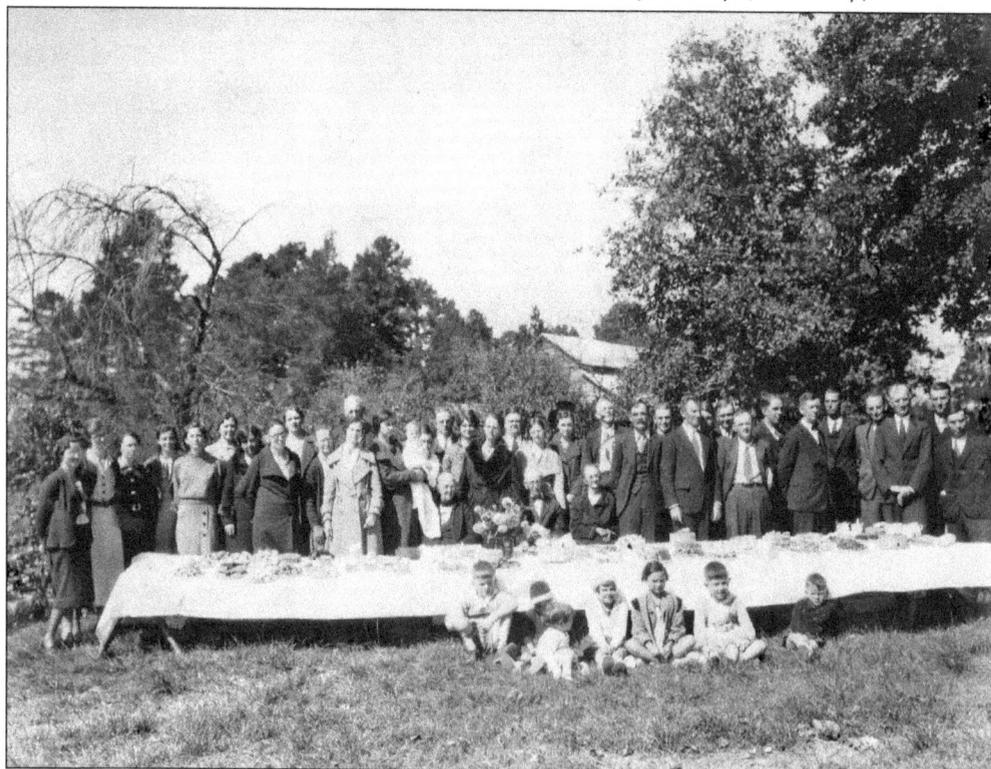

TOM ZACHARY. Perhaps Spring's most famous member is Tom Zachary, who played baseball for Guilford College and then professional baseball for 19 years. Zachary remained true to his Quaker pacifist beliefs while serving in a Quaker Red Cross Unit during World War I. Zachary then played with the Washington Senators, St. Louis Browns, Boston Braves, Brooklyn Dodgers, New York Yankees, and Philadelphia Phillies. Yankee Babe Ruth hit his 60th home run off of Zachary in a September 30, 1927, game against the Senators. Zachary joined the Yankees the following year and, ironically, roomed with Babe Ruth. Zachary pitched a 12-0 season in 1929, and he is the only major-league player to ever pitch a perfect undefeated season. He pitched three times in two World Series and never lost. He retired to his farm in Graham and died in 1969. (Dan Perry.)

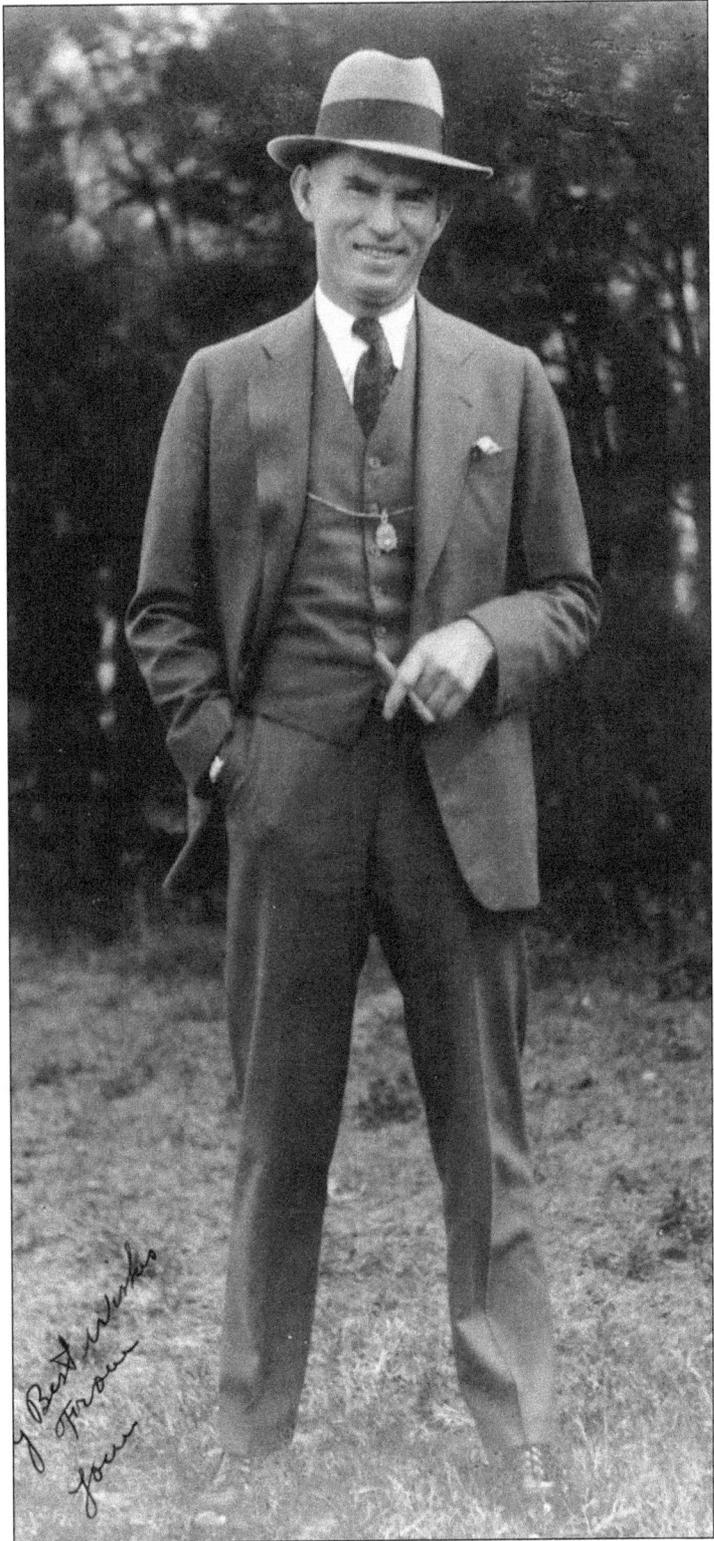

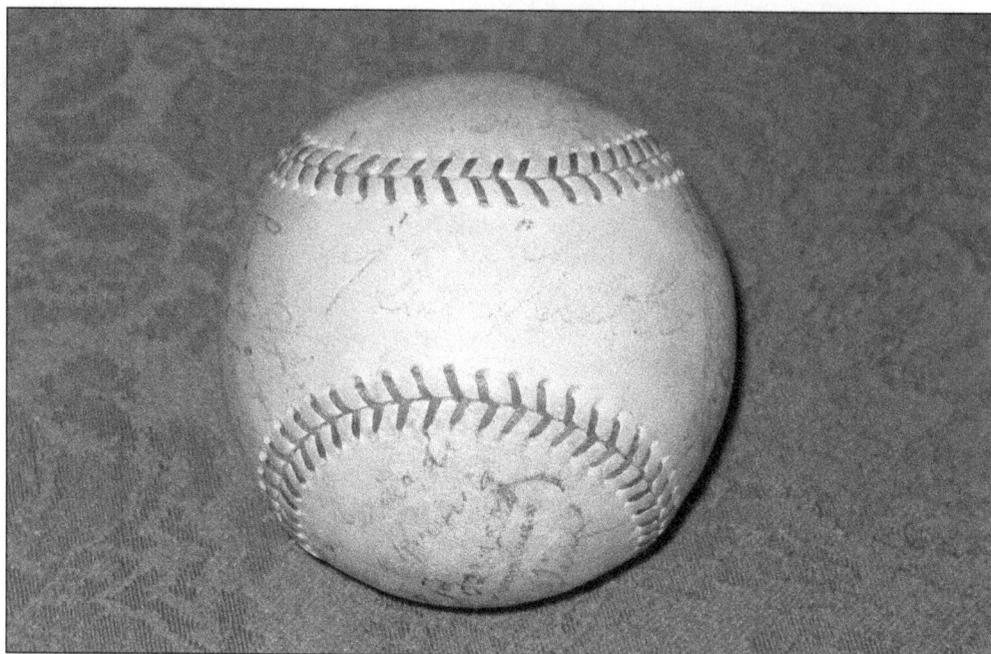

**BABE RUTH BASEBALL.** This baseball was signed by the 1928 World Series champion New York Yankees. Among the names on the ball are Stan Musial, Tom Zachary, and Babe Ruth. The ball belongs to an anonymous Spring member. (Author.)

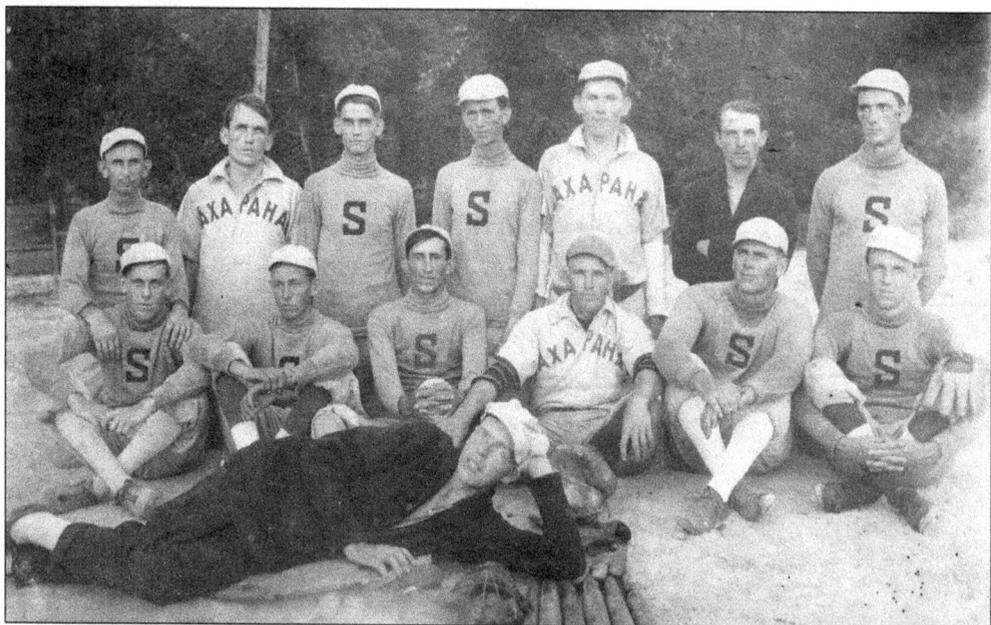

**SAXAPAHAW BASEBALL TEAM, 1910.** Baseball was a major pastime in the early 1900s. The North Carolina Yearly Meeting condemned the sport, but Spring Meeting had several players on local teams. The first names of players are not known, except for Spring members. Those pictured are (in front) Williamson; from left to right, (first row) Abernathy, Neal, Clay Perry, Tom Zachary, Edwards, Algie Newlin; (second row) Bates, Marlette, Durham, Martin, Pickard, Hunter, and Roney ?. The team bought its own shirts and played at the local school's ball yard. (Dan Perry.)

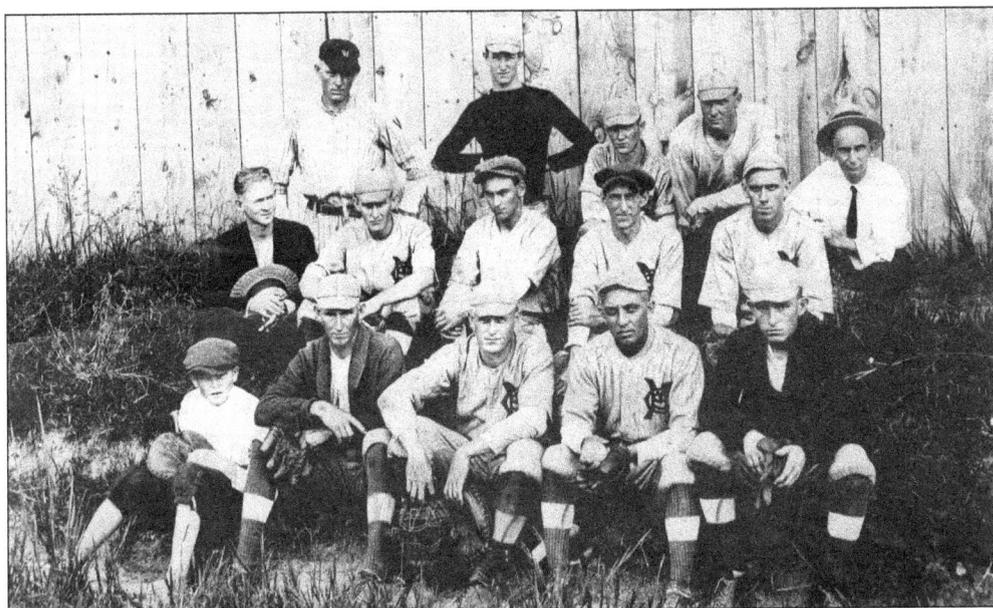

ANOTHER BASEBALL TEAM, C. 1915. Those pictured are, from left to right, (first row) unidentified, Joe Perry (Spring member), Seaton Quakenbush, Jardie Johnson, and Sherman Laton; (second row) Ed Gilliam, Leland Perry, Bill Lindley, Coy Durham, and unidentified; (third row) George Zachary (Spring member) and four unidentified. (Dan Perry.)

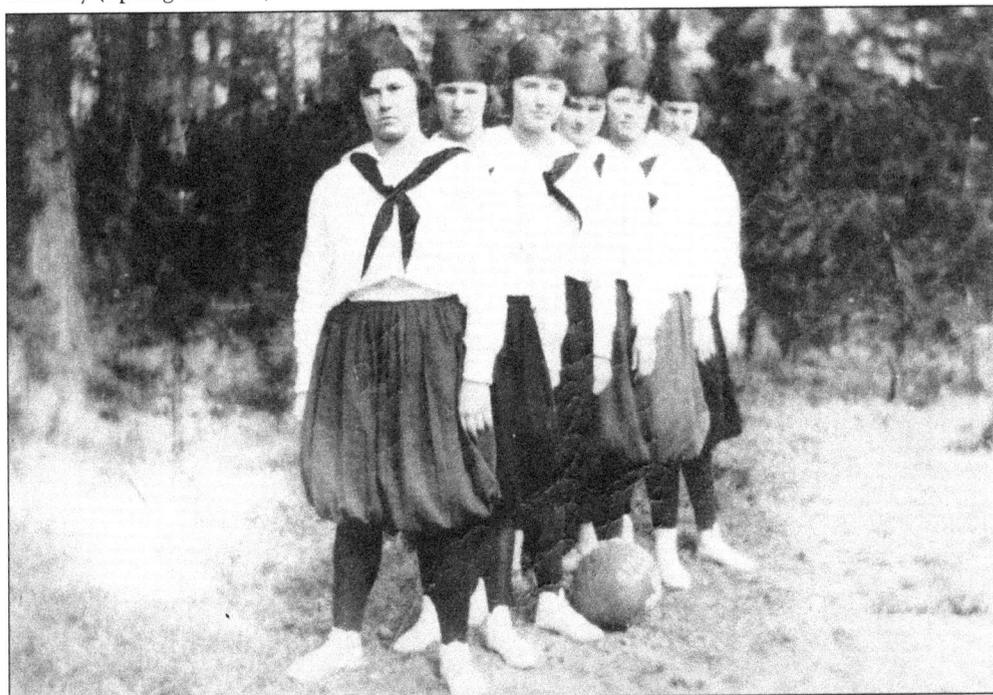

WOMEN'S BASKETBALL TEAM, C. 1919. This is the basketball team at Spring School. Those pictured are, from front to back, Bertha Zachary, Mabel McBane, Ela Mae McBane, Allene Marlette, Sexy Walters, and Swannie Crayton. Bertha went on to be a star player on the Guilford College basketball team. (Joe Bill and Jane Lindley.)

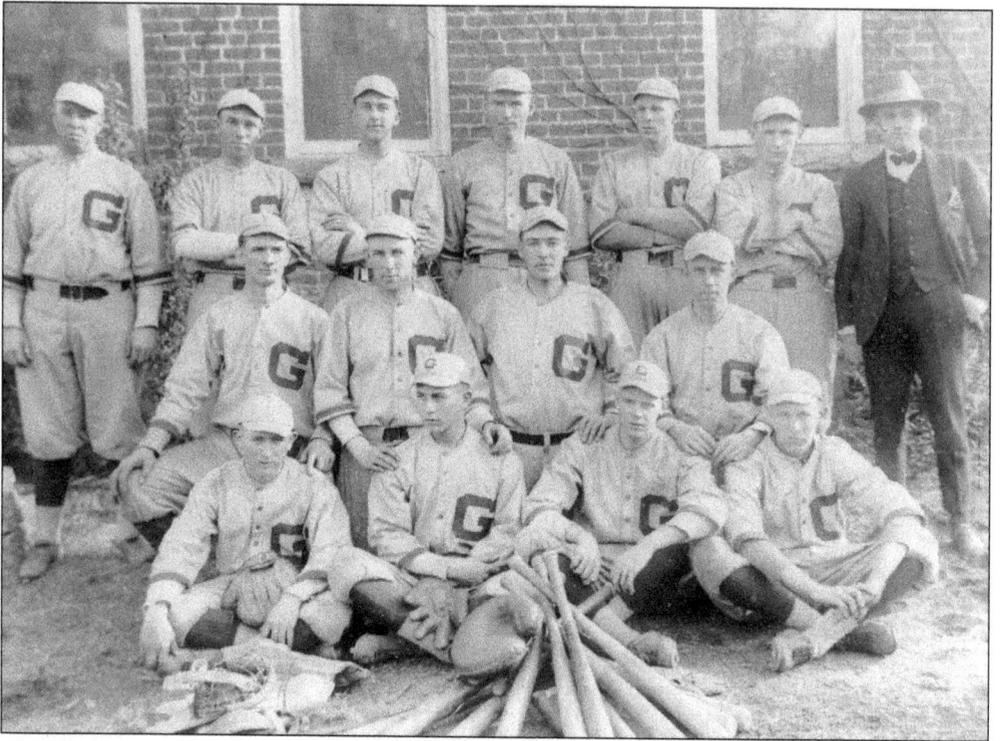

**GUILFORD COLLEGE BASEBALL TEAM.**
This is the 1917 state champion
Guilford College baseball team that
Spring member Tom Zachary played
on. Zachary played on the team from
1917 to 1918. (Friends Historical
Collection, Guilford College,
Greensboro, North Carolina.)

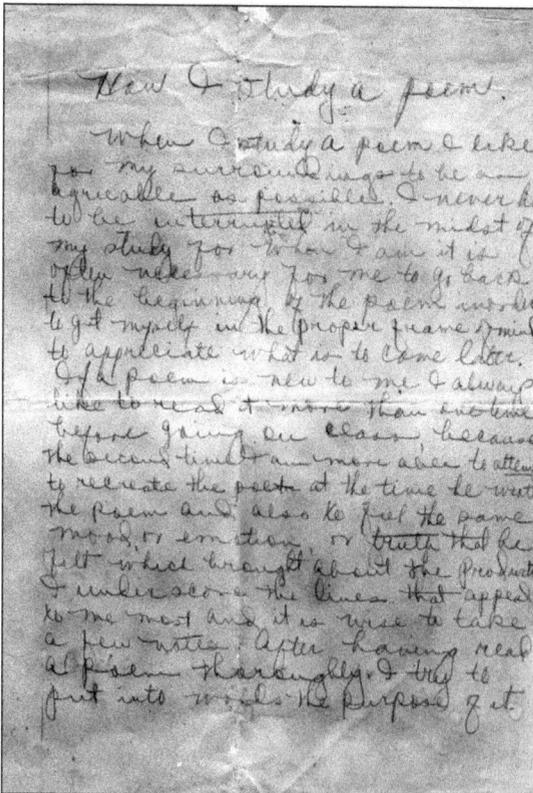

**BERTHA ZACHARY ESSAY.** This essay,
"How I Study a Poem," was written by
Bertha Zachary for her English III class.
She needs to be in an "agreeable" place
to "feel the same mood, or emotion,
or truth that he felt, which brought
about the production." (Aunt Bertha
folder, Spring Friends Collection.)

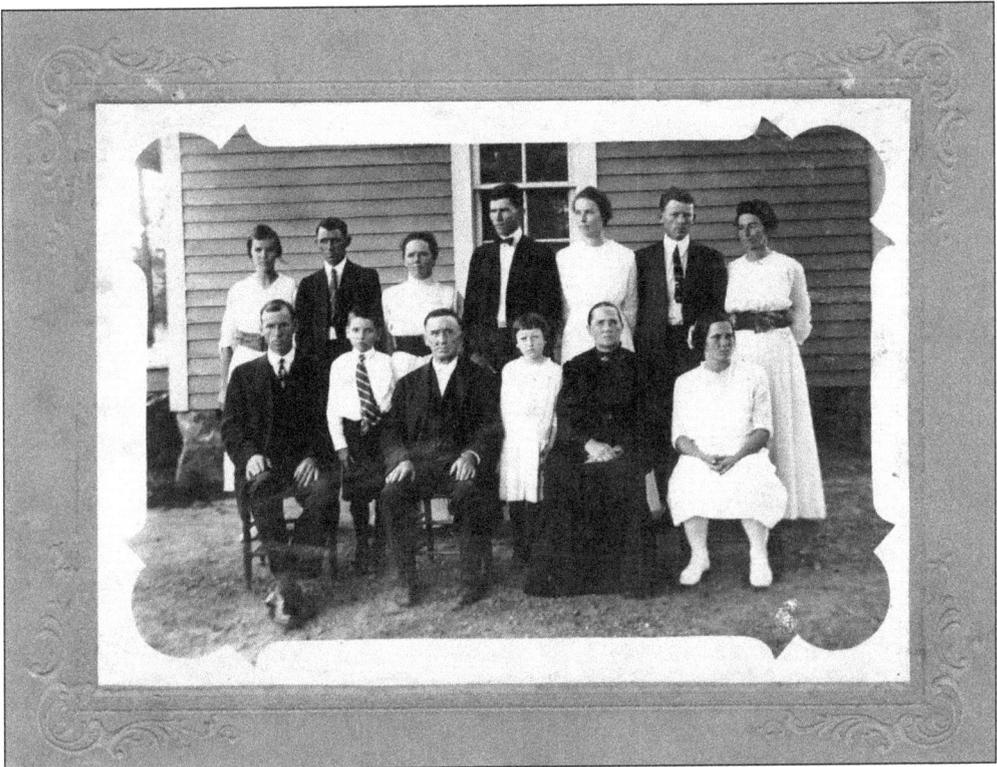

**ALFRED ZACHARY FAMILY, C. 1920s.** In this photograph is the family of Alfred Zachary. Those pictured are, from left to right, (first row) Foe, Mahlon, Alfred, Hazel, Ila, and Bertha; (second row) Alta, Jack, Callie, Tom, Ruth, George, and Mattie Ann. "Foe" was the nickname of Alpheus Folger Zachary, who was the first member of Spring Meeting to graduate from Guilford College in 1911. He served as superintendent of Spring Sabbath school. (Dan Perry.)

**TOM ZACHARY AND HIS MOTHER, MARY ELVIRA "ILA" GUTHRIE ZACHARY, C. 1930.** Mary served as an overseer in the meeting. (Joe Bill and Jane Lindley.)

*Alfred L. Zachary an Ou[...]* *in unity with me, ex[...]* *this meeting a concern to visit in* *the love of the Gospel meetings be-* *longing to Western Quarter.*

*This meeting expressed much* *unity in granting the request; liberating him to appoint* *meetings and such other service* *as the Lord may direct.*

*Taken from the minutes of* *Spring monthly meeting of friends* *held at Spring 1, 30, 1894* *and signed by direction* *of same*

*Samuel E. Woody* *Rodema E. Wright* } Clerks

MEMO CONCERNING ALFRED ZACHARY. This note is copied from the January 30, 1894, Spring minutes. Alfred Zachary petitions the meeting for permission to visit other meetings in the Western Quarter. Zachary was probably the first minister who served at Spring Meeting. He also served nearby Cane Creek Meeting . (Aunt Bertha folder, Spring Friends Collection.)

**LETTER FROM BERTHA ZACHARY GUTHRIE TO HER SON JOHNNIE.** This March 4, 1886, letter from Bertha Zachary Guthrie to Johnnie Guthrie reveals much about life in the late 1800s. As Quakers used to do, she uses the pronoun *thee* (instead of *you*) when referring to her son. She describes farming, his siblings' schoolwork, and a reminder that "a little girl who wears the cap with a white feather" has received two letters, possibly from Johnnie. He is reminded "that pretty little lady is on duty for next month [meeting]." (Aunt Bertha folder, Spring Friends Collection.)

**LETTER FROM MAN AT GUILFORD COLLEGE.** It is difficult to determine whom this letter is written to. E.O. Reynolds composed it in November 1886 at New Garden Boarding School. Reynolds writes to the George and Ann Guthrie family of Chatham Meeting, which was still connected with Spring Meeting at this time, concerning the health of their son or nephew John "Johnnie" Guthrie. He has an abscess, but the doctor expects him to live. John wants to come home, but he also does not want to miss his studies. The coordination of transportation and pickup is proving difficult. John died in January 1887. (Spring Friends Collection.)

**WILLIAM F. "BILL" PERRY AND SARAH CATHERINE BUCKNER PERRY.** According to an account by Jake Hadley, the Perrys moved to the Spring area in 1880s to avoid liquor stills in the Mount Olive community (formerly known as Lick Branch) in upper Chatham County. In the 1926 list of Spring committee members, Catherine Perry is listed as an elder, and Bill Perry was clerk. (Dan Perry.)

**ALFRED AND ADA BOONE MCBANE.** In a time when most Spring members had cars, Alfred McBane's family traversed over a mile by foot, on the dirt road, to the services at the meetinghouse in the late 1930s and early 1940s. Alfred and Ada were the parents of Edgar Holt McBane, who studied in the early years of Guilford College. He later donated $2,000 for the publication of Algie Newlin's history of Spring Meeting, *Friends "at the Spring."* Edgar bequeathed endowments for Spring that are still used today. According to legend, Alfred sat at the back of the meetinghouse and spat tobacco out the window. (Dan Perry.)

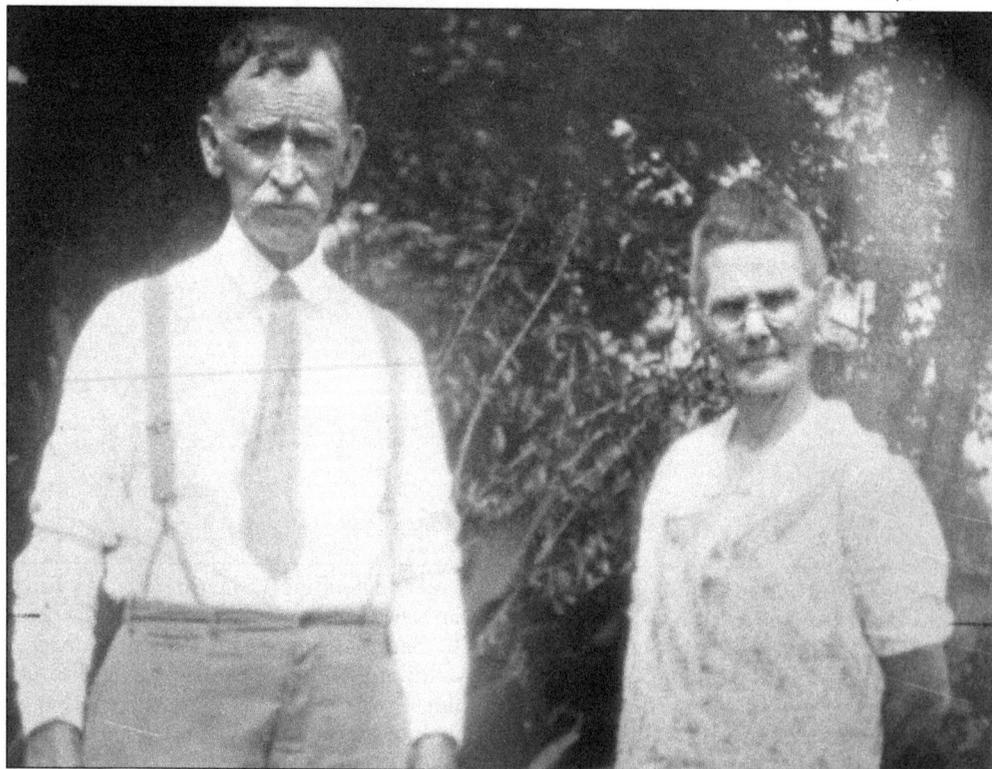

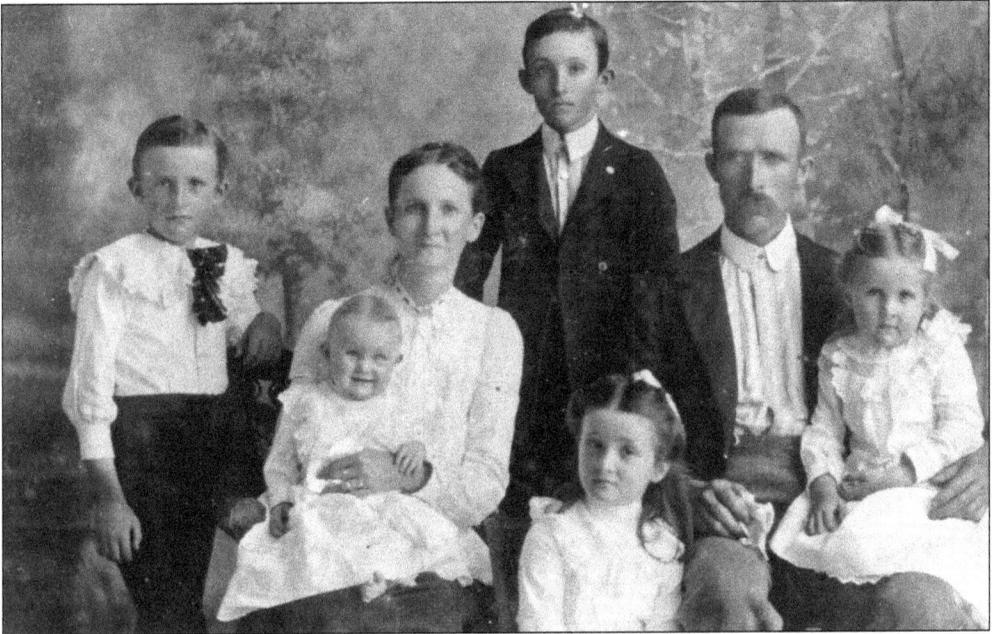

**GRANT MCBANE FAMILY.** From left to right are Ross, Lenora holding Mable, Perisho, Vera, Grant, and Sandra. Grant, along with Elzena McBane (Woody) and Seymour McBane, attended the last three years of New Garden Boarding School (1885–1888) After Spring Meeting ended segregated men's and women's meetings, Lenora McBane was named as clerk of the meeting; she was also an elder and on the Sabbath school committee. Perisho was killed in a gas attack in World War I. (Dan Perry.)

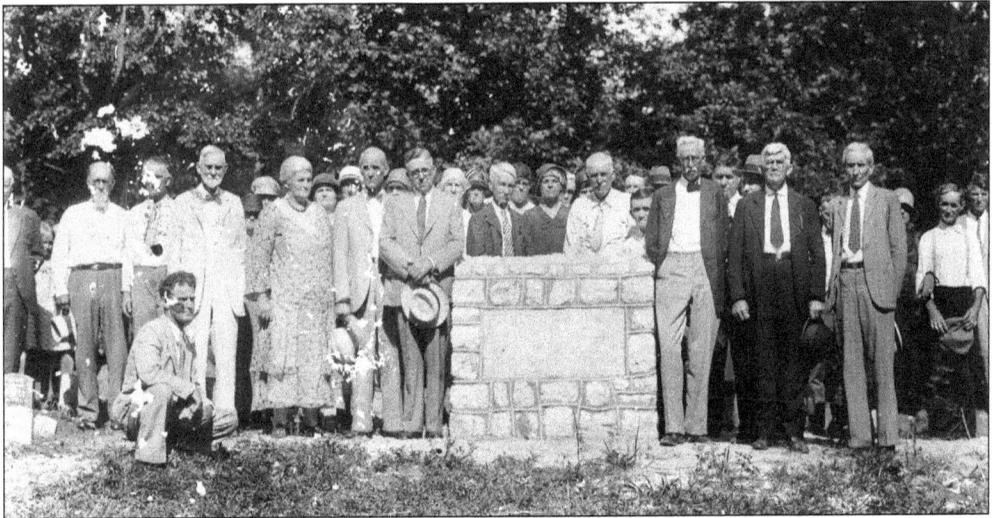

**E.P. DIXON.** Spring Meeting erected a memorial in 1978 for longtime member and respected local educator E.P. Dixon. The following is inscribed on the memorial: "Ernest P. Dixon / 1879–1953 / A Master Teacher / Father of / Eli Whitney Schools / Educator Historian Civic Leader, Farmer, / Teacher in the public schools of / North Carolina for 32 years 22 years / in this community, he motivated his / students and the community, his home / place stands 2 miles northwest." In this picture, taken at Cane Creek Meeting's cemetery, Dixon is kneeling by the stone marker. (Cane Creek Friends Meeting.)

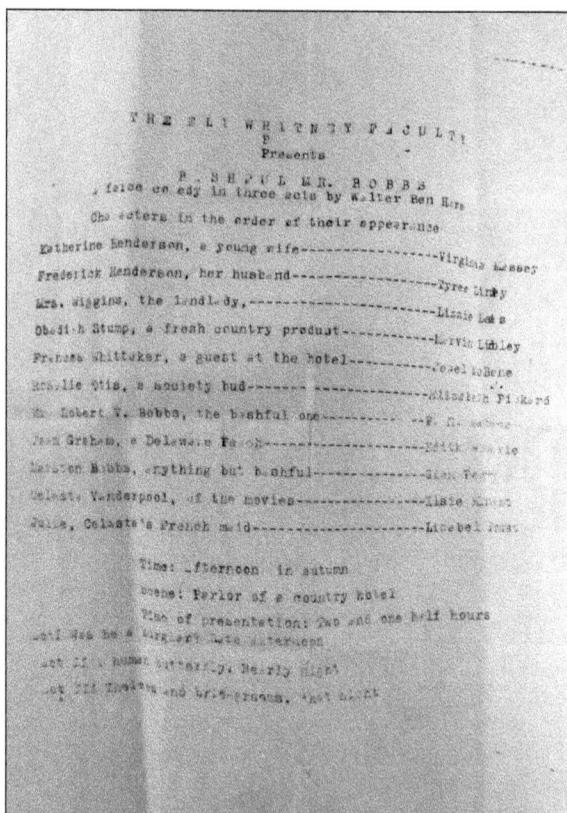

**PLAY AT ELI WHITNEY SCHOOL.** This handout is for a play presented by the faculty of the Eli Whitney School. The production was entitled *Bashful Mr. Bobbs*, written by Walter Ben Hare. Glenn Perry is listed as one of the actors. (Charles and Laurie Newlin.)

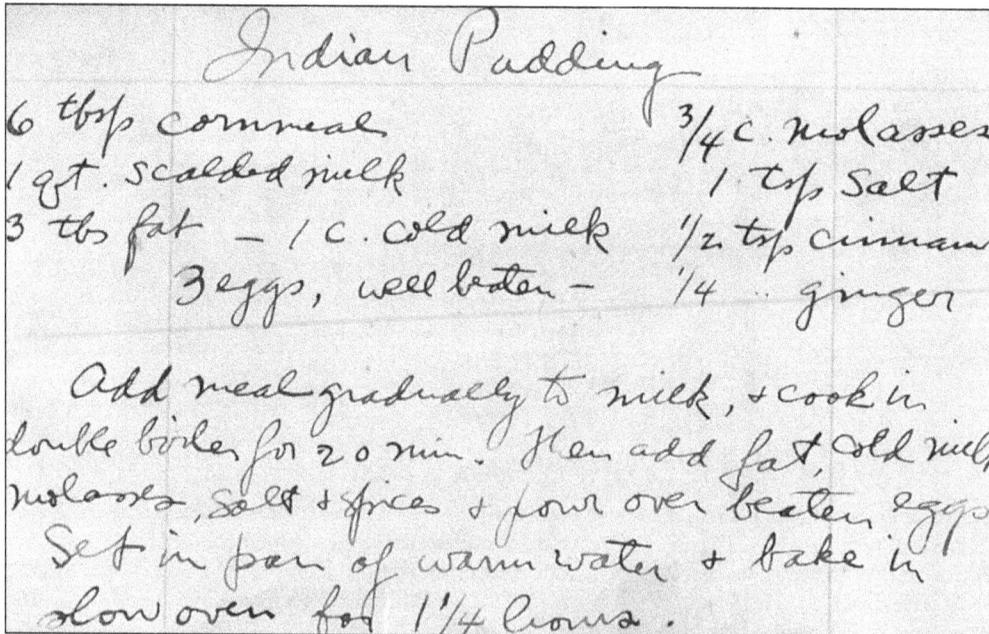

**RACHEL BRAXTON ANDREW.** Here is a recipe for Indian pudding. Rachel attended a recipe club for years, and the members put together recipe books. She was a member of Spring Meeting for most of her life. (Charles and Laurie Newlin.)

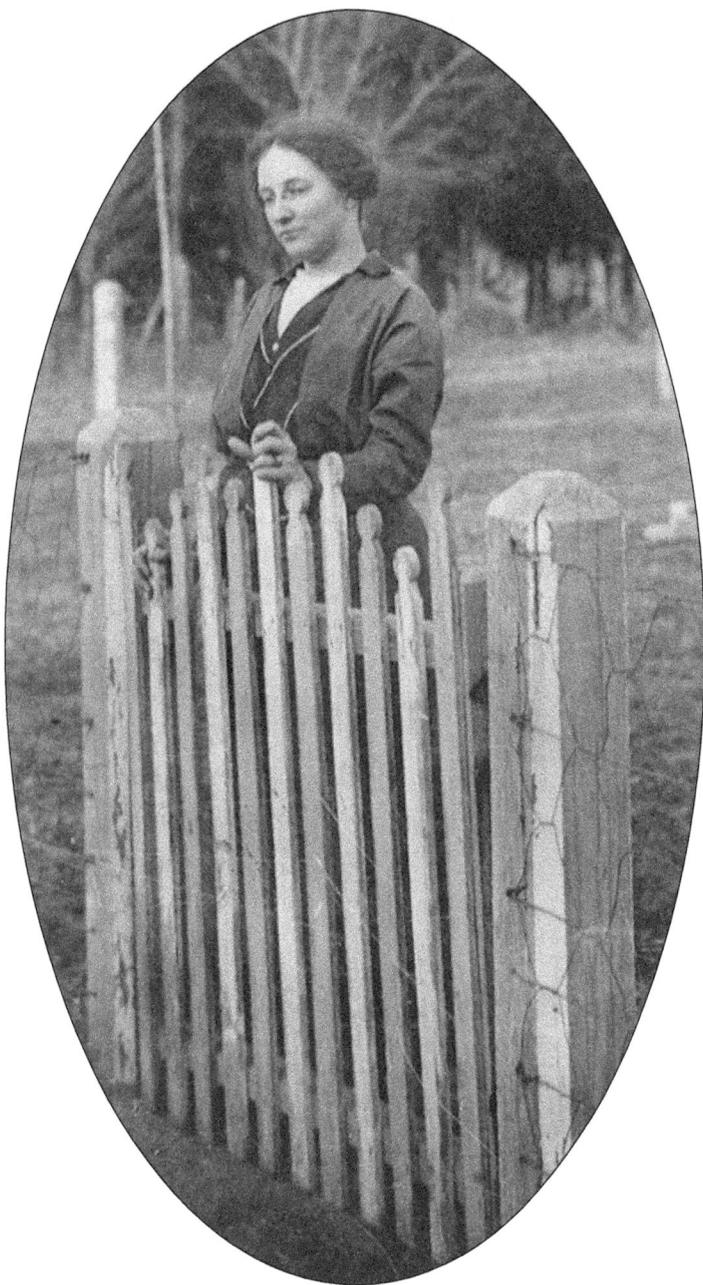

UNCLE ELI'S QUILTING PARTY. Not only was Dixon an educator but he also initiated in 1931 what is now called Uncle Eli's Quilting Party. The gathering of local quilters was begun by principal E.P. Dixon, who invited ladies to quilt in the newly constructed room of the new school complex in 1931. Seventeen quilts were worked on that day, and the ladies displayed their handiwork that evening at the PTA meeting. This local folk custom, now run by Mildred Guthrie, Nanny Lou McBane, and Elizabeth "Pat" Shaw Bailey, has been continued since the first Thursday in April 1931 on the grounds of the old Eli Whitney School, named after the famed cotton gin inventor. In the 1993 Spring minutes, Beulah Andrews McBane (pictured) was memorialized as a quilter. She taught music at Eli Whitney and attended the quilters party. (Cane Creek Friends Meeting.)

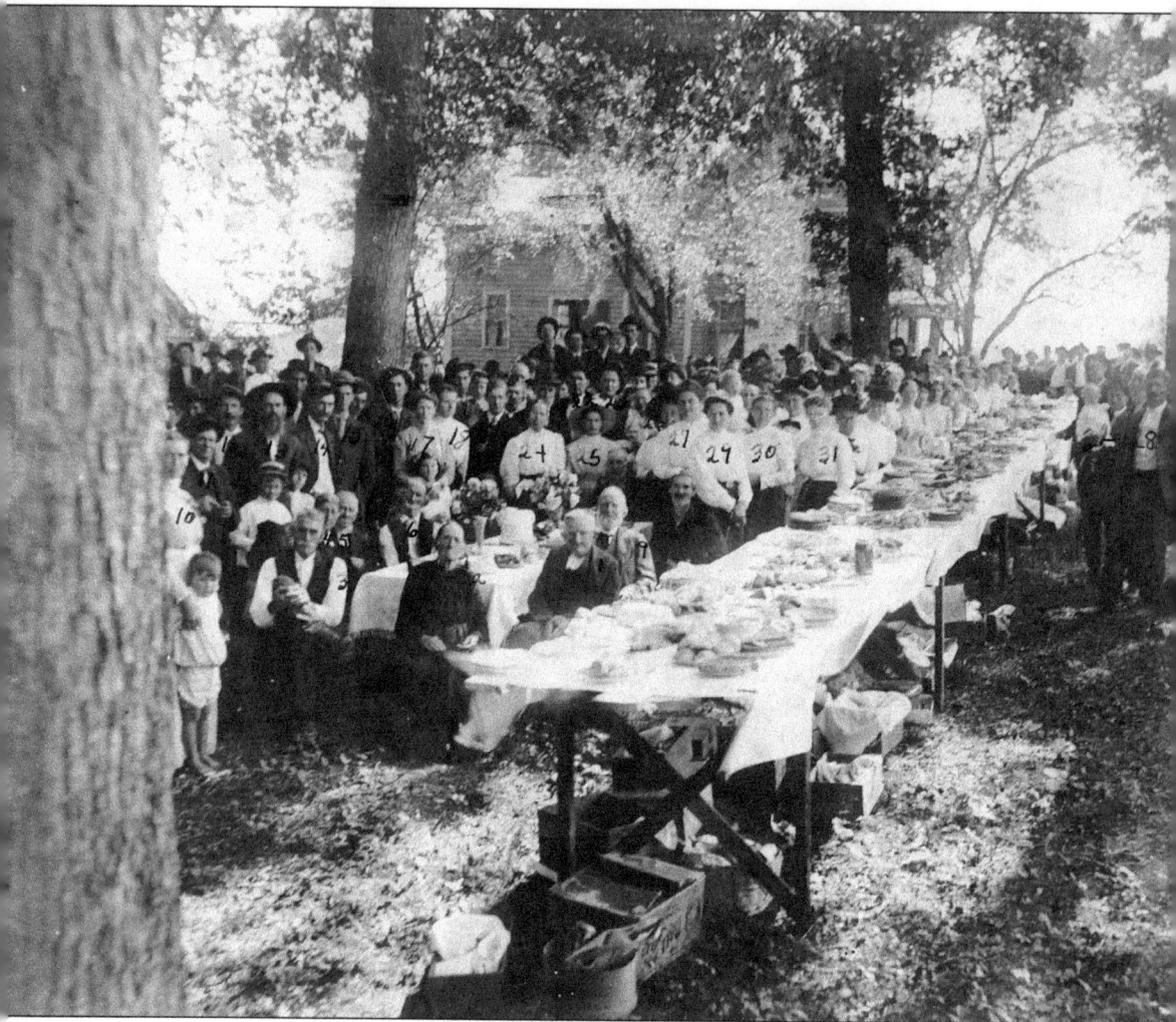

**WILLIAM HADLEY 82ND BIRTHDAY.** This picture was taken on October 1, 1910. The names of those in attendance read like a who's who of the community and demonstrate the intermarrying of families around Spring Friends Meeting. Hadleys, Zacharys, Andrews, Lindleys, Hollidays, and Braxtons were all part of the Spring membership. Family members representing the Hadleys, Zacharys, Andrews, Lindseys, Harrises, Hollidays, Braxtons, and Perrys attended this gathering. (Dan Perry.)

**WADE AND HAZEL FUQUAY, 1972.**
Hazel's father, Alfred Zachary, may
have been Spring's first minister. In
1911, the meeting recognized Alfred
for his service. He also taught at
nearby Green Hill School and served
at Cane Creek Meeting. Hazel was
known for being wise and generous
yet also thrifty. She attended Guilford
College. Wade graduated from High
Point College (now High Point
University) and taught at nearby Eli
Whitney School, where he also served
as principal. He received the 1978 Man
of the Year award from the Saxapahaw
Exchange Club. He is remembered
as both a great baseball coach and
teacher. He took up farming when he
retired. (Spring Friends Meeting.)

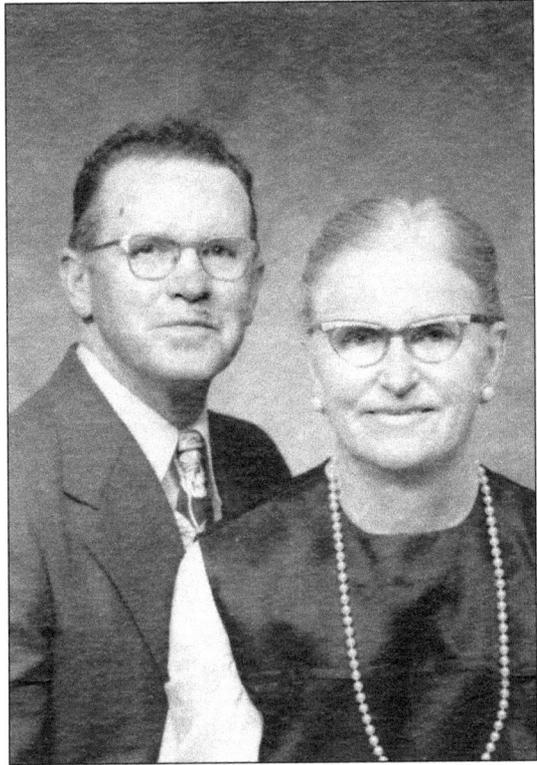

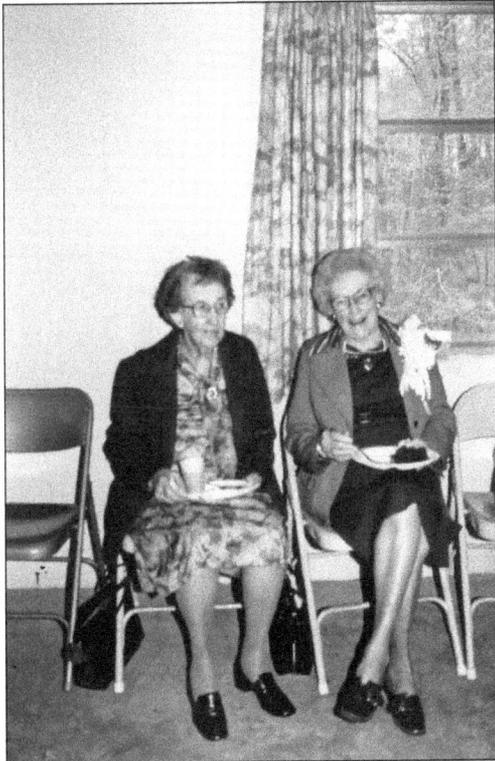

**KIVA MARLETTE (LEFT) AND BEULAH
MCBANE (APRIL 1983).** Kiva was a former
Baptist but became a Quaker after marrying
Lawrence Marlette in 1910. In her service
to Spring Monthly Meeting, she was an
elder and member of the stewardship,
evangelism, and outreach committees,
among other positions. Kiva was also a
pianist who played for worship, Sunday
school, and other events. She is remembered
both as one who read her Bible daily and
for her baked deserts. Aside from being the
longtime pianist at Spring Meeting, Beulah,
Kiva's sister, was an elder and served on
the house and grounds, flower, and music
committees. She also taught music at the Eli
Whitney School. (Spring Friends Meeting.)

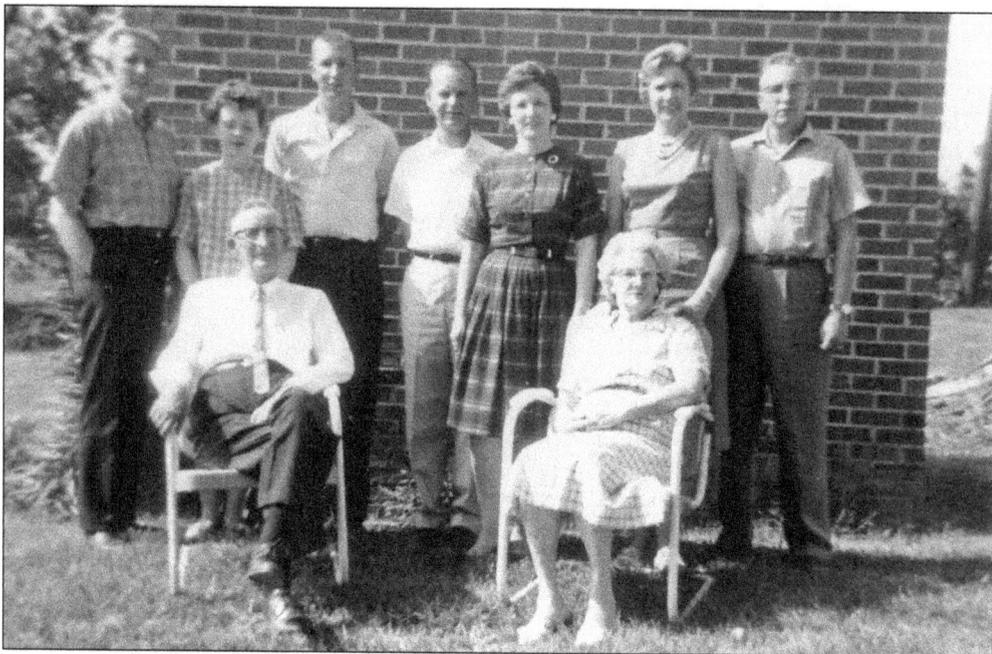

**ROSS AND BEULAH MCBANE FAMILY, 1962.** Those pictured are, from left to right, (seated) Ross and Beulah McBane; (standing) Donald, Shelby, Paul, Bill, Una, Bertha, and Burton McBane. Donald and Burton, along with Willard and Frank Marlette, sang in a quartet led by Beulah. (Paul and Shelby McBane.)

**ROSS AND BEULAH MCBANE, 1955.** This picture of Ross, Beulah, and Steve McBane was taken in front of their farmhouse. (Paul and Shelby McBane.)

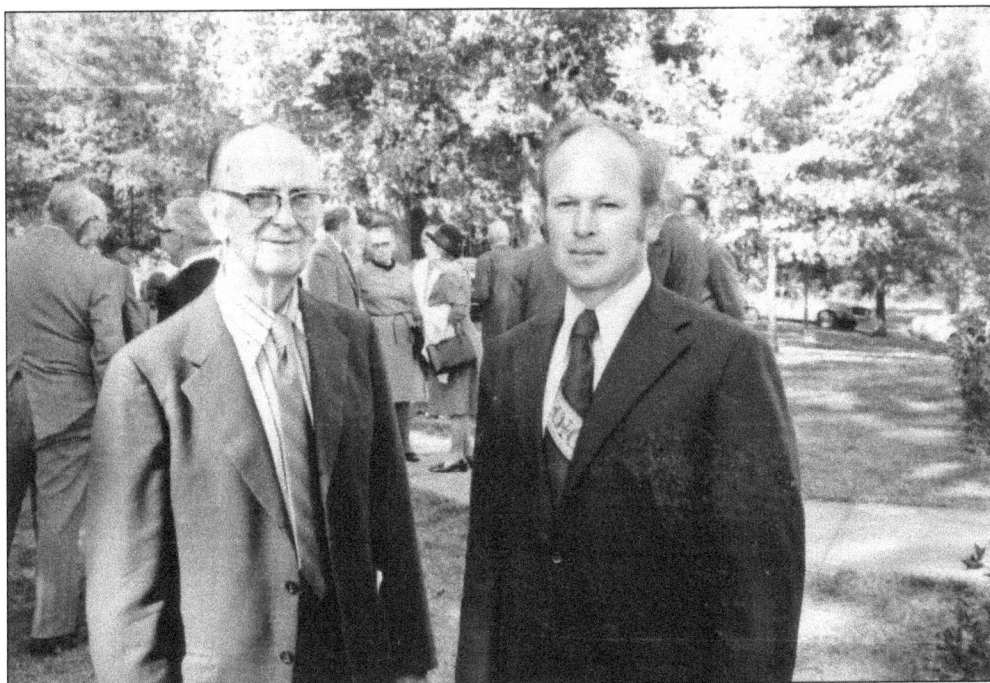

**JOHN BRAXTON WITH ALGIE NEWLIN.**
John Braxton (right) was a member
of Bethel Meeting, but his legacy
remains at Spring. He is a gunsmith and
blacksmith and made the carriages for
the canons at Forts Macon and Fisher
on the coast of North Carolina. He built
the iron rails that replaced the simple
wooden rail on the front steps of the
meetinghouse. Here, Braxton stands with
Algie Newlin at the 1973 anniversary
celebration. A local history buff, Braxton
served on the anniversary celebration
committee. (Spring Friends Collection.)

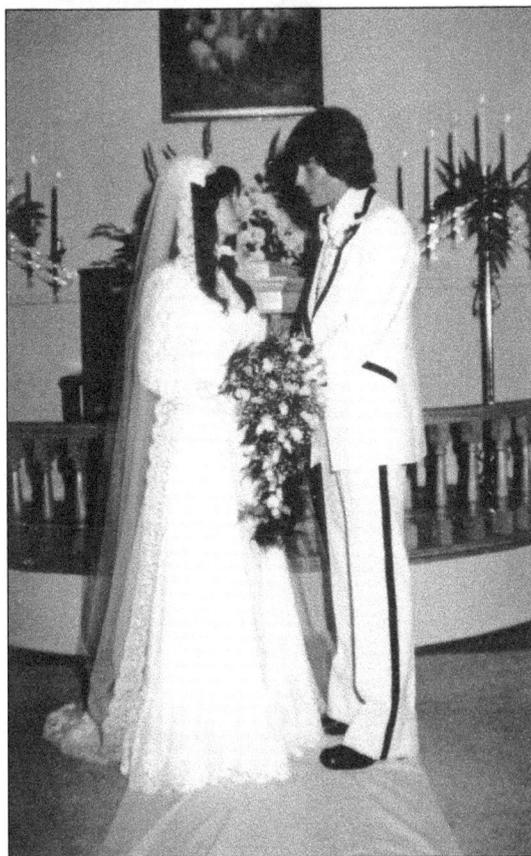

**CATHY McBANE WEDDING.** Dwayne
Marley and Cathy McBane (daughter
of Paul McBane) were wed in Spring
Meetinghouse on June 17, 1978. Cathy
served on the Christian education and
music committees in 1978. Joe Bill
Lindley, whose farm is directly beside
Spring, was combining that day and
left the fields to attend the wedding
and then immediately returned to his
farming. (Cathy and Dwayne Marley.)

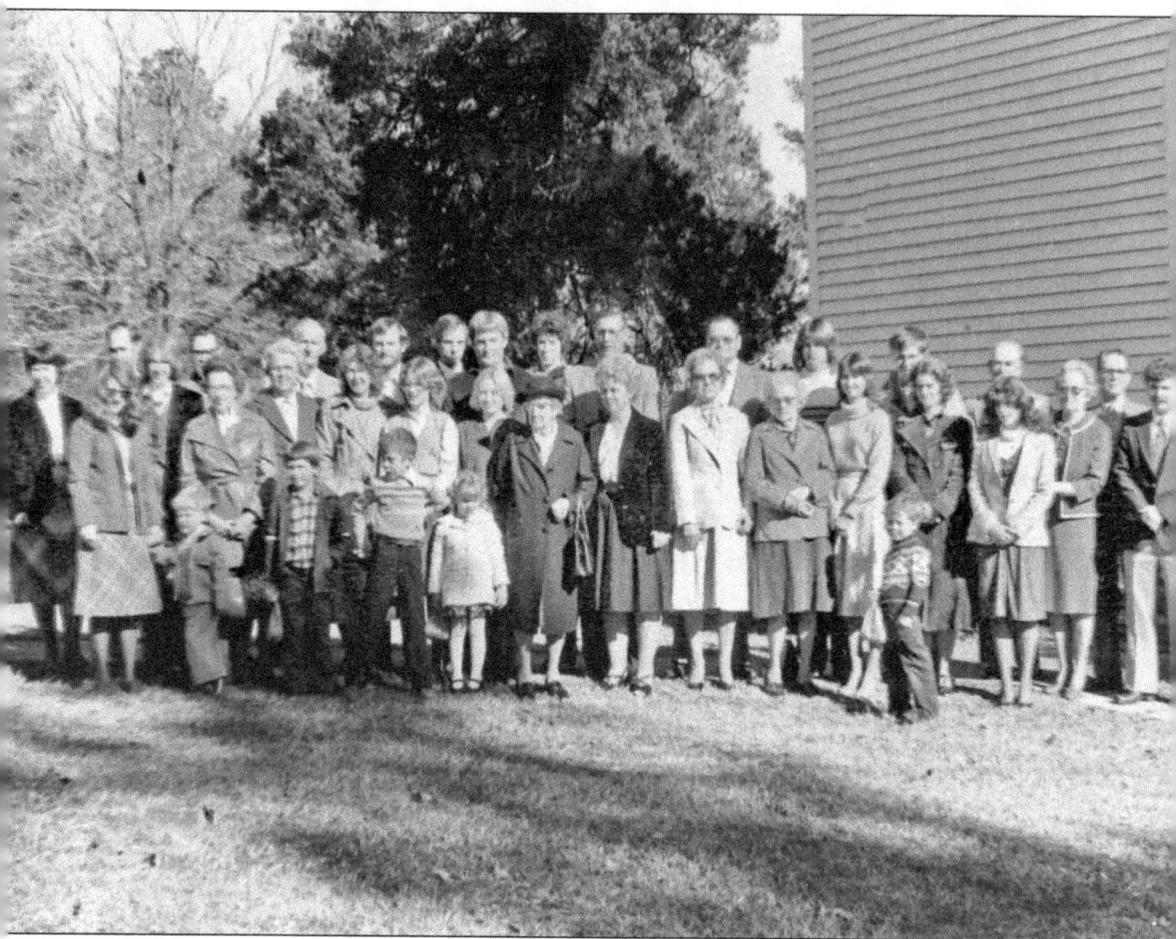

HOMECOMING. The date of this photograph is unknown, but homecomings at Spring were always festive affairs. In olden times, folks came from long distances and stayed overnight. As Spring moved into the modern age, cars allowed members to go home after meals and services. Tables were laid out with the finest of foods, and all enjoyed singing and special services. Friendships were renewed as present and former members reunited and told stories of days gone by. In this picture are, from left to right, (first row) the children of Wade Gowdy, Matthew Perry, Chris McBane, Terry McBane, and John Paul Braxton; and the women Kiva Marlette, Shelby McBane, Zilpha Hargrove, Beulah McBane, Cathy McBane; Wanda Braxton, and Susan Lewis; (second row) Barbara Lewis Gowdy, Margaret Fuquay Lewis, Pat Perry, Katy Perry, Lisa Perry, and Hazel Fuquay (just behind Susan Lewis); (third row) Jane Lindley, Joe Bill Lindley, Mary Joe Lindley, Pen Lewis (glasses), Mary Ruth Perry, Glenn Perry, Pat Perry, Dan Perry (behind Pat), Steve McBane, Mike Perry, Sheryl McBane, Paul McBane (glasses), Hal Hargrove, Joey Hargrove, Chris Braxton, Howard Harris, Wade Fuquay (glasses), and Gary Lewis. (Jane Lindley.)

**FOLKS AT SPRING.** This is a random photograph of Spring members. Those pictured are, from left to right, (first row) Jean Hargrove, Zilpha Hargrove, Jane Andrew Lindley, Howard Harris, Rachel Andrew, Shelby McBane, and unidentified; (second row) Hal Hargrove, Janet Zachary, George Zachary, Pat Perry, Joe Bill Lindley, Matthew Perry, Howard Andrews, Dan Perry, unidentified, John Braxton, Judy Braxton, and Paul McBane. (Jane Lindley.)

**JOHN ANDREW.** John Andrew, pictured here with sisters Beulah Andrew McBane (right) and Kiva Andrew Marlette, was not a member of Spring Meeting. He attended Bethel Presbyterian Church in Graham and worked at Guy Berker's Tire Service. (Joe Bill and Jane Lindley.)

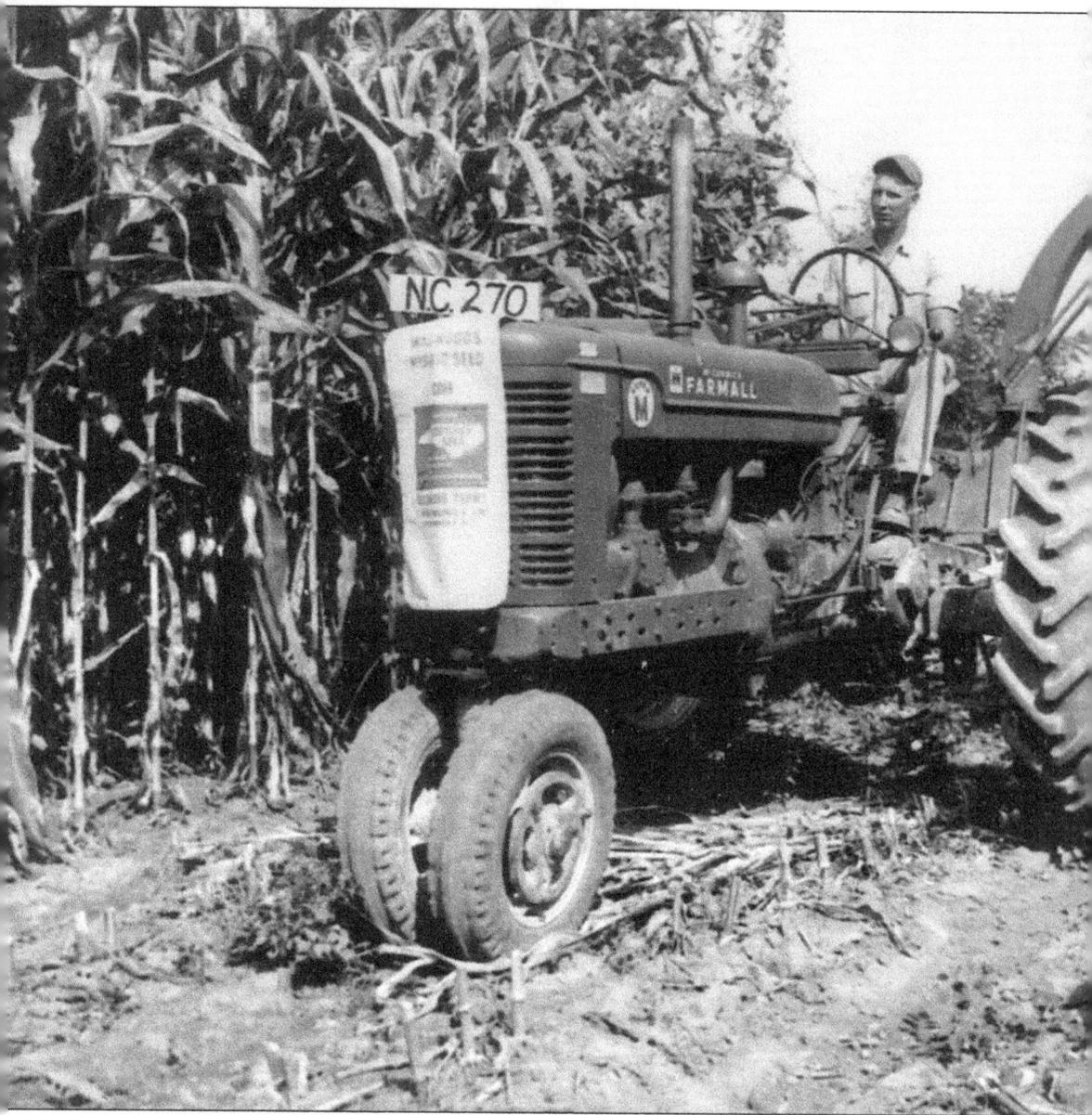

**PAUL MCBANE, 1962.** Paul McBane is a fixture in the life of Spring Meeting, where he has served on various committees. He and his family still run McBane Farms. (Cathy and Dwayne Marley.)

# *Three*

# SPRING FRIENDS MINISTERS

The notion of a pastoral system in Quaker history is difficult to address. Friends believe in the priesthood of all believers, thus any member can speak during the meeting. Still, the Philadelphia Yearly Meeting recognized that some aspects of ministry, such as visitation, were being neglected. Along with this, the spoken word was not as strong as it had been in the past years. Thus, they saw the need for pastoral leadership in the meetings. Still, not all Friends accepted the new ministry, and this led to divisions in the monthly and yearly meetings.

The pastoral ministry began at Spring Meeting around 1906. Spring could not afford a full-time minister, so it often shared a minister with the local meetings, usually Cane Creek, Chatham, Graham, and Rocky River. In the beginnings of pastoral ministry, many meetings recognized the gifts of a member, and these were recorded in the minutes. Alfred Zachary may have been Spring's first minister, beginning as early as 1905.

In the early years, ministers rode wagons to the meetings. John Permar served Spring in 1918, and he went to the meeting in a horse and buggy. Spring bought him a car. Both men and women served Spring; Cora Lee Norman (later Cora Lee Norman Johnson) was the first female pastor at Spring Friends Meeting. The pastoral ministry at Spring ended in 2001 with Richard Briggs.

**Cora Lee Norman Johnson.** Known as Cora Lee, Norman served Spring from 1921 to 1931. She was paid $100 a year for her services. Although she only preached on the fourth Sunday, she attended services regularly throughout the month. She also served Cane Creek Meeting from 1929 to 1932. (Cane Creek Friends Meeting.)

**J. Waldo Woody.** After the Civil War, North Carolina Friends, with assistance from the Baltimore Association, led the way for educating freed blacks. Schools near South Fork and Rocky River were established. It is not clear if Spring Meeting was involved in this process, but J. Waldo Woody of Spring led normal schools for black teachers in Greensboro from 1885 to 1888. Between 1899 and 1908, he was the business manage at Slater Industrial and Normal School in Winston-Salem (now Winston-Salem State University). It is not clear how long he served between Cora Lee Norman and Lewis McFarland. (Cane Creek Friends Meeting.)

LEWIS MCFARLAND. Lewis McFarland attended and later taught at Sylvan School, near Cane Creek. He served Spring Meeting from 1931 to 1936 as well as Cane Creek from 1932 to 1936. He was the superintendent of the Yearly Meeting Evangelistic Committee for many years and served as vice president of the new Young Friends Association of North Carolina Yearly Meeting. During his tenure, the attendance at Spring grew. McFarland invited Leila Sills Garner and York Teague to hold a revival in 1934. The minutes of August 1934 note, "Several were converted and reclaimed." The meeting showed its appreciation for McFarland by raising his salary to $125 a year. His wife, Pearl (pictured here with him), taught at Sylvan School. (Cane Creek Friends Meeting.)

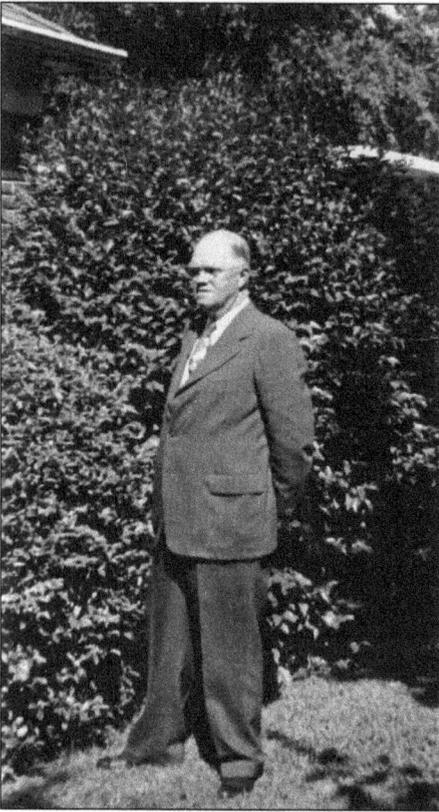

**VIRGIL PIKE.** Virgil taught at Sylvan School in 1926–1927. He served Spring in 1937, when he also was at Rocky River and South Fork Meetings. He resigned suddenly in 1938 and was replaced by Victor Murchison. (Cane Creek Friends Meeting.)

**VICTOR MURCHISON.** Victor Murchison was pastor of the Winston-Salem Meeting for 22 years, and he stayed at Spring from 1938 to 1943. He was taught at Sylvan School. Cane Creek Meeting started Sylvan School at the Grove in 1866 after the Civil War with funds from the Baltimore Association. Allen J. Tomlinson, who was from High Point, opened the new school. It quickly grew to be one of the largest schools in North Carolina. Pictured in this Ralph Johnson photograph are, from left to right, (first row) Victor Murchison, Alta Stephens, Marvin Moon, Maxine Stuart, J.B. Roach, Bronna ? Wells, and Edith Kimrey; (second row) Irvin Workman, Kathryn Dixon, Christine Coble, Frances Crutchfield, and Finley Coble; (third row) Norman Carter, Charlotte Holman, Paul Culberson, and Bynam Sharpe; (fourth row) Lohr Dixon, Josie Murchison, and Lorina Stephens. (Cane Creek Friends Meeting.)

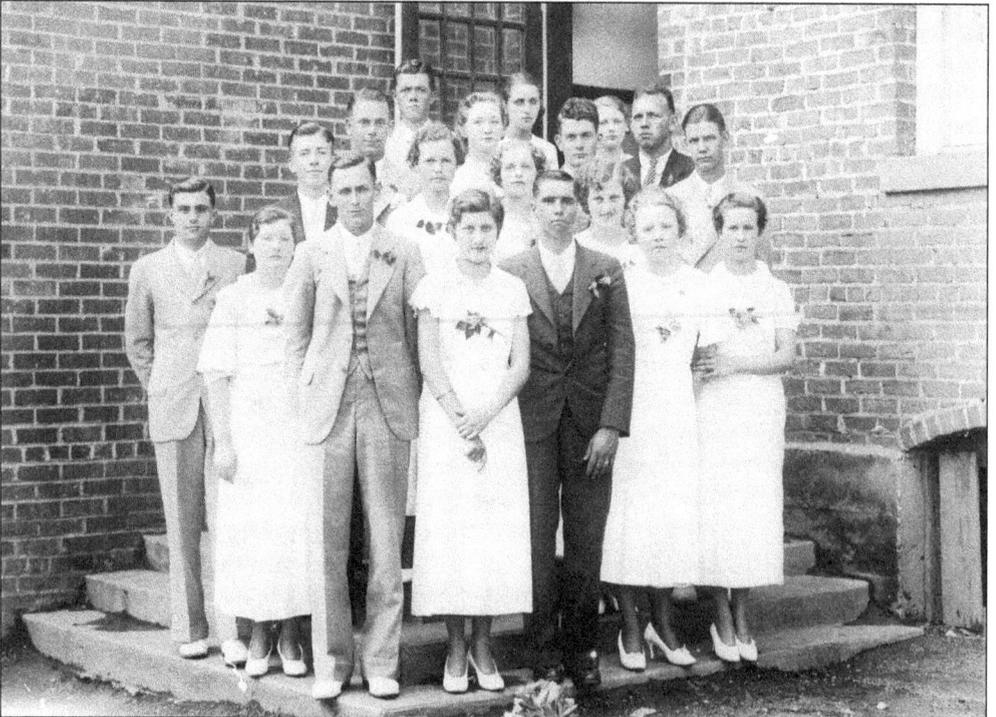

**ALLIE KEMP.** After Victor Murchison left Spring in 1943, he was replaced by Allie Kemp, who came from Bethel Meeting in Southern Quarter. Kemp served Spring from 1943 to 1944. Theodore "Ted" Perkins succeeded him in 1944 at a salary of $165 a year. During Perkins's time, membership fell from 77 to 51 in 1945, but this may have been because of differences between patriotic members and those with pacifist stances. (Cane Creek Friends Meeting.)

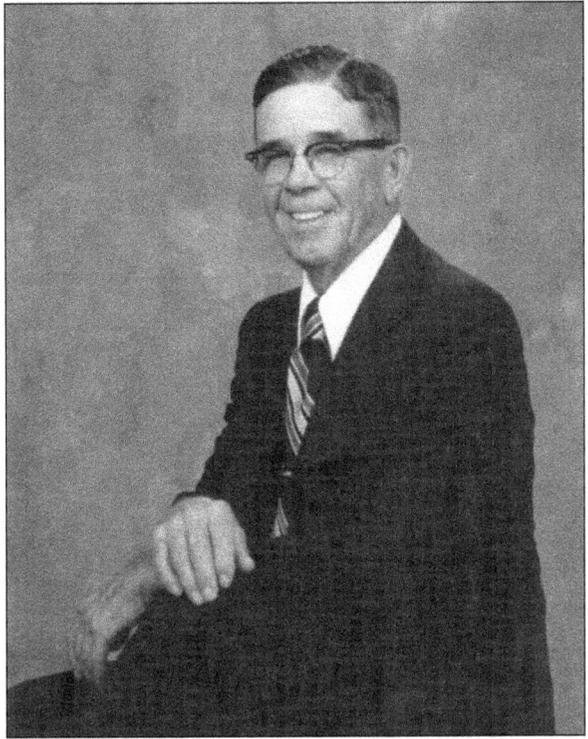

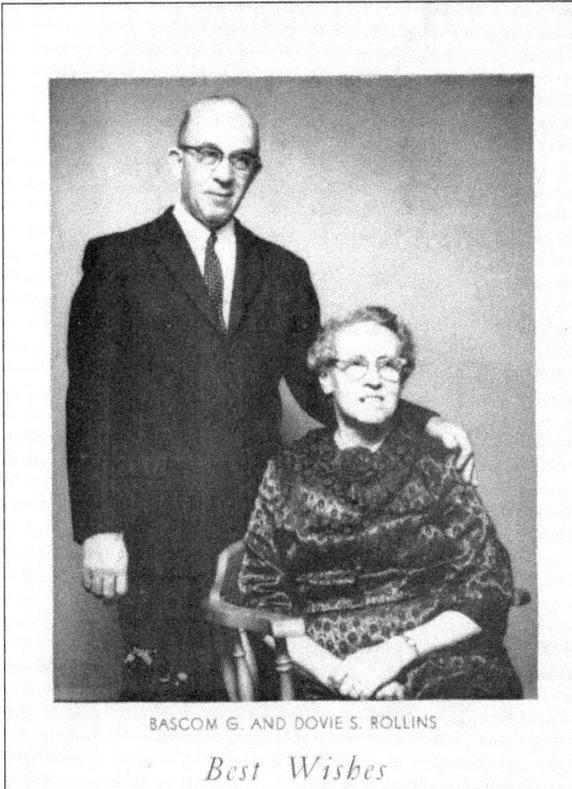

BASCOM G. AND DOVIE S. ROLLINS

*Best Wishes*

**BASCOM ROLLINS.** Rollins was not a minister at Spring, but he led revival services there in November 1946. He was a minister at Cane Creek from 1949 to 1956. (Cane Creek Friends Meeting.)

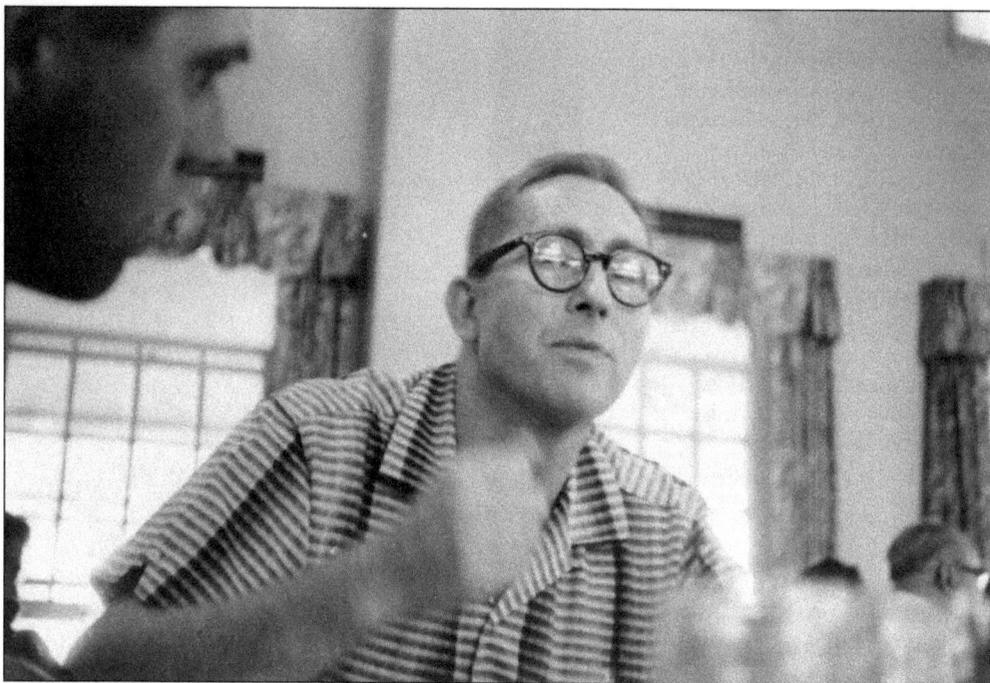

**J. FLOYD MOORE.** Moore served Spring Meeting from 1951 to 1952. A longtime figure in North Carolina Quakers, he was chair of the committee for the Fourth Friends World Conference held at Guilford College in August 1967. About 900 delegates and 400 Friends attended the gathering. (Friends Historical Collection, Guilford College, Greensboro, North Carolina.)

**MOORE LETTER TO SPRING.** Pastor Moore sent a newsletter to Spring members each month before he came to preach. In the February 22, 1951, newsletter he calls on the members to fight against the Congressional move to require universal military peacetime training. The newsletter states, "Now is the time to oppose it! It is one of the greatest of all threats to religious freedom." (Spring Friends Collection.)

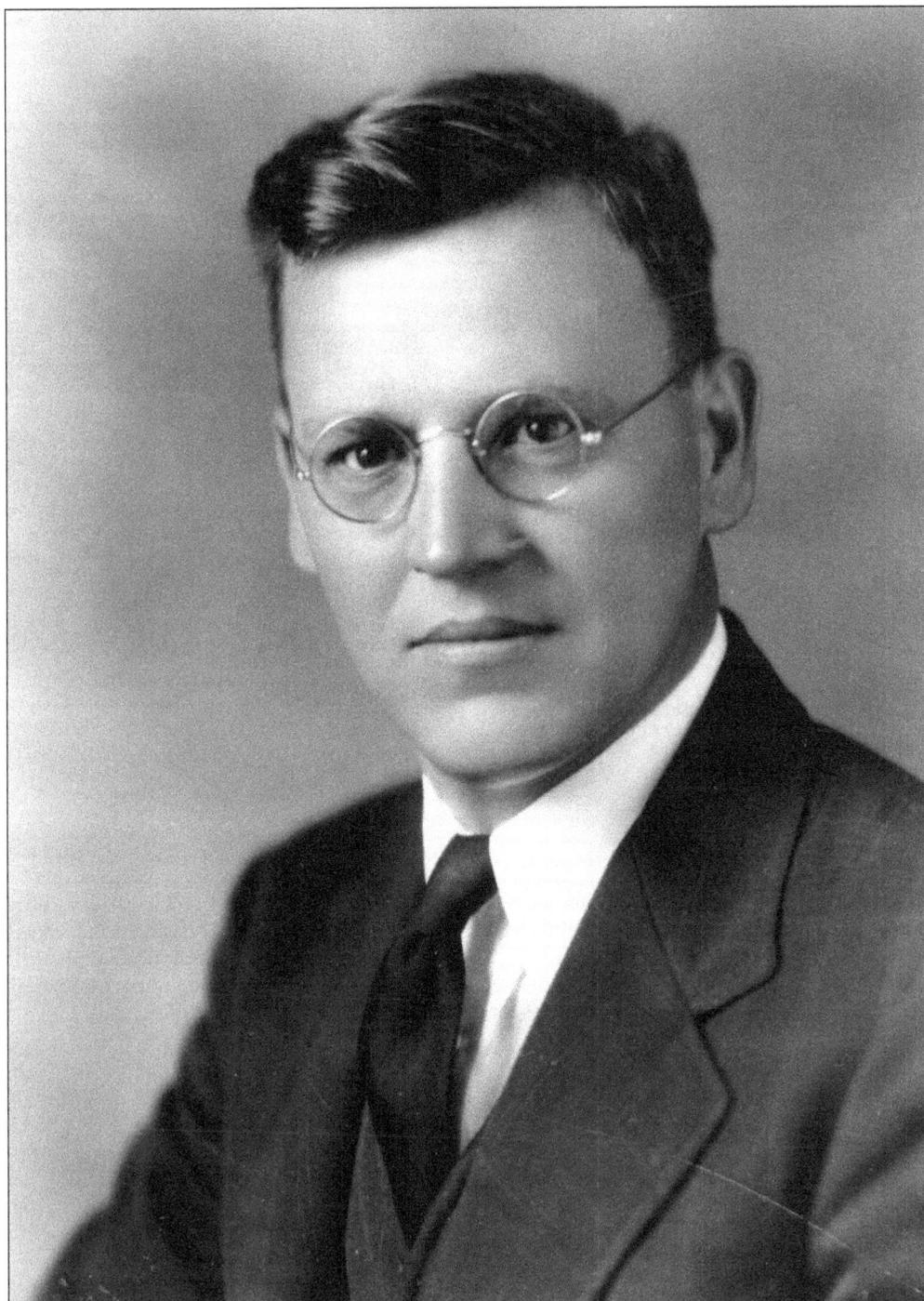

**NORMAN OSBORNE.** Norman Osborne served as pastor of Spring from 1957 until 1961, when Virgil Pike, who was also pastor at Chatham Monthly Meeting, took over as minister at Spring. Pike died in 1962, and Larry McIntire, who was also pastor at Plainfield Friends Meeting, filled the pulpit. McIntire had to leave suddenly for health reasons in 1963, and for a while, Spring had no minister. (Friends Historical Collection, Guilford College, Greensboro, North Carolina.)

SPRING FRIENDS MEETING
Sunday, June 11, 1967
Elbert Newlin, Minister

11:00 A. M.   THE MEETING FOR WORSHIP

I was glad when they said unto me, Let
us go into the house of the Lord.
                              Psalm 122:1

TODAY, the Minister's Subject is
              "CHILDREN."
The Text: And Jesus called a little
child unto him, and set him in the
midst of them. Matthew 18:2

Next Sunday, June 18th
10:00 A. M. Sunday School
11:00 A. M. Monthly Meeting

Sunday, May 28th, we had 24 in Sunday
School and 31 in the Meeting for Worship.

This Bulletin is supplied by the Yearly
Meeting, and the mimeograph work was done
by Elbert Newlin.

Are all meetings for worship and for
business duly held and are you regular
and punctual in attending them?
                    From Query 2

The Newlins are grateful to Spring for all
its helpfulness, its kindness, its
co-operation and its prayers. We hope as the
weeks and months come and go, the work
here will move forward in the Master's
Name.

The Newlin's are to be your Minister for
another Church Year, and the copy below
is due to be presented to the Monthly
Meeting.

May 22, 1967, in a telephone conversation
with Mary Ruth Perry, we received a "CALL"
to be your Pastor another Church Year,
July 1, 1967 thru June 30, 1968. We
accepted the Call, and are grateful to
you and our Lord for this Call.

As we understand the Call, we are to be
at Spring each Second and Fourth Sundays,
and bring a message during the Meeting
for Worship. The Salary to be $25.00
per trip.

Then at least once a month, we are to be
a guest in your home, for a meal, and
a visit.

Also, we hope Spring Friends will
continue to understand, that Extra
Visits, will have to be limited, because
of Doctor's Orders, and the expense
involved.

We hope and pray that the coming Church
Year, will be a helpful one for Spring
and for our Lord.
          -------?------------
Continue to let us know about the sick,
Etc. We can Pray for them,

---

**BULLETIN.** This Sunday bulletin outlines the details of the call extended to Elbert Newlin by Spring Meeting. Here, Newlin outlines the agreements of his service: he will preach on the second and fourth Sundays, he will eat and visit with a Spring family at least once a month, and he will receive $25 for each trip. He also reminds them extra visits will be limited due to doctor's orders and that there will be additional expenses for extra visits. (Spring Friends Collection.)

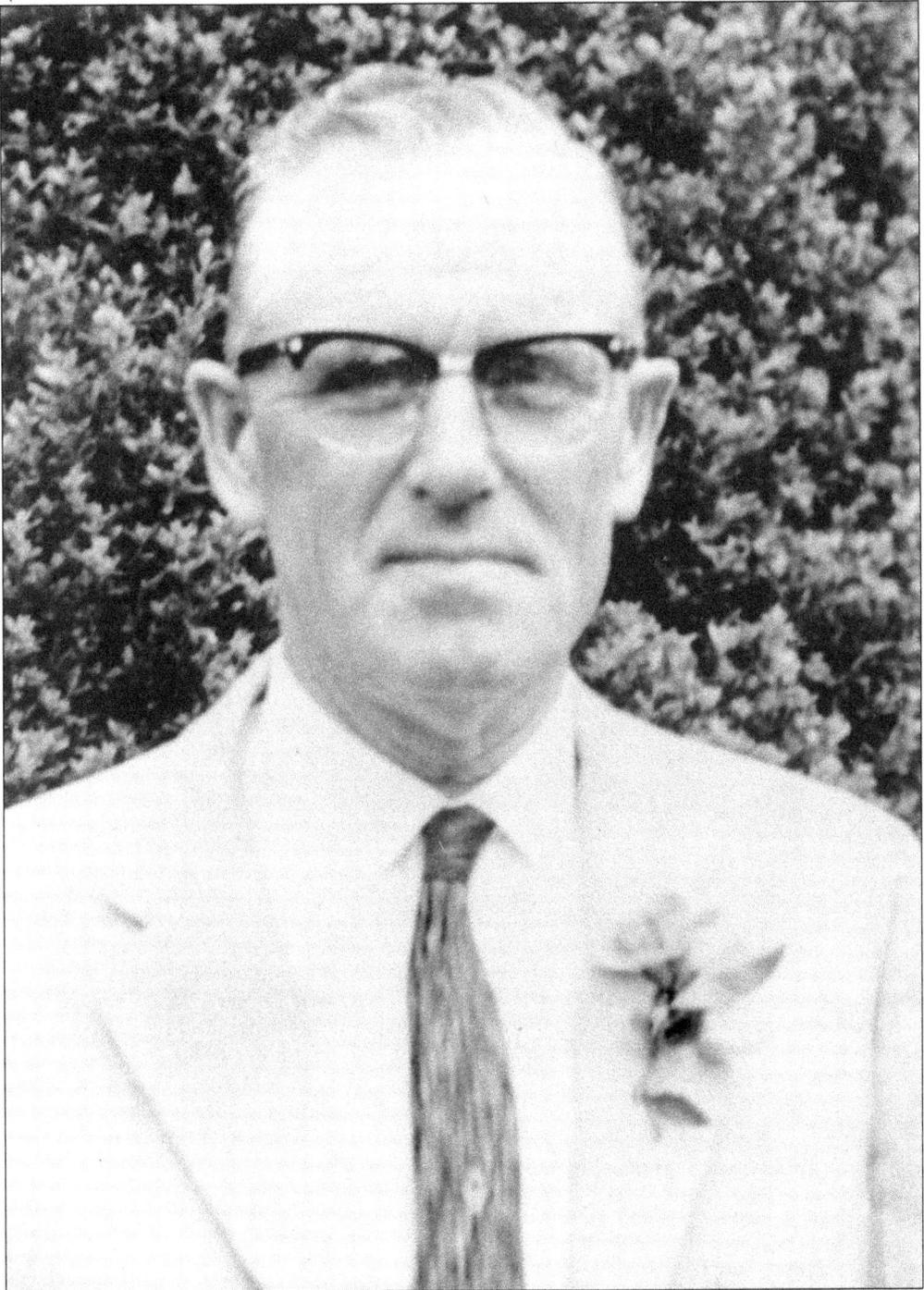

**YORK TEAGUE.** Was an evangelist and led services at Spring in 1934. He was accompanied by evangelist Leila Sills Garner and Lewis McFarland. Many were saved and some reclaimed by the meeting. Garner came back for a revival in 1940 and was pounded (given food by the members) by the meeting and given $50. Members recall that she stomped her foot when preaching. She was invited back in 1947 and received $108 for her services. (Cane Creek Friends Meeting.)

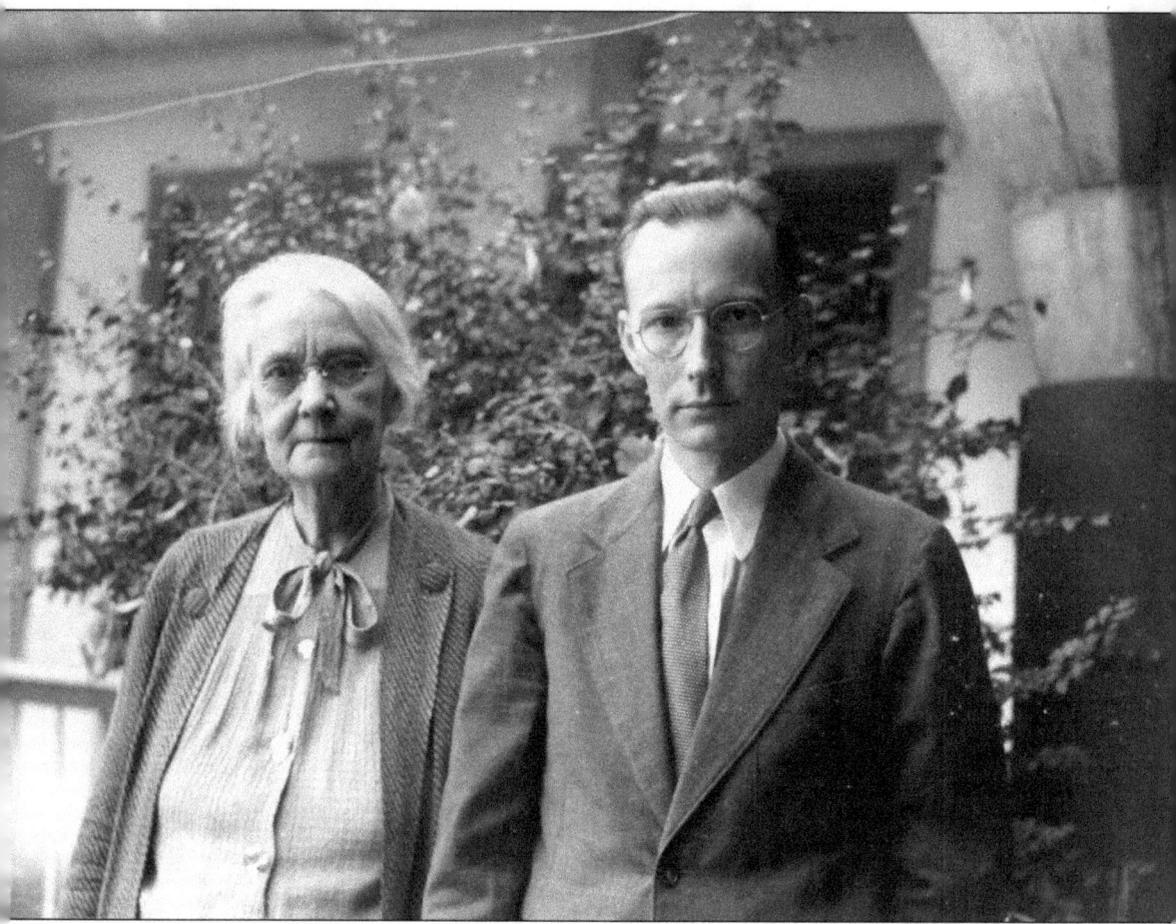

**ELLEN WOODY PAIN AND ARTHUR PAIN.** After the Spanish-American War, North Carolina Quakers focused on missions in several places in Cuba. Spring members Ellen and Martha Woody were missionaries in Cuba in the early 1900s. Ellen Woody and J.B. Wood visited Francisca Cala in Havana in 1899 and then returned to serve as missionaries in 1900 in Aguacate, Havana Province. Ellen, along with Arthur Dowe, was an evangelist and preached in tent revivals, visited jails, and performed other aspects of ministry from 1900 to 1907. Ellen and her sister Martha broke local cultural taboos when they boarded in a home along with Arthur Dowe and J.B. Wood. Zenas Martin, who led the missionary efforts in Cuba, looked into the matter and eventually sent the two men back to the United States. In 1907, Ellen requested funds from Spring to initiate a new meeting in Madruga, Cuba. In 1901, Spring Meeting sent a donation of $10 to missionary Mattie Woody, and in 1914, $14.50 was sent for missionary support. (Friends Historical Collection, Guilford College, Greensboro, North Carolina.)

*Four*

# THE 200-YEAR CELEBRATION

In 1970, Wade Fuquay, Orvil Dillon, Jane Lindley, Mary Ruth Perry, Mildred Marlette, and John and Judy Braxton began planning the 200th anniversary of Spring Meeting. By 1972, the plans were submitted to the meeting. The minutes of July 1972 note, "An exhibit of small items, pictures, maps would be held on Saturday and Sunday in the Hut, a worship service at 11:00 a.m. on Sunday and Sunday afternoon devoted primarily to the history of our meeting and community."

The Alamance County Historical Association added to the celebration when it installed a roadside marker commemorating Spring Friends Meetings.

Seth and Mary Edith Hinshaw collected historical items for the anniversary. Bertha Lindley Walker composed historical information from 1900 to 1973, and Hazel Fuquay gathered pictures. At the request of the meeting, Algie Newlin, a member of Spring from his birth who taught history at nearby Guilford College, began writing a history of Spring, which was eventually published in 1984. A donation of $2,000 by Edgar McBane defrayed the cost of publication.

The 200th anniversary was filled with celebration and memories. On Saturday, October 13, at 2:00 p.m. the first service was begun. After singing "The Church's One Foundation," Edward F. Burrows, a professor of history at Guilford College, delivered a brief presentation. The unveiling of the historical marker followed after singing "Dear Lord and Father of Mankind." All enjoyed exhibits in the Hut, and many celebrants toured the cemetery as well.

On Sunday, the celebration continued with a worship service led by Orvil Dillon, followed by dinner on the grounds at 12:30 p.m. Wade Fuquay presided over the afternoon meeting, where the recognition of visiting Friends was followed with the reading of the history of Spring School by Mary Ruth Perry. Dr. Algie Newlin and Seth B. Hinshaw, pastor of Rocky River Meeting, both presented a history of Spring Friends Meeting.

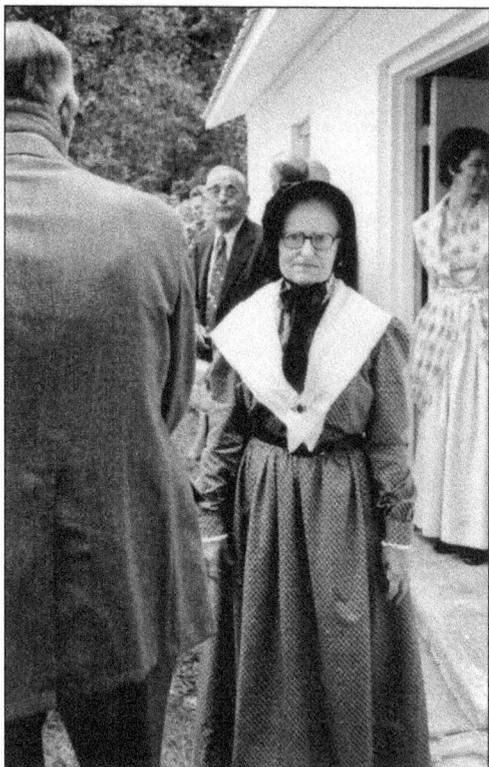

IN COSTUME. Hazel Zachary Fuquay is seen in costume at the 1973 anniversary at the entrance to the Hut. She was the youngest of 11 children of Alfred and Ila Guthrie. Hazel served on literature, missions, and house and grounds committees and was an elder. She is the wife of Wade Fuquay, who taught Sunday school for many years. (Spring Friends Collection.)

HISTORICAL MARKER, 1973. The unveiling of the historical marker is shown here. In this picture, Mike Perry stands on the left. The identities of the Girl Scouts are unknown, but Spring Meeting did sponsor a local Girl Scout troop. (Spring Friends Collection.)

ALGIE NEWLIN SPEAKING, 1973. Dr. Algie Newlin was a long-revered member of Spring Friends Meeting. He studied at Guilford College and went on to earn his doctorate at the University of Geneva in Switzerland. Among his accomplishments were several publications as well as being codirector of the Friends International Center in Geneva and serving the North Carolina Yearly Meeting. (Spring Friends Collection.)

SETH HINSHAW SPEAKING, 1973. Seth Hinshaw comes from a long line of Quakers. Trained at Duke University, he has served the North Carolina Yearly Meeting in many capacities. His book *The North Carolina Quaker Experience* is a respected reference work on North Carolina Quakers. Behind him is the pulpit pew. To his left is Mildred Marlette. There is a funeral fan in the book rack of the pew in the foreground. (Spring Friends Collection.)

**MILDRED MARLETTE SPEAKING, 1973.** Mildred earned an AB from Guilford College and an MA from the University of North Carolina at Chapel Hill. She was hired in 1948 as dean of women and assistant professor of English at Guilford. Mildred attended Spring Meeting regularly. In the picture above, she is on the right. Below, she addresses the anniversary meeting. The Sunday school room doors can be seen clearly to her left and right. (Spring Friends Collection.)

**CHILDREN IN PERIOD COSTUME, 1973.** Those pictured are Sarah Lindley (left), Mary Joe Lindley (center), and Katrina Braxton. (Spring Friends Collection.)

**DAN MCBANE AND ALGIE NEWLIN, 1973.** Dan McBane (left) was a member of Chatham Monthly Meeting who attended the celebration. (Spring Friends Collection.)

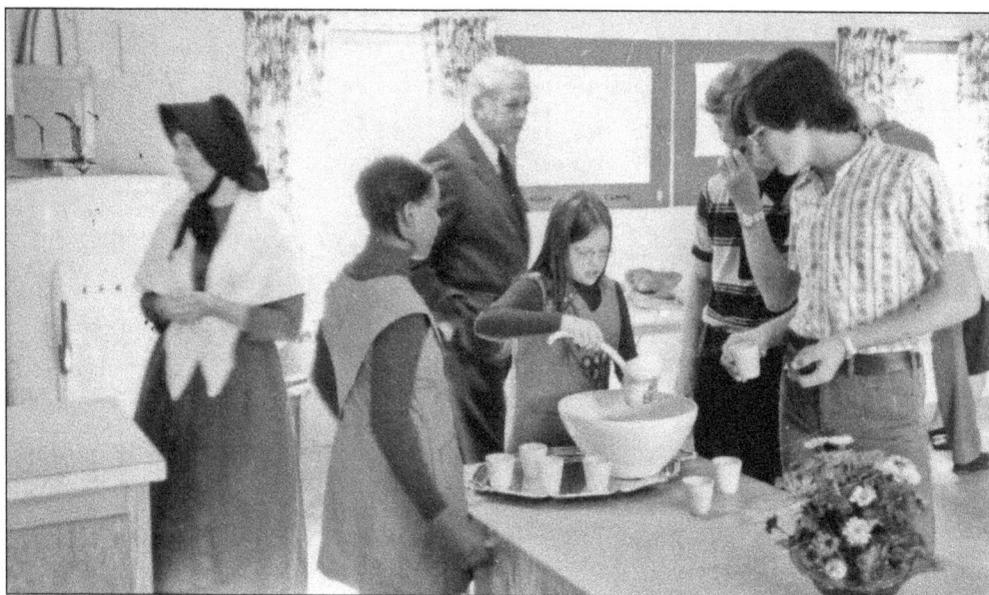

TWO GIRL SCOUTS. The names of these Girl Scouts are unknown. They are serving punch in the Hut for the anniversary celebration. Jane Lindley is to the left. Spring Meeting supported the Girl Scouts and the Brownies, and the troops met in the Hut. Janet Ursary worked with the Girl Scouts, and Jane Lindley assisted her and led the Brownies as well. In the 1974 minutes, it is noted that the meeting donated $10 to the Girl Scout troop. Others in the picture are unidentified. (Spring Friends Collection.)

FARM IMPLEMENTS, 1973. The anniversary celebration included the display of a flax wheel and tools used in the past by Spring members. Here, an unidentified person sits in front of a flax wheel and various farm implements. (Spring Friends Collection.)

FOLGER "FOE" ZACHARY. Pictured in 1973 are Foe and his wife, Lizzie. Foe went to Guilford College and graduated in 1911. He taught at Green Hill School, which was near Spring Meeting. In 1902, the one-room school was the host to 40 students. Several Quakers taught at the school, which offered high school–level courses that were sufficient to admit the students into Guilford College. Foe also served as clerk of the monthly meeting. (Spring Friends Collection.)

ENSIGN FAMILY, 1973. In this photograph, Peter Ensign and Joy Ensign (to the right of Peter), holding their twin girls, are behind the Sunday school rooms at the back of the meetinghouse. The names of the others in the picture are unknown. (Spring Friends Collection.)

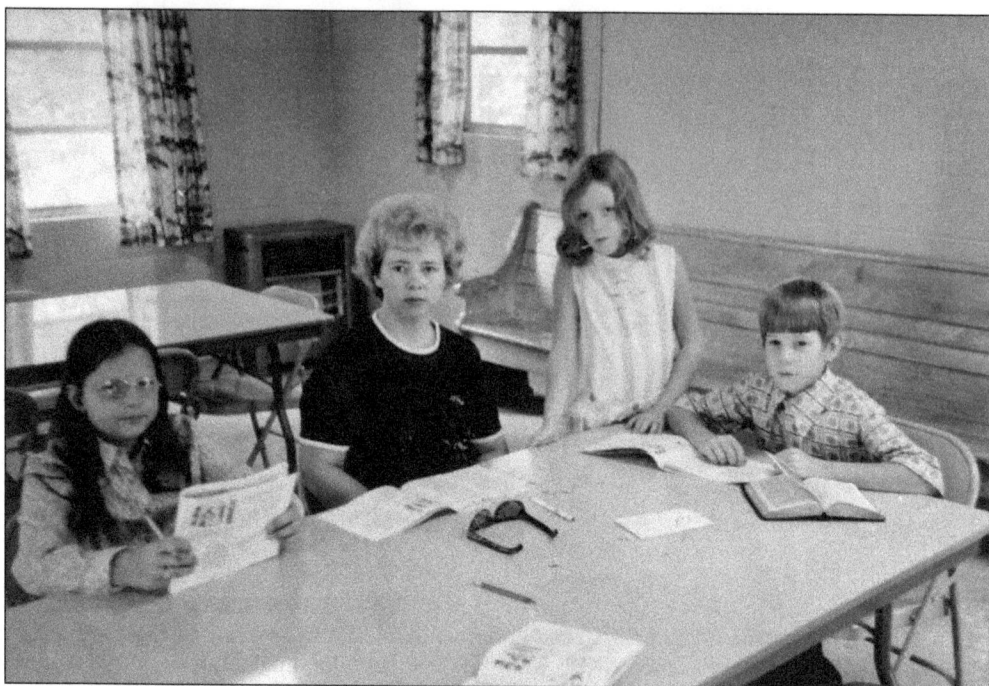

SUNDAY SCHOOL, 1973. Here is a Sunday school class held in the Hut. Those pictured are, from left to right, ? Ensign, Shelby McBane, Mary Joe Lindley, and David Lindley. (Spring Friends Collection.)

SUNDAY SCHOOL, 1973. Another Sunday school class is in the Hut. Those pictured are, from left to right, Brodie Andrew, Peter Ensign, Cathy McBane, Bobby McBane, and Joey Hargrove. (Spring Friends Collection.)

**SUNDAY SCHOOL IN THE MEETINGHOUSE, 1973.** Here, Wade Fuquay is teaching Sunday school in a room located behind the pulpit area of the meetinghouse. The door to his left leads into the other Sunday school room. The one to his right goes out the back of the meetinghouse. (Spring Friends Collection.)

**SUNDAY SCHOOL LESSON.** Here is a David C. Cook Sunday school lesson for Easter, April 17, 1938. Spring used David C. Cook lessons for years. (Charles and Laurie Newlin.)

# THE LESSON STORIES CARD

Vo. XXXIX WEEKLY No. 2 Part 3

DAVID C. COOK PUBLISHING CO., ELGIN, ILLINOIS

Lesson 3                           April 17, 1938
### THE VICTORIOUS SERVANT (Easter)
Acts 2: 22-36

GOLDEN TEXT: This Jesus hath God raised up. —Acts 2: 32.

PRIMARY MEMORY VERSE: Thou shalt make me full of joy.—Acts 2: 28b.

BEGINNERS MEMORY VERSE: We shall see him. —1 John 3: 2b.

LESSON STORY

Based on the International Uniform Sunday School Lesson, copyrighted by the International Council of Religious Education, and used by permission.

We should think that everyone would love the dear Lord Jesus who was so kind and helpful, but some wicked men did not love him. They planned to take away his beautiful life. He let them take the life of his body, but the real Jesus, the part that loves and helps and plans for his friends, they could not touch. That part went to be with the heavenly Father. Loving friends laid the body of Jesus in a garden belonging to a rich man who loved Jesus. They placed it in a cave and rolled a great

**NURSERY, 1973.** Spring uses the Hut for children who leave the meeting during worship. Those pictured, from left to right, are Tim Ursary, Sarah Lindley, and Janet Ursary (Tim's mother). Zilpha Hargrove's daughter Janet ran the nursery on the anniversary day. Mothers with small children took turns in the nursery on Sundays. (Spring Friends Collection.)

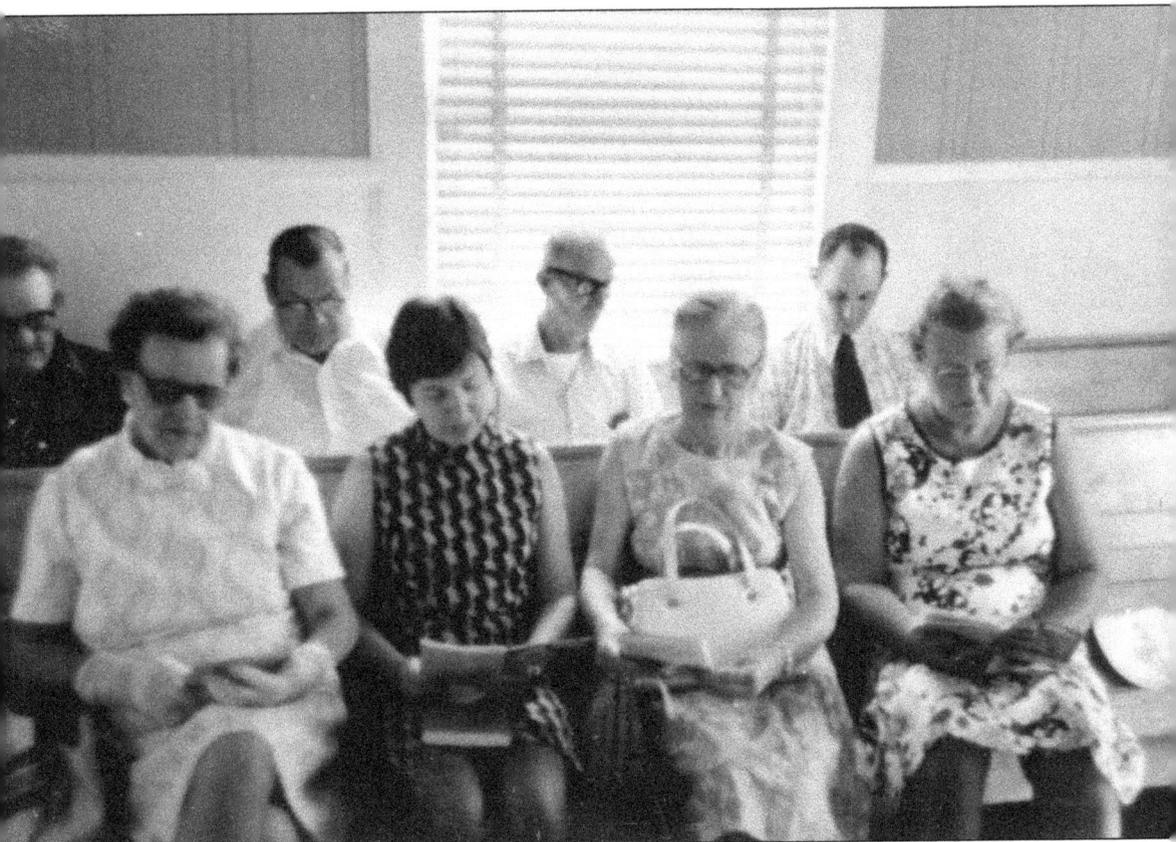

SUNDAY SCHOOL CLASS, 1973. Sunday school was also held in the meetinghouse. Those pictured in the meeting room are, from left to right, (first row) Elizabeth Zachary, Jane Lindley, Hazel Fuquay, and Mary Ruth Perry; (second row) Howard Harris, Hal Hargrove, Glenn Perry, and Joe Bill Lindley. The blinds are no longer in use in the meetinghouse. (Spring Friends Collection.)

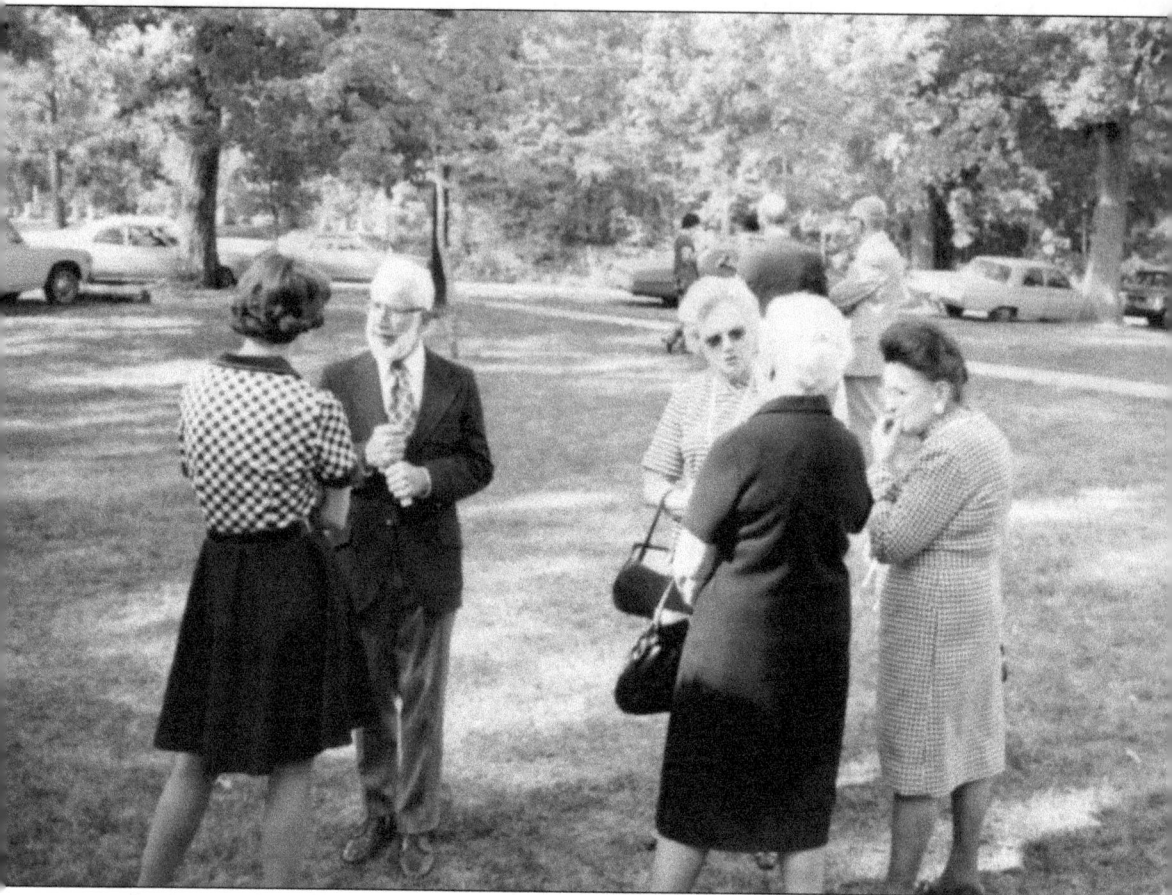

GUESTS, 1973. Numerous folks visited for the celebration. Many came from other meetings in the area. Pictured here are unidentified guests. (Spring Friends Collection.)

# Five

# "IT'S ABOUT THE BUILDING"

One member summarized the draw and the mystique of Spring Friends Meeting succinctly: it is the building. There is something about the simple white structure known as Spring Meetinghouse. Through the years, passersby stopped at the white clapboard meetinghouse, opened the imposing and unlocked front door, and rested in silence on the creaking wooden benches. Some left notes and offerings in the nondescript wooden plates on the plain table in front of benches.

The meetinghouse is a basic structure with interior dimensions of approximately 50 feet in length, 31 feet in width, and 17 feet in height. On each wall are five plain, arched windows and a heavy double door graces the entranceway. Inside, the floor slopes gradually to the front, where a circular dais is enclosed with a curved railing. Benches face forward, but in the pulpit area, benches on the left and right are perpendicular to those facing the front. These were originally reserved for elders. The offering table stands between two simple chairs.

Changes in the interior reflect changes to approaches to worship. A lectern on the floor has replaced the pulpit, signifying the move from sermons to talks and guided meditations. The large painting of Jesus that once hung behind the pulpit area has been removed.

Four ceiling fans were added for practical reasons, and a clock has replaced the Sunday school register. Six simple oil lamps of three slightly different designs adorn the otherwise plain, wainscoted walls on both sides of the meeting area. With the help of the Philadelphia Meeting, Sunday school rooms were added in the back of the meetinghouse.

NORTH

DOOR ?                                                    DOOR ?

A

B

Women's Side          — Shutterd Wall          Men's Side

A                          A
I                          I
S                          S
L                          L
E                          E

Front

A.  Gallery                    C.  Gallery Bench
B.  Facing Bench               D.  Gallery Rail

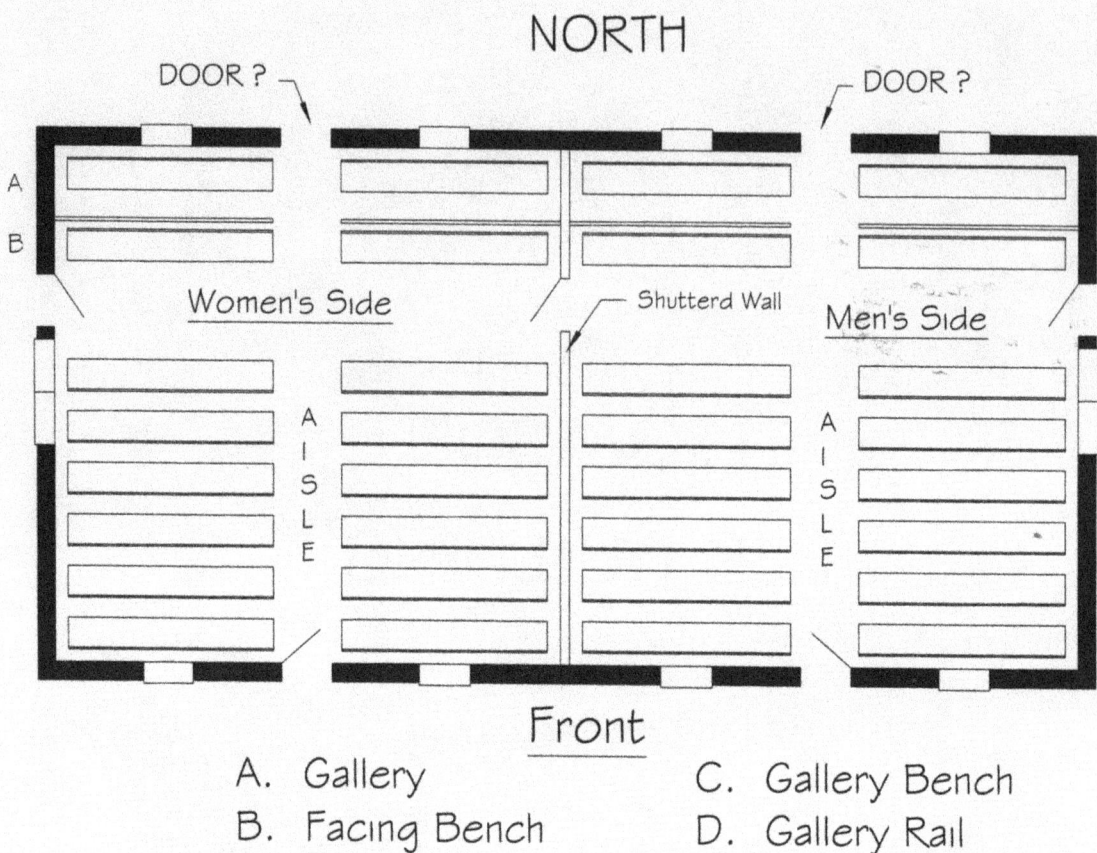

**DRAWING OF SPRING FLOOR PLAN.** This drawing is of the floor plan of the 1876 Spring Meetinghouse. There were few appointments; wooden chairs were very uncomfortable compared to modern standards. Also, there was no stove in this building. Women and men worshipped separately; women sat on the left and the men on the right for discrete yet simultaneous meetings. Separate doors offered segregated entrances, as well. The shuttered partition between the two rooms could be raised for joint meetings. The galleries at the top of each side were for elders and ministers who served as examples of worship for the rest of the members. Separate worship ended around 1887. It is not clear if there were doors in the rear of the building. The present building is not partitioned. (Adapted by Gerald Hampton from a drawing by Algie Newlin based on the recollections of Alpheus Zachary.)

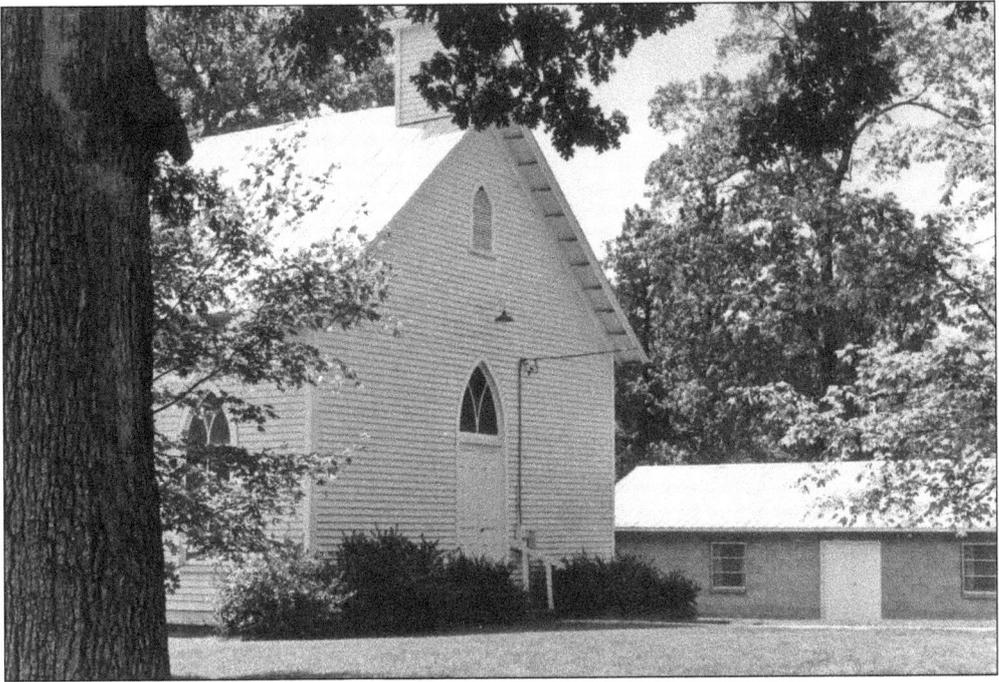

**SPRING MEETINGHOUSE.** The entrance to the meetinghouse has two doors, each roughly eight feet tall and 30 inches in width. The doorway is topped with a Gothic-style window. Despite the old lock, the doors are always unlocked. (Spring Friends Collection.)

**WINDOWS.** The windows also are built in the Gothic style. They measure nine feet by 40 inches in width. Before the days of air-conditioning, the windows were opened on hot days. Bees often caused problems for members, and one member used to spit snuff out of a window. Once, when smells from local cattle farms filled the room, one pastor openly complained about the stench. He was politely reminded that the cattle farmers paid his salary. (Author.)

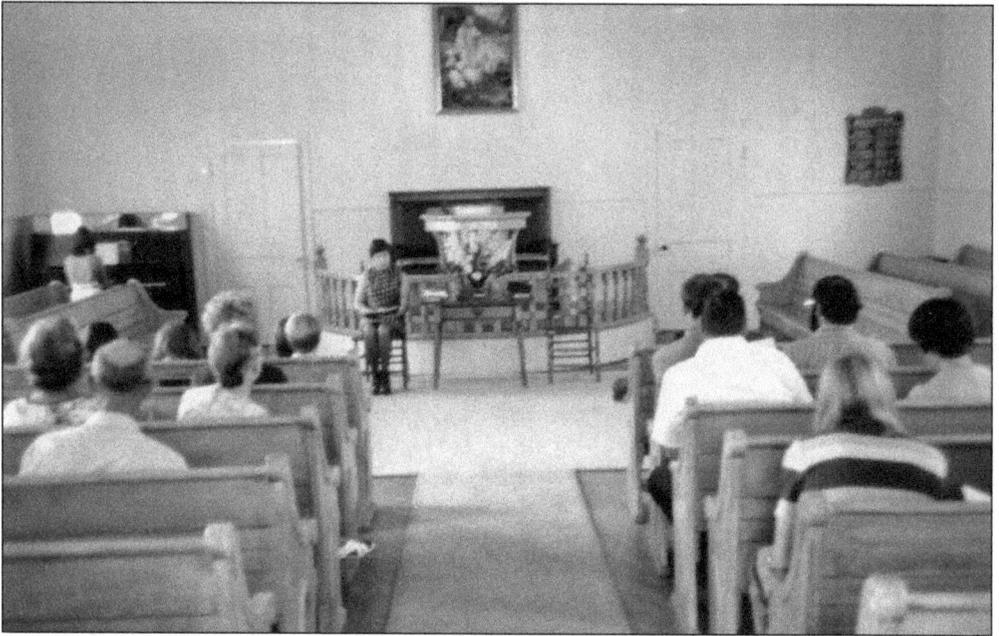

SANCTUARY. The meetinghouse was repaired in 1955 for $2,450, and these repairs included new flooring, interior wainscoting, and a new ceiling. The typical Quaker simplicity is seen in the plain walls with wainscoting, the austere offering table at the front of the meetinghouse, and the two ladder-back chairs on the sides of the table. (Spring Friends Collection.)

FOUNDATION STONE. This rock, which dated from the time of Thomas Lindley, was used in the foundation of the original meeting. Thomas Lindley donated the land where Spring Meetinghouse now stands. At the request of Wade Fuquay, it was placed into the concrete step leading into the Hut. (Author.)

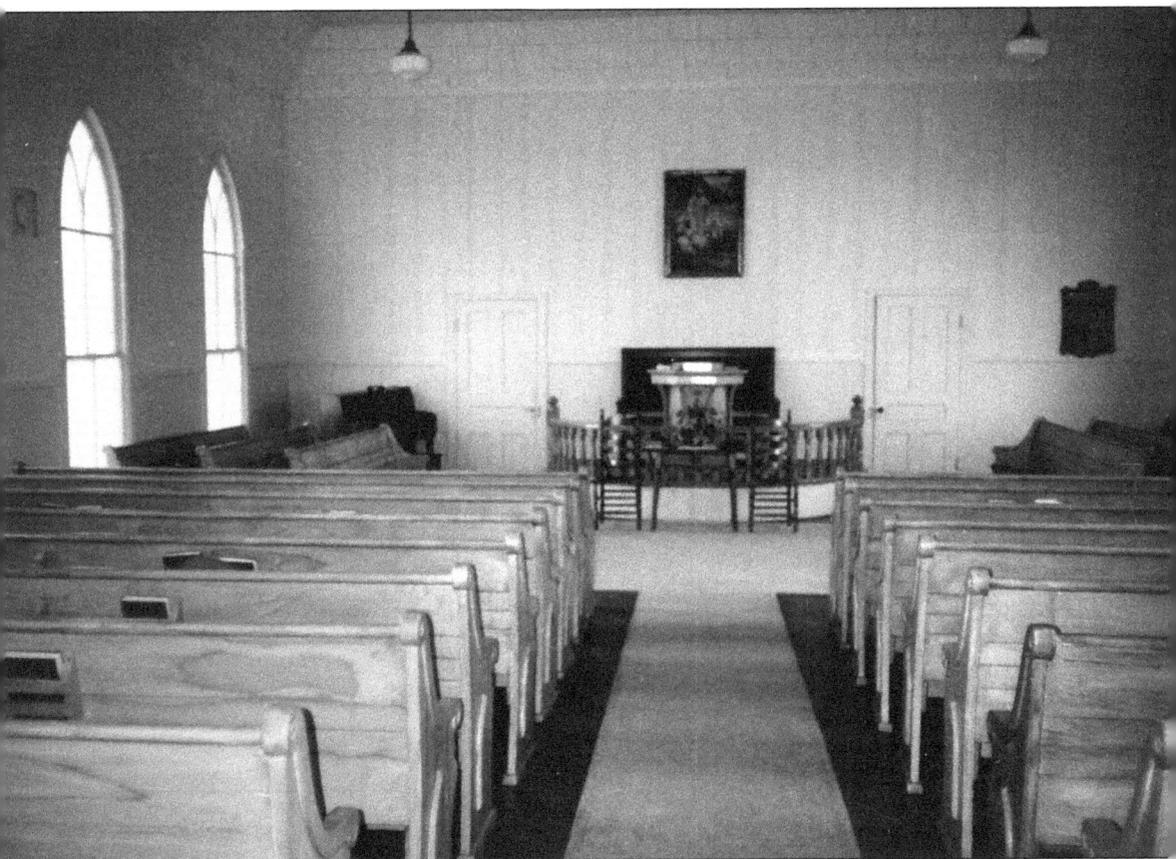

**PULPIT AREA.** From the very late 1800s up to about 2000, Spring worship was influenced by the burgeoning evangelical movement that burned across the United States. This evangelical trend is revealed by the pulpit area with a lectern, a symbol of preaching nourished by the study and mastery of words; this is the very opposite of the normally silent and reflective manner of open worship of Quakers. In this undated photograph, the old pulpit is visible on the stage area, constructed in the 1907 building. In the 1950s, there was discussion among Spring members to sell the pulpit furniture in order to bring more people back into the meeting. The proposed sale of pulpit furniture may indicate a move back to the unprogrammed, traditional style of Quakers. Above the pulpit is a depiction of Jesus, and the Sunday school attendance register is to the right. Today, the pulpit area has no lectern, and the painting has been removed—signs of a return to the traditional Quaker ways of open worship. (Spring Friends Collection.)

**LIBRARY BOOKPLATE.** Since Spring Meeting had a school, there was the need for a library. The Spring library was funded in part by the Philadelphia Meeting and through donated books as well. Some of the books date to the late 1700s. Pictured here is Elias Hicks's 1825 *A Defense of the Christian Doctrines of the Society of Friends*. The bookplate reveals that Philadelphia Friends donated it. As noted on the bookplate, this volume belonged in the H&CH departments, which probably meant the history and church history sections of the library. (Spring Friends Collection.)

**OLD LIBRARY.** Theology and history works filled the shelves along with children's books. The old bookcase at Spring was constructed of pine boards and trim and measured 65 inches tall by 34 inches wide. (Author.)

**LIGHTS.** The oil lamps were replaced when the Rural Electrification Act of 1936 brought electrical power to the Spring area. In June 1936, the meeting voted to install electric lights "when the line comes close enough." In December, the meetinghouse was hooked up at a cost of $10.50. The lamps were reinstalled later for decoration but are sometimes used for night services. (Spring Friends Collection.)

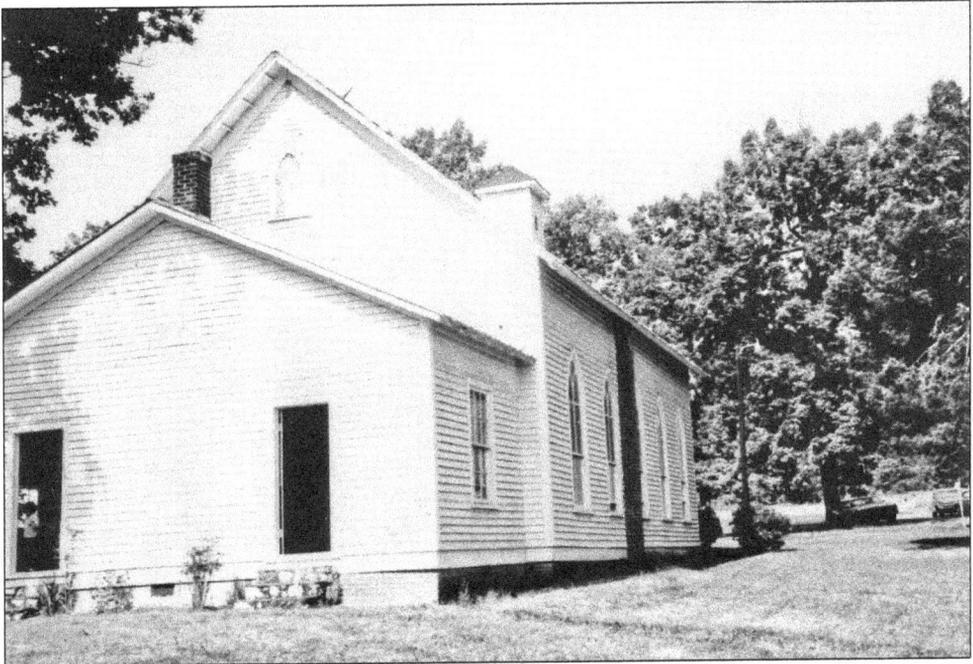

**SUNDAY SCHOOL ROOMS.** In this 1973 photograph, the Sunday school rooms are seen from the rear of the meetinghouse. In 1942, the Philadelphia Yearly Meeting sent Spring Meeting $75 to build Sabbath school rooms. Minutes indicate they were built quickly, because paint for the rooms was purchased in 1943. Each 14-foot-by-14-foot room had its own form of heat, but only the left room had a chimney. The flue from the other room ran through the wall to the chimney. Each room had exit doors. A door also connected the rooms to each other. (Spring Friends Collection.)

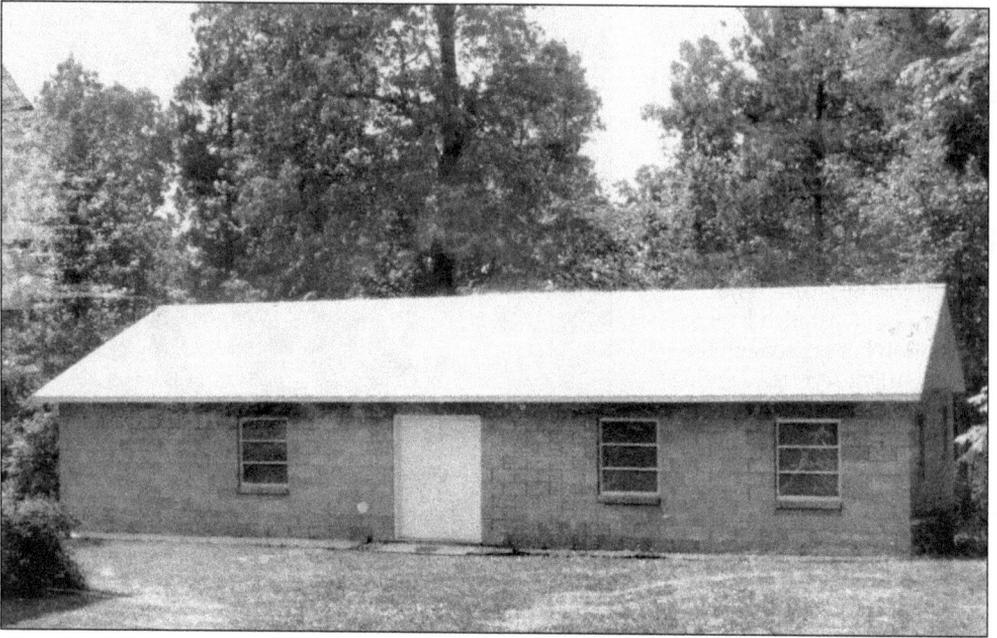

HUT. In 1969, Orval Dillon, the pastor at Spring, led the way for the construction of a concrete block building known as "the Hut." Baxter "Buck" McBane, who did not attend Spring Meeting, offered his expert advice for the project. He attended Spring School and was a hobo in his youth, but later he settled down and worked a tobacco farm. Today, the Hut serves as a Sunday school room for adults or youth, a children's room (children leave the meetinghouse during open worship), and a space for business meetings. (Friends Historical Collection, Guilford College, Greensboro, North Carolina.)

INSIDE THE HUT. Here, Wade Fuquay (center) stands with unidentified people at the 1973 anniversary celebration.

**CABINETS IN THE HUT.** The cabinets have a history of their own. Orval Dillon built them during his time of service at Spring to honor baseball player Tom Zachary. This photograph was taken during the 1973 anniversary celebration. (Spring Friends Collection.)

**BELL.** The handbell was rung to begin and end Sunday school classes. The tradition dates to the late 1800s. Grant McBane, who taught in the local school, rang it there. The bell traditionally rested on the table at the front of the pulpit. It was stolen in the early 1960s but was discovered when authorities arrested an Orange County man for theft, and the bell was returned. In September 1981, Sunday school superintendent Zilpha Hargrove discovered the bell had been stolen again. This is the replacement bell. (Spring Friends Collection.)

**BELFRY BELL.** A belfry was added in 1921 for $7.75. Howard Harris rang the bell every Sunday, but in the Spring minutes, it is also noted that Neal Hargrove and James Andrew were appointed to ring the bell at 9:30 a.m. and 12:00 p.m. Neal and James were also in charge of building fires "when needed" for a salary to be paid by the meeting. The belfry was eventually enclosed, but it was reopened in 2010. Members often ring it on first Sundays. (Author.)

*Six*

# THEIR STORY
# IN THE STONES

Interpreting grave markers and stones is often an exercise in educated guesswork. Still, the Spring Friends Cemetery is worth examining, even if speculation must be utilized. British Friends generally left no markers or placed them flat on the ground. The types and styles of markers used in the Spring Friends Cemetery tell a story, and a walk around the cemetery reveals information that is not readily available in meeting minutes. Old tombstones and new markers reveal a cultural progression illuminating how Spring members remembered their lost love ones' heritage and/or economic status as well as how they followed funerary customs of their day.

In the late 1700s, slate and soapstone were used to mark graves. In most cemeteries in the region, slate was generally used before sandstone. In the early 1800s, there was no local railroad, so gravestones had to be shipped by other means. Marble was not native to North Carolina (except in the extreme western part of the state), so stones were ordered through local stores and then inscribed by out-of-state cutters who shipped the final product back to the family. Some were prepared by traveling stonemasons. In 1828, the North Carolina Yearly Meeting requested that its members refrain from the use of elaborate stone markers. As seen in the Spring Friends Cemetery, most did not comply.

The construction of railroads made heavier marble headstones easier to transport to remote locales. Stonecutters in Raleigh, Charlotte, and Fayetteville competed with itinerant stonecutters. These artisans took artistic letter designs from readily available books and carved uniform marble headstones and markers. By the 1850s, about the time that the North Carolina Railroad's Company Shops opened in Burlington, marble stonecutters were established in smaller towns and communities throughout North Carolina.

The transition from marble to granite took place in the early 1900s throughout the North Carolina Piedmont. From the late 1920s through the 1930s and again in the 1960s, new markers and bronze plaques were placed on large granite stones. One McBane plot has two stories to tell: the remains of Daniel McBane, a Revolutionary War soldier and pioneer parent of the McBane family in North Carolina, were moved to the cemetery in 1936; William McBane, the only son of Daniel, continued that military tradition, participating in the War of 1812.

The names on grave markers recall past memories and genealogies. Here is the silent story of Spring Meeting in stones. (The stones and markers that follow were chosen for the historical importance of their styles, not family names.)

**PICTURE OF CANE CREEK CEMETERY.** This is a view of the older portion of Cane Creek Cemetery. The cemetery is perhaps the oldest in the Piedmont. (Cane Creek Friends Meeting.)

**SOUTH FORK FRIENDS CEMETERY.** This picture of the cemetery at South Fork Friends Meeting shows various styles of markers. A monument for a member of the Hadley family is in clear view. Towers and footstones are visible. (Cane Creek Friends Meeting.)

**PICTURE OF THE SPRING FRIENDS CEMETERY.** The cemetery of Spring is a cherished place. It is situated across the road from the current Spring Meetinghouse. Here, a cedar tree guards the grounds. Tradition says that the tree was large as far back as 1805. The first log meetinghouse was erected on this site. (Dan Perry.)

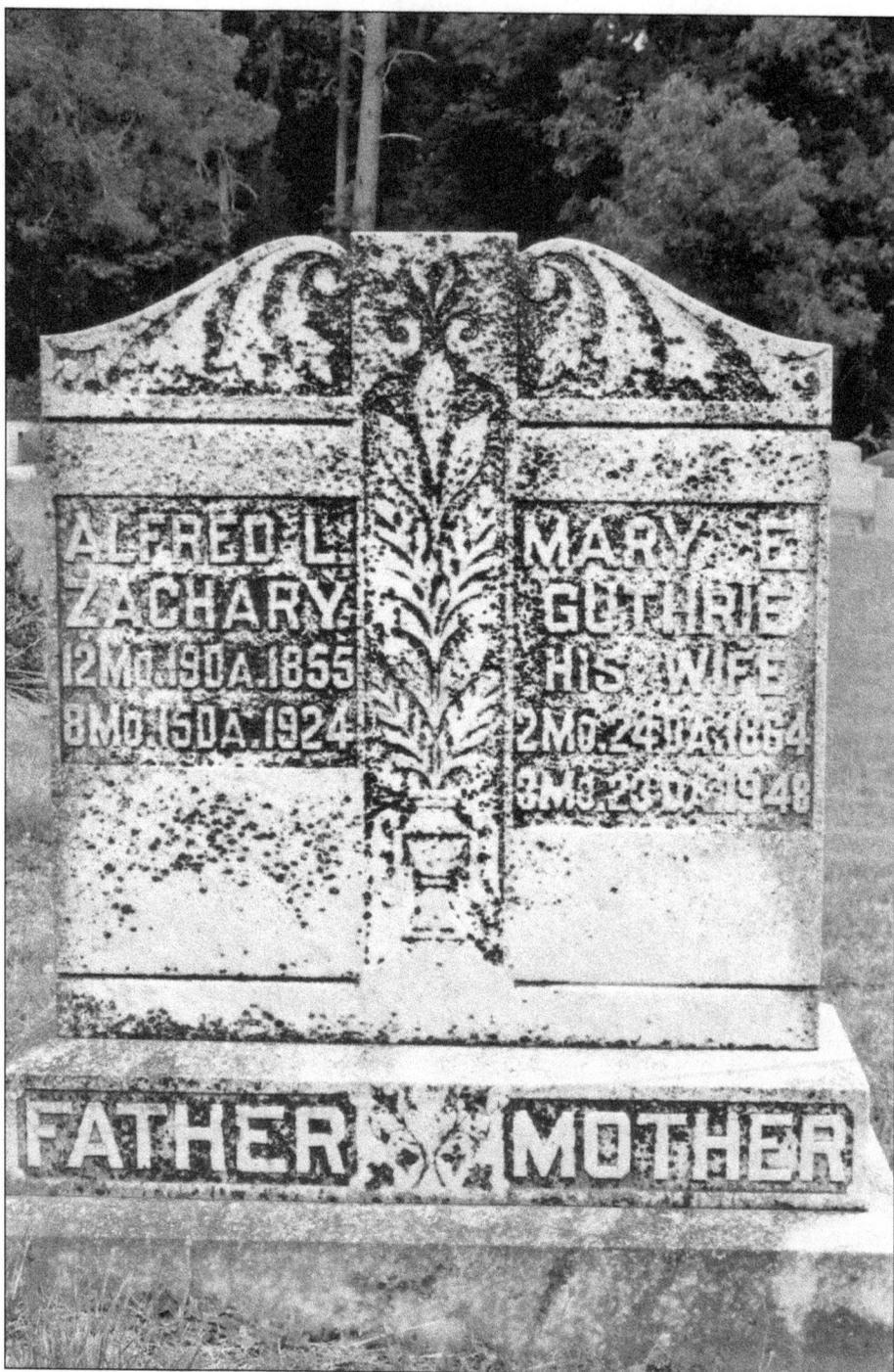

**ALFRED ZACHARY AND MARY GUTHRIE ZACHARY.** When people visit cemeteries today, they often expect to see grave markers such as this one. Ornate stones like this were the style in the early to mid-1900s. Here, a scroll is inscribed on the sloping top. The large marble monument is complemented with a fern in the middle and the words *father* and *mother* at the base. The stone rests on a marble foundation. (Author.)

HOLLIDAY MARKER. Reading old tombstones and markers is often more guesswork than positive identification of the deceased, and this marker is an excellent example of this process. This headstone is dated "1795 / 7 [day] 8 [month]." It is difficult to write clearly on this type of stone, and the effects of nature have taken their toll. The following initials appear to be "M H," but the last letter could be a poorly inscribed "M," as well. The little "o" in between the letters could signify a middle initial or simply a space between the two letters. Current cemetery records show this marker is in the vicinity of the Holliday (then spelled Holaday) family, with Henry and Mary F., who died in 1800 and 1797, respectively. These dates eliminate them as possible candidates for the grave. Records reveal that they had three sons—Samuel, Robert, and William. If this marker is indeed from the Holliday family, this suggests that another child may have died soon after birth. (Author.)

**MARY PYLE NEWLIN.** The barely legible "M N" on this gravestone was inscribed by hand on a carved piece of local soapstone. The top of the originally rectangular marker is broken off. According to current records, the stone is that of Mary Pyle Newlin, who probably died in 1806, but this is uncertain. (Author.)

**R.H. GRAVE MARKER.** This is a carved sandstone marker for an R.H., dated 1798. The rounded crown is enclosed by horizontal "wings." Such an "elaborate" headstone required more work and thus may be a sign of higher economic status in the community even though it was dated before slate stone was used. This style could also mean that a family member was more adept at carving tombstones. (Author.)

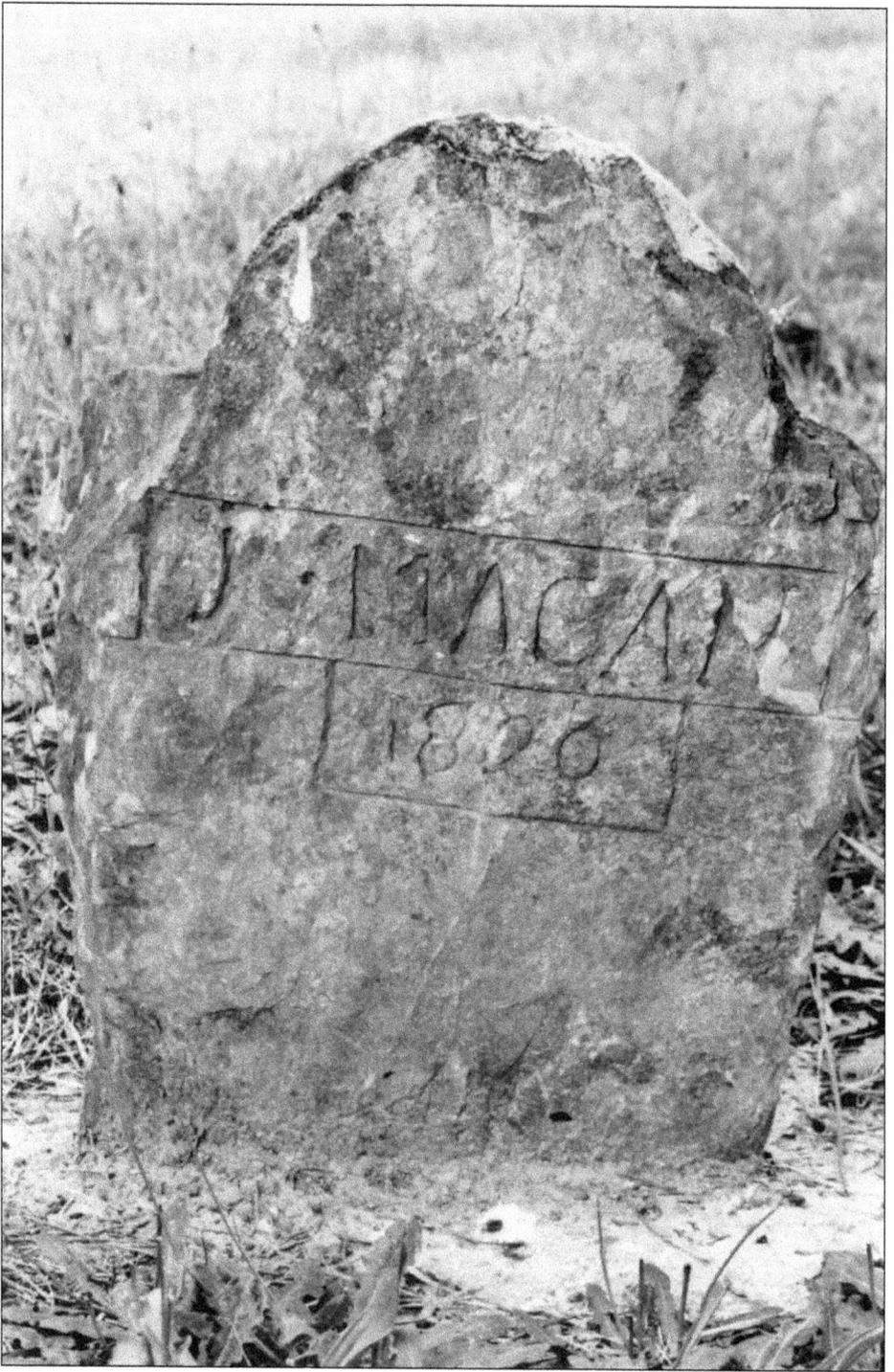

**J. MACAN MARKER.** Just two plots down from the Macan stone is a simple, hand-inscribed slate marker for a J. Macan, dated 1820. There also appears to be an inscribed circle at the top of the stone. Since other earlier graves in the cemetery were of carved sandstone, the 1820 Macan slate marker probably indicates a family of lower status. (Author.)

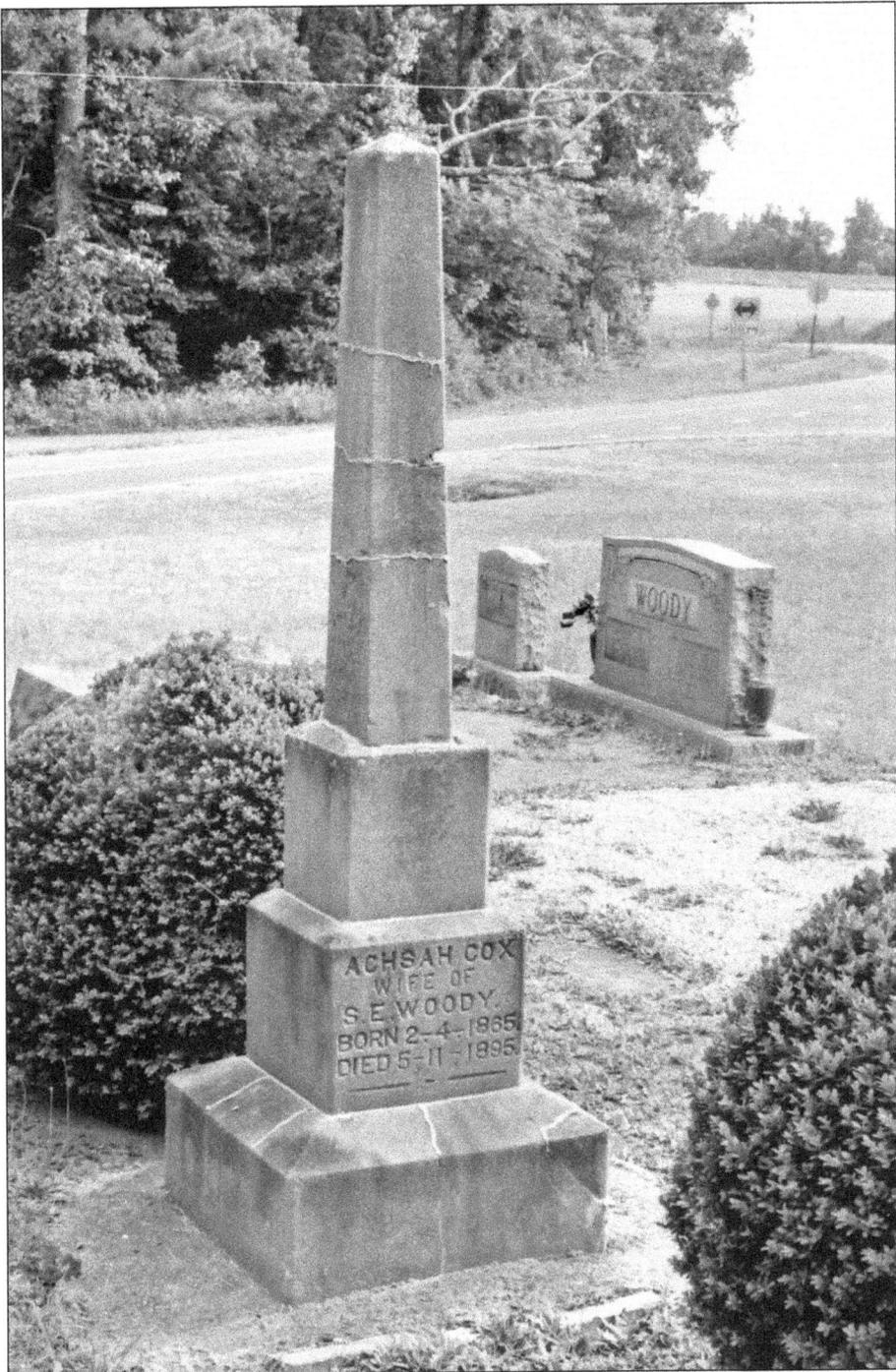

**OBELISKS.** Obelisks emerged in the early 1900s, and one example is illustrated in the marker for Achsah Cox, the wife of S.E. Woody, who died in 1895, and their child Silas Earnest, who lived only four years and died in 1897. The obelisk stands on a tiered ledger and is one of two such markers in the Spring Friends Cemetery. Achsah Cox was buried in the Cane Creek Cemetery, and this monument was erected to remember the family. (Author.)

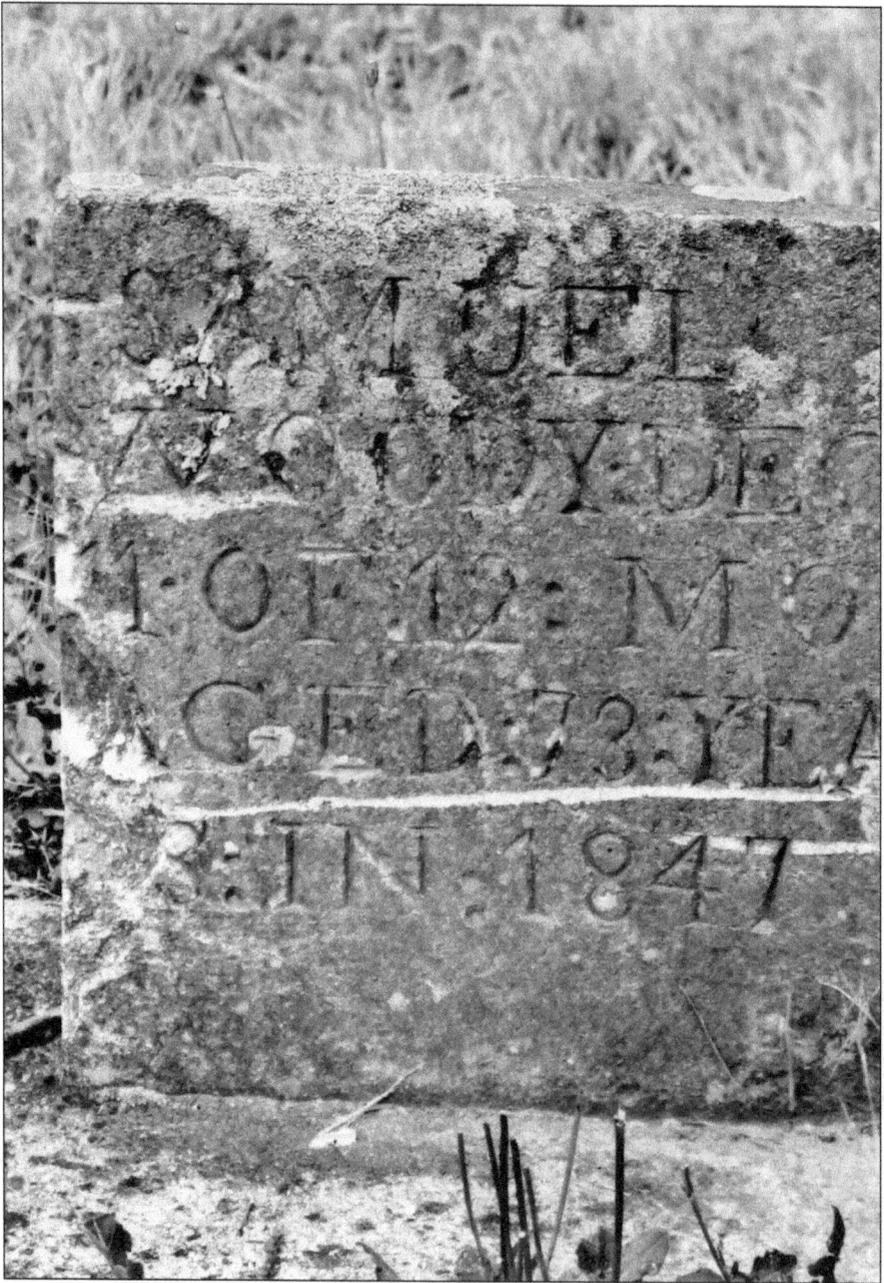

**SAMUEL WOODY.** This is the headstone of Samuel Woody, who died in 1847. The grave marker is nondescript, carved from a piece of local soapstone in a simple square shape. The letters are not inscribed, and this indicates the labors of one of three types of craftsmen. A local stonecutter would use a book of letters to mark and then inscribe the inscription. The simple style could indicate the work of a jack-of-all-trades, one of which was carving gravestones. This worker also would employ the use of a book of templates to carve the uniform letters on the stone. Sometimes, a family member was skilled enough to carve the stone and inscribe the letters. While the letters are uniform, their spacing suggests the carver was not very skilled. It reads as follows: "SAMUEL / WOODY: DEC / 11: OF 12: MO / AGED: 73 YEA / RS: 1847." (Author.)

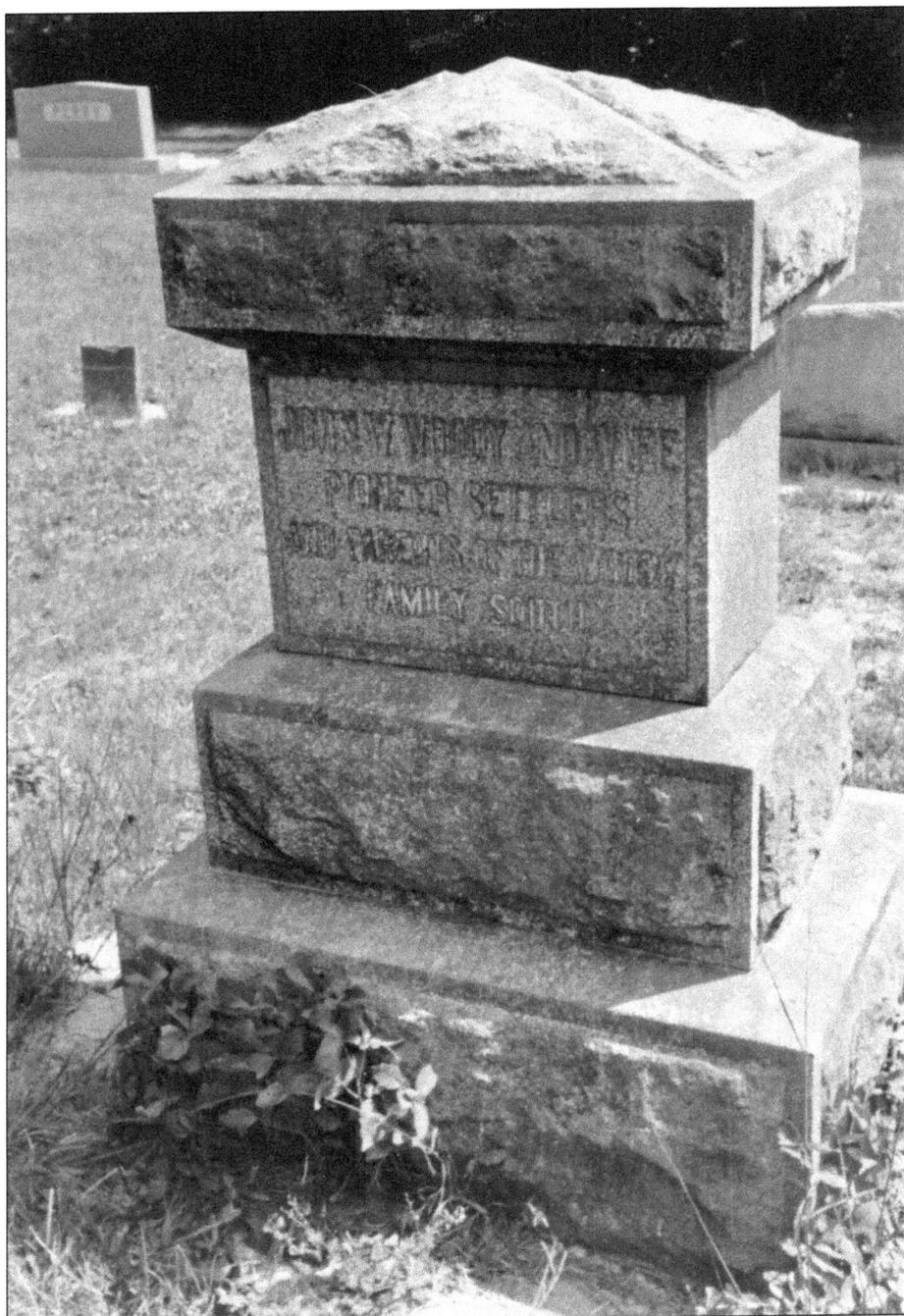

SHORTER OBELISK, 1973. This small monument memorializes "John W. Woody and Wife / Pioneer Settlers / and Parents of the Woody / Family South." John and his wife, Mary Gowan Woody, were not in the first group of settlers in proximity to the Spring area. One questionable tradition says that they left Massachusetts to escape the persecution of Quakers. They wound up in Maryland and then migrated further south to settle on the Haw River. Here, he set up Woody's Ford on the south end of his land and eventually ran a ferry there as well. Woody later built a bridge over the river, and portions of the bridge remain today. (Spring Friends Collection.)

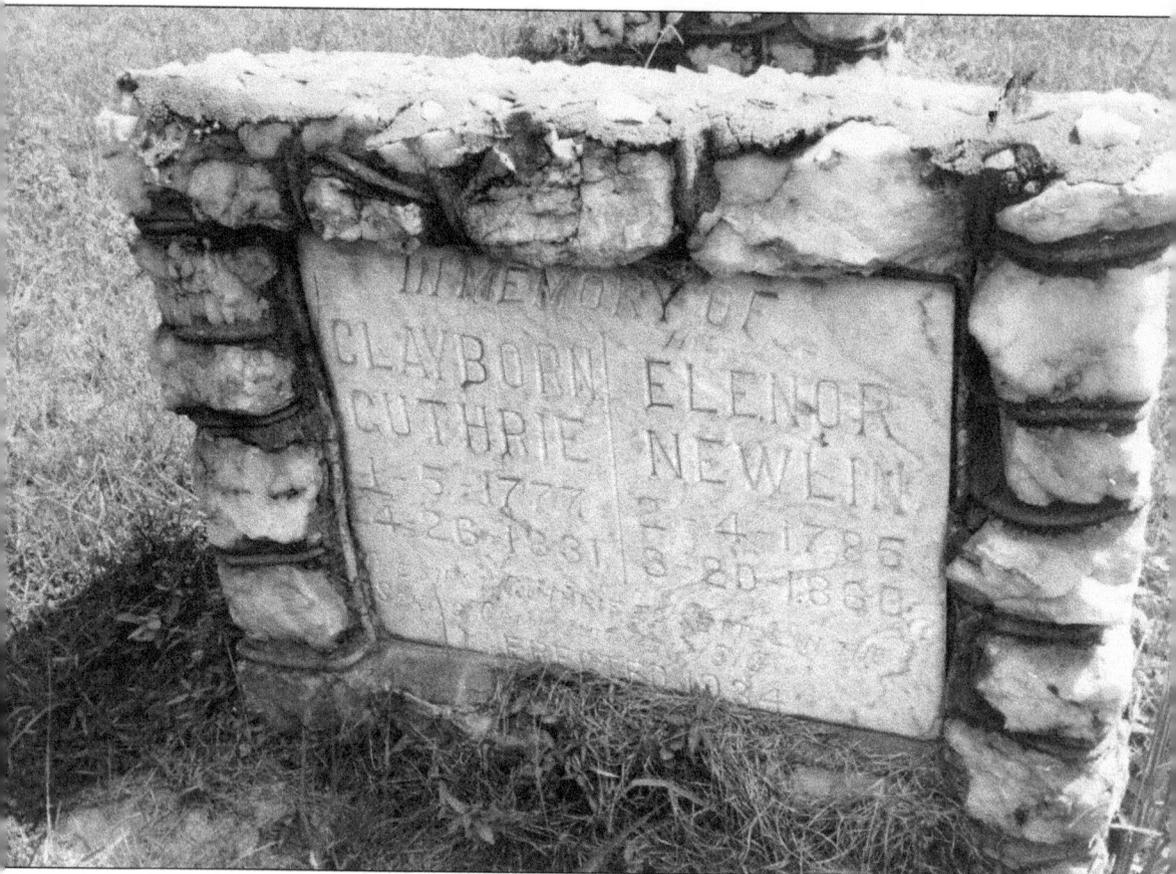

**WHITE STONE FRAME, 1973.** This white marble tombstone, encased in white stones, was erected in 1934. It marks the graves Clayborn Guthrie and his wife, Elenor Newlin, who died in 1831 and 1860, respectively. (Springs Friends Collection.)

**MARBLE STONE MARKER.** In the 1830s, large migrations of people from Europe arrived in the United States. Everyone looked for work, and some were trained stonemasons. Their considerable skills led to the manufacture of marble headstones, which soon became readily available if one could afford the costs of both inscription and freight. This marble stone memorializes Deborah Jane McPherson. Born in 1825, she was buried in 1851 at the young age of "25 ys. 7 m 25d." The style and cut of the stone indicate that it was probably ordered and then cut by out-of-state carvers. This process also suggests a middleman, most likely a local store owner. The gravestone letters are uniform just like those of Samuel Woody. Since this stone is only four years younger than the Woody stone, it indicates either a family of high economic status or a deviation from Quaker simplicity. (Author.)

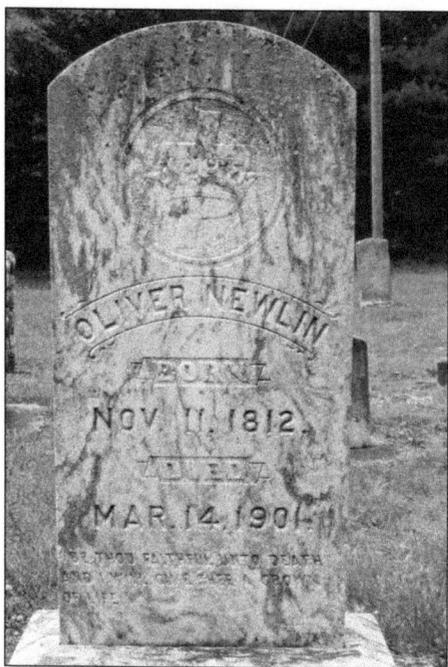

EXTENDED PHRASES. This 1901 marble stone marking the grave of Oliver Newlin has much to tell. The verse "Be thou faithful unto to death / and I will give thee a crown / of life" reveals a new style of elaborate and lengthy phrases. These extended inscriptions raised the price of the stone. Along with this, new adornments were being added to grave markers, as indicated by the carved cross and crown on the stone. This memorial also reveals another new trend—the stone carver's business name was now inscribed on the stone in an inconspicuous spot: on the bottom right is carved "Coopers-Raleigh." W.A Cooper Brothers bought out the older and well-established William Stronach's Raleigh Marble Works in 1894 and the Lougee and Goodwin Marble Yard in 1896. More elaborate grave markers were produced locally as opposed to out-of-state markers, such as those from Rogers and Miller in Richmond, Virginia. This saved money on funeral expenses. (Author.)

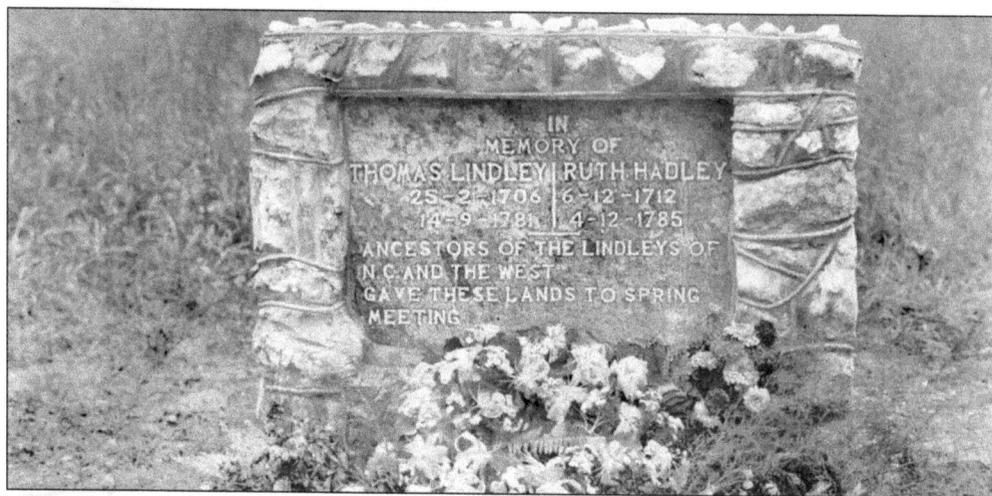

THOMAS LINDLEY. Thomas Lindley, along with Henry Holliday and Hugh Laughlin, prospected the land along Cane Creek in either 1750 or 1751. The following year, they moved their families from Pennsylvania to this area. Thomas Lindley built what became Lindley's Mill just over a mile west of the land that he deeded to his son, which became the home of Spring Meeting. It is very certain that when British and American forces clashed on September 1781, the area they chose was Lindley's Mill, where ample provisions would have fed many troops. Here is a new trend of grave markers that emerged in the early to mid-1900s possibly reflecting a local, vernacular style (endemic to a small region) of monument, which is found in various cemeteries that surround the Spring community. The marble marker is encased in a mortar-and-white-quartz border. This 1928 gravestone honors Thomas and Ruth Hadley Lindley, who died in the 1780s. This photograph is unique because it is a postcard. It was fashionable in the early 1900s to have one's image or that of a significant event made and reproduced on a postcard. This photograph was taken prior to 1928. (Cane Creek Friends Meeting.)

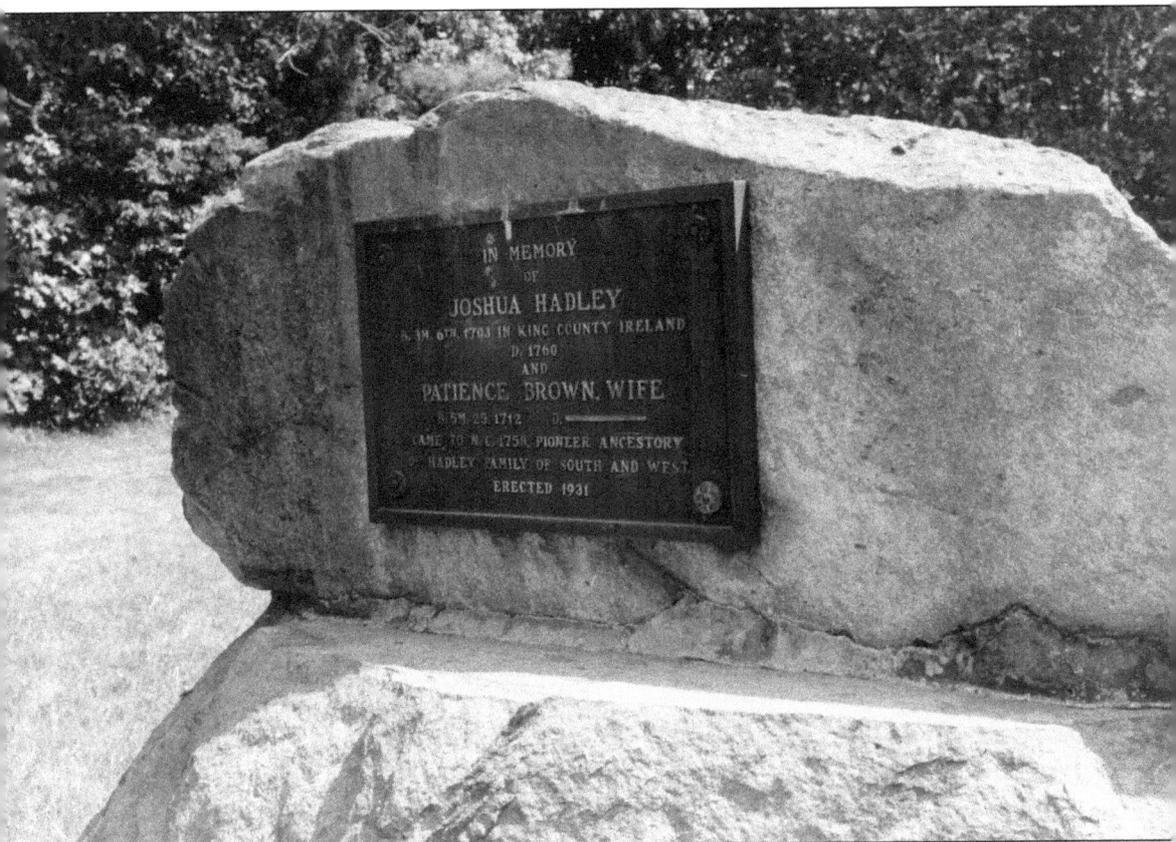

**Plaques on Markers, 1973.** Another type of marker emerged in the late 1920s through the 1930s. At this time, several venerable Spring families remembered their ancestors of long ago with new markers and plaques. One example is that of Joshua Hadley and his wife, Patience Brown, erected in 1931 on a large irregular stone that rests on another large stone. (Spring Friends Collection.)

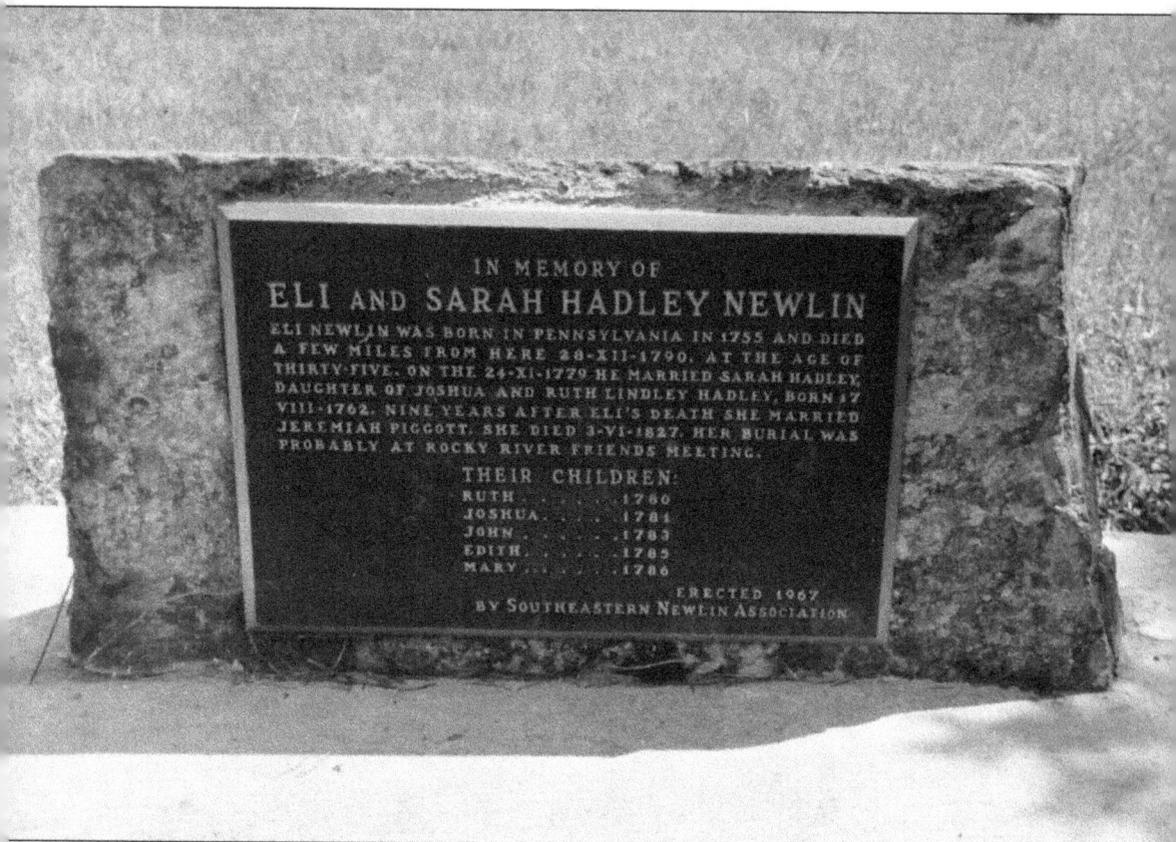

**ELI NEWLIN, 1973.** In the 1960s, a new trend emerged when plaques containing the history of the deceased were placed on large monumental stones. This plaque explains that Eli Newlin was born in Pennsylvania in 1755 and died at the age of 35 a few miles from Spring. His wife, Sarah Hadley Newlin, was born in 1762. After Eli died, she married Jeremiah Piggot. She died in 1827 and may be buried in Rocky River Friends Meeting's cemetery. The Southeastern Newlin Association erected the marker 1967. (Spring Friends Collection.)

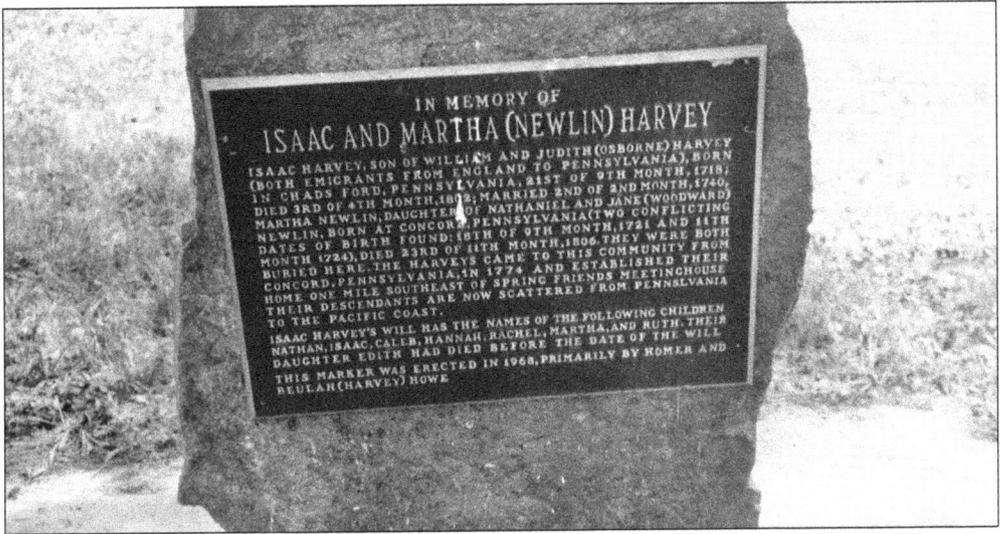

ISAAC AND MARTHA (NEWLIN) HARVEY MARKER, 1973. This marker notes that Isaac Harvey was the son of William and Judith Harvey, who emigrated from England to Pennsylvania. Isaac, who married Martha Newlin, was born in Pennsylvania and then settled just one mile southeast of Spring Meeting. The marker is filled with information such as the conflicting dates of Martha Newlin's birth. It also lists the children of Isaac and Martha. Below the marker is a flat concrete base with the names "William" and "Elizabeth" inscribed in the concrete. (Spring Friends Collection.)

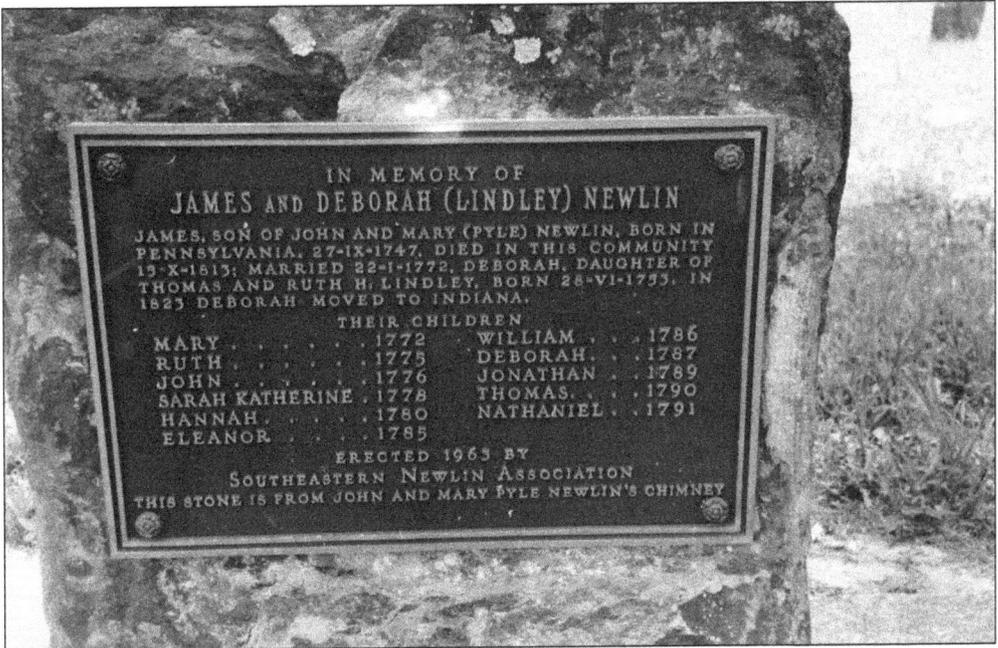

JAMES AND DEBORAH NEWLIN MARKER, 1973. This marker notes that James was born in Pennsylvania and died in 1813 in the Spring community. In 1823, his wife, Deborah, moved to Indiana, and this may have been part of what is called the Great Migration of Quakers. They had 11 children who are listed on the plaque. The stone on which the plaque is mounted is from John and Mary Pyle Newlin's chimney. (Spring Friends Collection.)

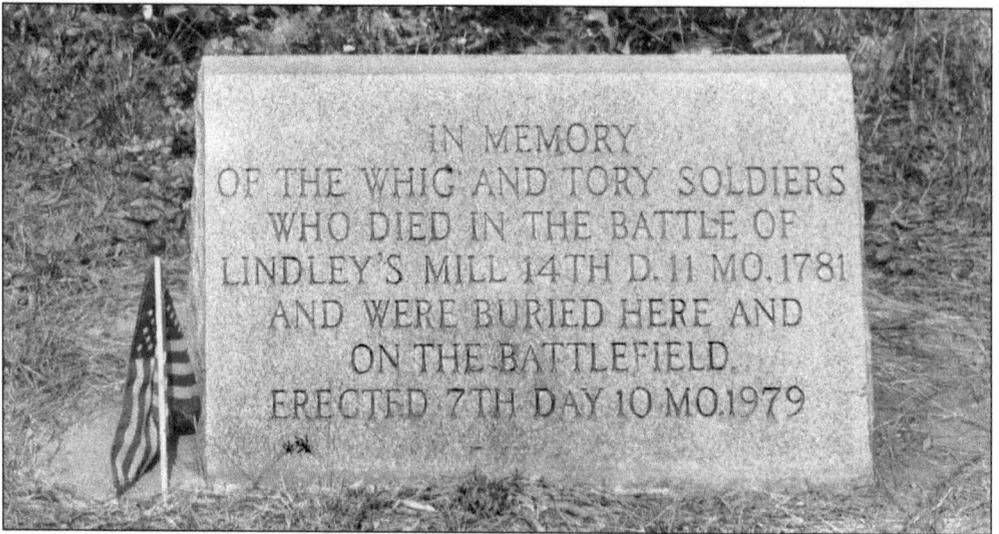

**AMERICAN REVOLUTION MARKER.** In 1979, Spring Friends approved the use of cemetery funds to purchase a marker to remember the American Revolutionary War soldiers, Whig and Tory, who died in the Battle of Lindley's Mill in September 1781. These brave men were duly honored with a memorial marker in 1979. (Author.)

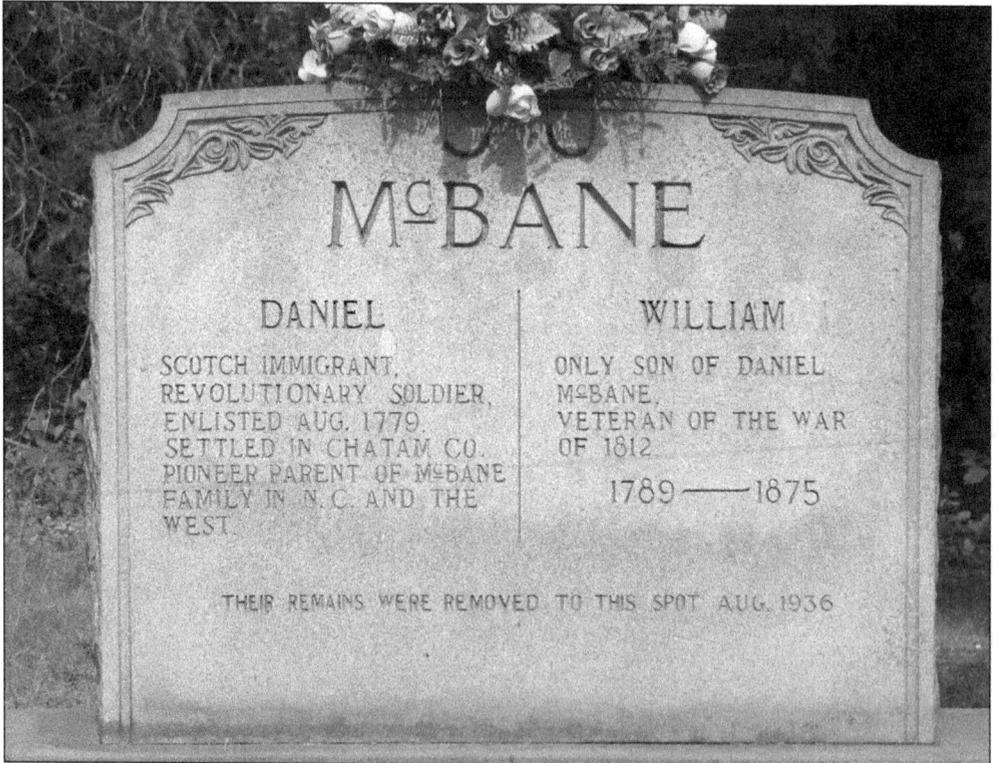

**MCBANE GRAVESTONE.** The remains of Daniel McBane, a Revolutionary War soldier and pioneer parent of the McBane family in North Carolina, and William McBane, the only son of Daniel, who fought in the War of 1812, were buried together in the Spring Cemetery in 1936. It is not known if they were disowned by the meeting for their military service. (Author.)

# Seven

# SPRING TODAY

The legacy of Spring Meeting continues today. Roads are named after the earliest members; one example is Woody Lane. Lindley's Mill still produces flour, and the Lindleys and McBanes farm land that was procured a long time ago.

The current Spring Meetinghouse was constructed in 1907 and is the oldest intact Quaker meetinghouse in Alamance County. It is typical of other early-20th-century frame churches with gable front and weatherboarding. The windows of the otherwise austere building are of the Gothic Revival type, with pointed arches. This style is usually found in urban church buildings.

Members of Spring still retain the Quaker tradition of pacifism. On March 22 in 2004, 2005, and 2006, Ron Osborne marched in an antiwar rally in Fayetteville, North Carolina. The date marks the anniversary of the commencement of the war in Iraq.

In May 2006, Taylor Ross Marley, son of Cathy McBane Marley and Dwayne Marley, built a garden with benches and bridges across the spring runs. The project was for his Eagle Scout award, which he received that June.

So, the springs are still flowing, and the doors remain open—as both have been for nearly 250 years. This is the story of Spring Friends Meeting.

**SIDE VIEW OF SPRING FRIENDS MEETING.** In this image, the simple clapboard building and the Sunday school rooms are surrounded by beautiful grounds. In the foreground is the garden area constructed by Taylor Marley. (Cathy and Dwayne Marley.)

State of North Carolina
Department of Cultural Resources
Division of Archives and History

This is to certify that

SPRING MEETING HOUSE

has been entered on

THE NATIONAL REGISTER OF HISTORIC PLACES

by the

United States Department of the Interior
upon nomination by the State Historic Preservation Officer under
provisions of the National Historic Preservation Act of 1966 (P.L. 89-665).

The National Register is a list of properties "significant in American history,
architecture, archeology, and culture — a comprehensive index of the significant
physical evidences of our national patrimony." Properties listed thereon deserve
to be preserved by their owners as a part of the cultural heritage of our nation.

_____
Director, Division of Archives and History
and
State Historic Preservation Officer

March 19, 1987
Date

**HISTORICAL PLAQUE.** Spring Meeting was approached in July 1986 about having the 1907 meetinghouse placed in the National Register of Historic Places. In February 1987, Spring was notified that the North Carolina Department of Cultural Resources nominated the Spring Meetinghouse for this honor. On March 19, 1987, the nomination was approved, and Spring Meetinghouse was placed in the National Register. (Spring Meetinghouse.)

# BIBLIOGRAPHY

Hamm, Thomas D. *The Quakers in America.* New York: Columbia University Press, 2003.

Hinshaw, Seth B. *The Carolina Quaker Experience, 1665–1985: An Interpretation.* Greensboro, NC: North Carolina Friends Historical Society, 1984.

Kars, Marjoleine. *Breaking Loose Together: The Regulator Rebellion in Pre-Revolutionary North Carolina.* Chapel Hill, NC: University of North Carolina Press, 2002.

Little, M. Ruth. *Sticks & Stones: Three Centuries of North Carolina Gravemarkers.* Chapel Hill, NC: University of North Carolina Press, 1998.

Newlin, Algie I. *Friends "at the Spring": A History of Spring Monthly Meeting.* Greensboro, NC: North Carolina Friends Historical Society, 1984.

Ready, Milton. *The Tarheel State: A History of North Carolina.* Columbia, SC: University of South Carolina Press, 2005.

Teague, Bobbie T. *Cane Creek: Mother of Meetings.* Snow Camp, NC: North Carolina Friends Historical Society, 1995.

Troxler, Carole Waterson and William Murray Vincent. *Shuttle & Plow: A History of Alamance County, North Carolina.* Graham, NC: Alamance County Historical Association, 1999.

Visit us at
arcadiapublishing.com